Technique of Photographic Lighting

Norman Kerr

Amphoto
American Photographic Book Publishing Co., Inc.
Garden City, New York 11530

For her enthusiastic support, to Ann

Unless otherwise credited, the photographs in this book are by the author, courtesy Eastman Kodak Company.

Copyright © 1979 by American Photographic Book Publishing Company, Inc.

Library of Congress Cataloging in Publication Data

Kerr, Norman, 1930–
 Technique of photographic lighting.
 Includes index.
 1. Photography—lighting. I. Title.
TR590.K47 778.7 78-10801
ISBN 0-8174-2455-5

Manufactured in the United States of America

"There are only two problems in photography. One is how to conquer light. The other is how to capture a moment of reality just as you release the shutter."

—Edward Steichen

Acknowledgments

To my colleagues and the many photographers of my acquaintance for their freely offered insights. To Doug Lyttle, Professor of Photography at Rochester Institute of Technology, for his comments and suggestions on the manuscript. To the memory of Minor White who first made me aware as a student that photography is much more than just a technical craft.

CONTENTS

Introduction

Lighting is the most difficult technical problem in photography. It can also be the most challenging and the most exciting. Whether the photographer wishes to use his craft as a form of documentation, as a personal language, as entertainment, or as art, the control of light is an essential technique to be learned.

This book is a new approach to the subject of photographic lighting. It deals with the fundamentals of *why* the effects of light occur, and not exclusively with lighting equipment or subject matter. The fundamentals, when understood, provide the photographer with the maximum potential for controlling light, regardless of lighting equipment or subject matter.

Chapter 1 presents a vocabulary of light, a description of the six visual qualities of light and their roles in lighting. This vocabulary is essential to organized understanding about light. Unfortunately, lighting is usually defined in part by the technical precision of scientific terminology and in part by the imprecise jargon of the visual artist. But what the scientist precisely observes and defines, and what the artist intuitively understands and communicates, are not easily synthesized into a method for solving the technical problems of photographic lighting. The vocabulary of light is an attempt to rectify the verbal problems encountered in discussing the control of light.

Chapter 2 examines how artists have always used and controlled light as a tool for visual communication. More than mere illumination, light serves to define and describe our environment, and it can be controlled with exquisite precision.

Chapter 3 examines light and emotion: that intangible area of how light affects all of us. From the beginning, the great photographers have used this power in their images; some of the results are discussed here. Visual communicators must develop the ability to handle this exciting tool for psychological control.

Chapter 4 presents some methods for controlling light by means of its six qualities. By learning to recognize and control the six qualities of light, the photographer can confidently manipulate light regardless of subject matter or lighting equipment. The photographer can control light rather than be controlled by it.

The last half of the book is a visual summary of the first half. The reader can now see what has been previously discussed and can envision why and how lighting effects occur. If he or she wishes, the reader may put aside entirely the verbiage of the first part and concentrate his or her attention wholly on the second part. This book was designed with that in mind; more than half of this book is devoted to the pictures and their captions. This is not meant to be merely repetitive but to acknowledge that photography is, after all, a purely visual craft.

PART I
THEORY

1

The Vocabulary of Light

A PLAN FOR INVESTIGATION

SIX TERMS FOR DEFINING THE VISUAL QUALITIES OF LIGHT

Before we can systematically observe and control light, we need a few words to describe light quality — not hundreds. If we use too many words, the answers become as complex as the subject itself. Moreover, we need words that relate to vision and visual communication, which are definable in visual terms. We don't want words that depend on charts, graphs, and formulas for understanding.

To describe the qualities of light and provide a language for visual communication by light, I propose the following six terms:

Brightness Contrast Diffuse
Color Specular Direction

Each means essentially what we probably think it means. Each can be defined verbally and visually. Six is also the lowest common denominator that will usefully describe all the qualities of light as a visual communication tool.

INVESTIGATION GUIDELINES

Unless we follow a few very important guidelines in our exploration of the visual qualities of light, our investigation will be haphazard and confusing.

First, we will be talking about *one light source* — not a studio full of spotlights, floodlights, reflectors, and the like. The six qualities of light cannot be illustrated by investigating the interrelationships of multiple sources. This approach to learning about lighting tends to be too specific. The explanations do not promote fundamental understanding; they merely become increasingly complex and tedious.

Second, it makes no difference if this one light is the sun or an artificial source. Although different types of light may exhibit variations in light quality, no one type can be said to uniquely possess all the six qualities.

Third, lighting consists of the light source itself and the surface of the object being illuminated. Light quality cannot be evaluated without considering both at the same time. A simple illustration will show us why. Take a clear, sunny day. At any place on the earth, with the sun high in the sky, the illumination from this light source will be just as bright as at any other place on the earth on a clear, sunny day. Now let's imagine ourselves standing on two different surfaces, one a large black-top parking lot, the other a large expanse of fresh snow. The former environment would appear dark to our eyes and the latter blinding. In each of these samples, it is the surface, not the source, that profoundly affects the visual environment.

Source and surface — the two parts of the visual

environment; each of the six visual terms of light quality is affected or is modified by them. In investigating and utilizing each of the six, we will always want to relate them to source and surface.

Fourth, in discussing light and lighting for photography, we must always think about effects as they may ultimately be recorded in the photographic image. It is not easy to visualize the response of film with our eyes. Such a skill requires experience, knowledge, and concentration. This book assumes that you already have a working knowledge of the photographic process and that you understand my references to it.

THE TWO CATEGORIES OF LIGHT QUALITY

The six visual terms of light quality can be divided into two categories: comparative and formative. Think of them only as learning aids, however; they are not opposite or exclusive categories. (For example, each of the six qualities can play a role in creating a sense of form.)

Comparative Category. This is the area of light quality which science investigates and includes brightness, contrast, and color. These are the terms we usually think of when describing light quality in verbal or numerical terms. Our eyes cannot be depended upon to objectively evaluate these three qualities. They usually fail to recognize exact changes in them because we seldom have a point of reference for making comparisons.

We can attach names and numbers to these three qualities. We can, for instance, label different colors of light by name, that is, red, green, blue, and so forth. We can identify one color balance of light as 3200 K and another as 5400 K. A brightness level of 200 footcandles is exactly twice as bright as one of 100 footcandles. Contrast can be measured and assigned ratios between light and shade, such as 2:1 to 8:1, and the ratios have precise mathematical relationships. Isn't it curious, then, that when our eyes are not dependable evaluators, we can nevertheless be very precise in our verbal and numerical descriptions of these impalpable phenomena?

The three comparative light qualities can be altered in the photographic image even after exposure. These relative qualities remain changeable until the photographer decides to quit manipulating them. Indeed, the control of these three qualities by the photographic system itself is one of the unique and exciting aspects of visual communication with photography.

Formative Category. This consists of specular, diffuse, and direction light qualities. These three light qualities play the major role in revealing the sense of dimension, space, volume, shape, and texture. The formative qualities are not easily assigned measured values, but our eyes, if trained, can be dependable evaluators in recognizing and manipulating them with great precision and in sensing changes in them.

The formative qualities are fixed once the camera shutter is clicked. They cannot be changed with the photographic process. Because decisions regarding the formative qualities must be made before exposure, they may seem more difficult to control. There are no measuring devices available for consultation, and the experiences of others as guidelines are not easily verbalized, perhaps not even relevant. Our own experience and judgment must be our guides. Isn't it curious, then, that when our eyes can be trusted to be dependable evaluators, we find ourselves in a situation where the variables are not easily assigned numerical values or verbal identities?

COMPARATIVE CATEGORY OF LIGHT QUALITIES

BRIGHTNESS

Brightness is the quality of radiating or reflecting light. We verbally qualify brightness as "lighter" or "darker." With a light meter we can accurately measure brightness differences. However, these simple descriptions are insufficient to fully describe the brightness quality of light in visually communicative terms. There are other terms, such as the collective and local roles of brightness, brightness key, and literal brightness quality, that we must understand to more completely define brightness light quality.

The Two Roles of Brightness Quality. Brightness light quality has two different roles to play in visual communication: the collective role and the local role. The collective role involves all the tones in the image. Changes occur in the collective role when the overall brightness of the illumination changes or when there is a change in the overall exposure of photosensitive materials. The local role involves a change in brightness quality of only certain parts of the image. Some of the ways in which this change can occur are: use of shadow-casting devices; inclusion or exclusion of objects of various brightnesses in the scene; use of colored filters that change tonal relationships of some colored areas within the scene; darkroom manipulation; variable density filters; and introduction of secondary light sources. The local role of brightness quality is a visual means for increasing or decreasing emphasis in a given area of the scene or photograph — a very useful tool for effective visual communication.

Brightness Key. Collective brightness quality is usually evaluated only in terms of "correct" exposure. However, there are situations where a correct exposure, or a standardized photographic interpretation of the brightness quality, may not be the best visual communication. For example, a dull, gray day can be many times brighter than the illumination in a baby's nursery, but the mood of each environment suggests different brightness quality interpretations in the final photograph.

This leads us to brightness key — that is, whether the tones in the photograph should have a preponderance of one brightness level. If there is a strong preponderance of dark tones, the image has a low brightness key; and if there is a strong preponderance of light tones, the image has a high brightness key. Each of these situations makes an active statement about brightness light quality.

Some subjects seem to be more appropriately recorded when the brightness key is definitely stated in visual terms. A dull, gray day may be best recorded as dark and somber, and the baby's nursery as light and airy. The photographer should consider his light meter information as only a starting point and adjust his film exposure accordingly: toward greater exposure for a high-key feeling, and less exposure for a low-key feeling.

In the two examples given, only the collective role of brightness in the scene has been mentioned. So I should emphasize that a certain brightness key may not be achieved if dominant objects or large areas in the scene have contrasting brightness values. Again a reminder to always consider both surface and source when examining the qualities of light. A dull, gray day may not produce a low brightness key if large areas in the scene are light in tone. Conversely, the illumination in the nursery may not produce a high brightness key if many of the objects in the scene are dark in tone. In other words, the local role of brightness quality should be consistent with the collective role for an overall brightness key to be visually communicated.

Literal Brightness Quality. Our eyes see a brightness range much greater than that which can be reproduced photographically on film. The most limiting range of brightness is that reproduced in a photographic print. The white of the paper can never be as bright as, say, the brilliance of the sun in a cloudless sky. (However, even though the actual brightness range of nature has been enormously compressed in a photographic print, we generally accept the reproduction as a reasonable facsimile if somewhere in the reproduction there is found the extremes of both a rich black and a clean white, inclusion of which provides visual parameters that indicate all the other tones in the photograph are visually relative to those in the original scene.) We come closer to a literal brightness quality if we use photography to produce a transparency that is subsequently viewed by transmitted light or projected onto a screen in a darkened room.

Occasionally, we forget the limited capacities of film to reproduce literal brightness quality and are disappointed with results. We should remind ourselves that photography interprets brightness quality; it seldom duplicates it.

COLOR

We should understand several terms relating to the color quality of light. They are:

Color balance in terms of neutrality.
Color effects as deliberate deviations from neutrality.
Local and collective roles of color quality.
The names of the primary photographic colors and visual identification of these colors even when seen in very weak saturation.
Color temperature and Spectra Distribution Index.

The guideline for investigation which states: "In discussing light and lighting for photography, we must always think about effects as they may ultimately be recorded in the photographic image," is especially significant when we discuss color, inasmuch as color can be profoundly altered by any stage of the photographic process. Color of light and color response of the photographic process are totally interrelated; thus the color quality of light cannot be examined without simultaneously considering film response.

Handling color film for precise color balance requires meticulous care. Our eyes are easily fooled by subtle changes in color balance. Furthermore, our perceptions of color are emotional and subject to change from one day to the next. Color film is one of the most complex products made for consumer use, yet color photography can be simpler than black-and-white photography.

Color is so enchanting that even off-color results are perceived as interesting. Color itself is a charming subject for visual images. In fact, color photography will tolerate poor lighting effects that would otherwise be very disagreeable in black-and-white. Color is a remarkable visual phenomenon, and in discussing the color quality of light we are touching only a small part of a vast and fascinating subject.

Neutral Color Balance. This is defined as a lack of color influence in any neutral tones (white, grays, and black). When this occurs, the purity of the colors is also maintained. Neutral color balance is nominally achieved by matching a given type of color film with a given type of light, for example, daylight-type color film with daylight-type illumination. This simple match provides a satisfactory neutral balance for most photographic subjects.

We become very fussy about neutral color balance of some subjects, for instance, when it is possible to compare colors in the photograph to colors in the scene, or when a photograph of a scene contains delicate, subtle, and neutral colors. A photograph with a strong sense of color, or a variety of colors, is more tolerant to shifts in color balance than one containing many neutral tones or delicate and subtle colors.

Precise evaluation of neutral color balance is complex. We can only evaluate neutrality by comparison, and the conditions necessary for making comparisons must be precisely controlled. We must use standardized lighting for making such comparisons and follow through with carefully controlled processing for predictable results. Evaluation of color is also complex when direct comparisons cannot be made. In such cases, the evaluator must possess an innate sense of color balance. And unless a person is born with this skill (like being born with the aural sense of perfect pitch), effective color evaluation can only be developed with experience.

Fortunately, most subjects do not require extreme precision of color balance for neutrality; nominal color balance is adequate for most visual communication. Indeed, it is my experience that the charm of color is a blessing, for without it color photography would be overwhelmed with the nit-picking technicalities of neutrality.

Color Effects. These are innately related to the emotional character of color. The entire photographic image, or large parts of it, is deliberately shifted from a neutral color balance to produce color effects. Such effects are achieved by placing colored gels over light sources or in front of the camera lens. They can also be achieved by using the "wrong" type of illumination with a given type of color film, by using such films as infrared color film, and by manipulation of processing techniques. However, color effects are easily overdone. Color is seductive and we are tempted to excess. Be sure they are consistent with your visual message.

The Two Roles of Color Quality. As with brightness quality, color quality can be said to have two roles: collective and local. The collective role involves the overall color balance of the photograph. This is affected by the type of color film (daylight or tungsten), the color balance of the lighting, the use of filters over the camera lens, and manufacturing tolerances of color balance between different emulsion numbers of a given brand of color film. The local role involves the colors of the objects themselves and the manner in which they are reproduced by various brands of color film. The local role can be controlled by localized lighting effects, local manipulation of filters in the darkroom, inclusion or exclusion of various objects in the scene, and choice of various color films for their own peculiar reproduction effects on specific colors.

The Primary Photographic Colors. The primary photographic colors are: red, green, blue, cyan, magenta, and yellow.

Red, green, and blue are additive primary colors. Additive primary colors are used when light itself is employed to form color images. Color television sets use very small adjacent points of red, green, and blue light to produce full color images. If the red, green, and blue spots of light are equally brilliant, we see white or shades of gray. Unequal mixtures of two or three of these primary colors produce all the various colors. In the absence of the three primary colors, we see nothing, or black.

Cyan, magenta, and yellow are subtractive primary colors. Subtractive primary colors are used when dyes or pigments are employed to form color images. Color films use cyan, magenta, and yellow dyes to create all colors. If there are no dyes, we see white; if all three dyes are equally present, we see shades of gray. Unequal amounts of two or three of the dyes produce the various colors. A maximum density of all three dyes produces black.

To obtain a neutral balance from a given emulsion number of a given film, subtle filters (called Color-Compensating, or CC, filters) of one or more of these six colors may be needed in front of the camera lens. Red will absorb unwanted green and blue. Green will absorb unwanted red and blue. Blue will absorb unwanted green and red. Cyan will absorb red, magenta will absorb green, and yellow will absorb blue. Various densities of these six color filters can also be used for color effects. Even subtle but deliberate deviations from a neutral balance can produce profound emotional over tones.

Color Temperature. One way to identify the color balance of a light source is by its color temperature. Color temperature is noted in degrees Kelvin (K) and is related to the color appearance of light emitted by a black-body radiator. As the black-body radiator is heated, the color appearance of its light changes. At high Kelvin temperatures the proportion of blue is greater while at low Kelvin temperatures the proportion of red is greater. This color appearance is based on the red/blue ratio of the light. The third primary color, green, is not considered in color temperature. To obtain the color temperature for a given light source, its illumination is compared to that of a heated black-body radiator. When a color match is obtained, the Kelvin temperature of the black-body radiator is assigned to the given light source as its color temperature.

Two color temperatures are of particular note because almost all color films are balanced to one or the other. Daylight-type color film is balanced to 5400 K and tungsten-type color film is balanced to 3200 K. When each type is used in the color temperature of light for which it is designed, the results can be expected to be neutral. If a different color temperature of illumination is used, an adjustment is required to bring the color results back to neutrality. Light-balancing filters correct for given shifts in color temperature.

Color temperature may seem a simple and useful way to designate and measure the color quality of light. Unfortunately, this is not the case. For one thing, some light sources, for example, fluorescent lamps, cannot be assigned a color temperature. Fluorescent lamps do not have a proportional amount of energy at all wavelengths of light and therefore cannot be assigned a meaningful color temperature. Even daylight and electronic flash contain some disproportionate amounts of some wavelengths of light. Moreover, color temperature is too simple a measurement to usefully compensate for the complex interrelationships between color film and color quality of light. It is my experience that refined use of CC filters offers more meaningful control and that such control excludes information about color temperature.

Professional photographers commonly do not use color temperature measuring devices for evaluating existing color balance. Instead, they make a test on a given emulsion number of a given brand of color film and evaluate the results on a standard illuminator using CC filters to determine any necessary color adjustments. If any CC filter

correction seems desirable, that combination is used in front of the camera lens for all future photography with that emulsion of color film and that particular light source.

The combination of CC filters found by this technique not only corrects differences in color emulsion batches but also compensates for color changes in illumination — provided the same light source is used again and remains unchanged. However, light sources do change, sometimes so gradually that the photographer is unaware of it. Therefore, a color measuring device can be helpful if a satisfactory one is available.

Spectra Distribution Index. In recent years, a new color meter, called a Three-Color Meter, has been developed which provides a meaningful method for measuring the color quality of light in terms of photographic response. It measures color quality in terms of Spectra Distribution Index numbers that are based on equal, just noticeable differences in color perception. S.D.I. numbers are obtained by using a color metering device that evaluates two color ratios: red/blue and red/green. These ratios are then transferred to a calculator dial to determine a CC filter, or a combination of CC filters, needed to balance the illumination to a neutral. We examine this device further under "Control of Color Quality." It is a new and promising method for measuring the color quality of light in a way that is more meaningful than measuring color temperature.

CONTRAST

Contrast of light is the difference, or rate of change, between various brightnesses and reflectances of light. These differences occur because of the alternating presence of light and shade and the tonal characteristics inherent in the subject. As with the other two comparative light qualities, contrast is also altered at every stage in the photographic process. Because the word "contrast" is easily misused, we must be very specific about how it is used with reference to light quality. The terms we will employ are: light ratio, ambient light, total and local contrast.

Light Ratio. This is the precise measurement of the brightness difference between light and shade. It is obtained by first measuring the illumination in the light area and then the illumination in the shadow area. The difference is stated as a ratio (such as 2:1) or as the difference in f-stops between the two brightnesses. (An incident-light meter is best for this measurement inasmuch as we are measuring illumination, not reflected light.) The measurement of light ratio would not be too important if film responded to light exactly as our eyes do. Generally, however, film tends to record a much smaller range of tones.

Ambient Light. That illumination which does not come directly from a primary light source is ambient light. It is environmentally reflected illumination. It has no direction quality, creates no obvious light and shade effects, and keeps shadows from becoming totally black. Ambient light enables us to find things under a table, locate items in the darkened corners of a room, and see texture in the shadowed folds of fabric. It is light that is reflected off all the many surfaces of any environment in which there is some illumination. Ambient light pervades most lighting environments in the same

way that air tends to occupy a vacuum.

If there is a lot of ambient light, there will be a lot of illumination in the shadows, making them less dark. And with the shadow areas less dark, there is less brightness difference between them and those areas lit by the main light source. Therefore, the lighting contrast (light ratio) between light and shade will be lower. If there is no ambient light, the lighting contrast will be at its maximum because the shadows receive no illumination from the light source and none from ambient light. The shadows, therefore, will be totally black.

We on earth seldom run into this situation, but in the black void of space, astronauts often do. Their solution is to try and create ambient light. During a space walk, they can so align their bodies that light reflecting from their spacesuits helps to illuminate the shadows. However, this only works when the astronauts get rather close to an object. An umbrella-like reflector may be very helpful to create greater amounts of ambient light. But always remember that while our eyes seldom encounter an absolute lack of ambient light on earth, it is quite easy to produce such an effect photographically on film.

Ambient light can be thought of as reflected light. But the term reflected light implies some control or manipulation and suggests that its light comes from a specific direction. Ambient light emanates from all parts of the environment and it can happen without thought or plan. Deliberate control of ambient light is a primary control of lighting contrast — the contrast between the brightness of the lighted area and the brightness of the shadow.

Ambient light should not be confused with available light. The latter term is commonly used to describe light that is not directly controlled by the photographer. Available light can have strong direction as well as specular quality; ambient light does not.

Total and Local Contrast. Total contrast considers a total range of tone while local contrast considers only adjacent tones. It is important to understand the difference, otherwise the photographer may obtain uncontrolled or unwanted effects. By increasing total contrast, for example, he may inadvertently obliterate the existing good local tonal relationships. Let's look at two situations.

Highest total contrast exists when there are included in the scene both a maximum density of black and a clear white. However, if there are no intermediate shades of gray in this situation, we would have at the same time the lowest possible local contrast, because within the dark areas there would be only solid black, and within the light areas, a complete absence of any other tone but white.

In another situation, say, a piece of white sculpture against a white wall illuminated by a soft diffuse light coming from one side, we would have an example of rather low total contrast. There would probably be no pure white and no black. But the soft diffuse light would cast good form-defining shadows and the shades of gray would produce good local contrast. Here we have an example of good local contrast but low total contrast.

Remember that total and local contrast are independent visual phenomena. They may act together but not necessarily. Total contrast is controlled by the photographic process and/or light ratio while local contrast is controlled by skillful use of the formative qualities of light, namely, direction, specular, and diffuse qualities. We will investigate this subject further when we discuss "Control of Contrast Quality."

FORMATIVE CATEGORY OF LIGHT QUALITIES

SPECULAR AND DIFFUSE

Specular is defined as "mirrorlike" while diffuse is said to be "scattered or widely dispersed." These definitions are not entirely adequate for our discussion on lighting, although the general meanings are appropriate. The two are fundamental keys for describing light quality. They are also interrelated; it is possible to imagine specular and diffuse as two extremes with portions of each quality existing in between the extremes.

Specular Light Sources and Specular Surfaces. Specular light is that which emanates from one specific point. Specular light is also that which travels in straight lines, as a beam of light, for example. The sun, as we know it here on earth, is a specular source because it is very nearly a point of light. (Its disk subtends an angle of about ½°.) Another specular source is a small, bare light bulb. If this source is relatively far away from that which it illuminates, it too is perceived as very nearly a point of light. A spotlight in a theater is also a specular light source. It may not be as small a source as a light bulb, but it does throw light as a beam in one specific direction. Perhaps the ultimate specular light is a laser beam. It is not only a very small point source, it also directs its beam very strongly in one very precise direction.

Specular surfaces mirror the light falling on them off in a specific direction. Glass and chromed metal are specular surfaces, as are wet, glossy, oily, and highly polished surfaces.

Specular quality light should not be compared with brightness — the sun is no more specular than a small light bulb. Specular quality and brightness

quality are different light qualities, completely independent of one another.

Diffuse Light Sources and Diffuse Surfaces. Diffuse light comes from a source that has a large area. Imagine this large source as many adjacent points of light, with each point sending out rays in many directions. Diffuse light does not produce such lighting effects as specular light because it comes from many points and thus from many directions. A cloudy, overcast sky is a diffuse light source. The light comes equally from a very large area, horizon to horizon. In fact, this source is so large that it effectively simulates the effects of ambient light. Another diffuse source is light reflected off a large white surface or a window open to skylight.

Perhaps the most diffuse source, aside from ambient light itself, is that created by a whiteout in a snowstorm. Here the light emanates equally from all directions — above as well as below. There is no horizon, no void of light, no shadows, and no sense of direction quality. People get hopelessly lost when trapped in such a storm.

A diffuse surface takes the light falling on it and scatters it off in many directions. Most dry, rough, and porous surfaces are diffuse. As with specular quality light, diffuse quality light must not be confused with brightness. A diffuse light is not necessarily less bright than specular light. Brightness, as we said, is a separate light quality.

Interaction of Diffuse and Specular Qualities. A good example of specular and diffuse quality light in combination is ordinary daylight. The sun is a small source and is highly specular as it exists in our

sky. The envelope of sky around the sun is a very large diffuse source. Together they produce daylight, a type of lighting not easily duplicated by artificial means.

Specular-diffuse quality can sometimes be altered with a given light source if distance between the source and subject is changed. A light bulb in a reflector is more specular than diffuse. Even though the reflector makes the light source larger, the source is still relatively small compared to, say, a large window open to skylight. However, if the bulb in the reflector is brought very close to a small subject, the light source will begin to occupy more area relative to the size of the object being illuminated. In this case, the source becomes more diffuse and less specular.

There is no exact line of demarcation between a specular and diffuse quality source, but in general a light source that subtends an angle of less than 20° will be more specular and one that subtends an angle of more than 30° will be more diffuse. Tiny sources are specular; large sources are diffuse.

A diffuse surface will modify the specular light falling on it. The specular light coming from one specific direction is scattered off in many directions as diffused light. Likewise, a specular surface will modify diffuse light falling on it to some extent. Light falling on a mirror from a diffuse source will tend to be reflected off more strongly in one direction, making the reflected light more directional than it was.

A diffuse surface can be made very specular when wet. It can also be made more specular when light hitting it skips off the surface with little scattering, as when driving on a diffuse-surface concrete highway heading into the setting sun. Conversely, a specular surface can look diffuse when lit with a very soft, enveloping, diffuse light. Thus a diamond or a shiny new car won't sparkle on a dull, overcast day as they do in sunshine.

DIRECTION

The direction from which light comes is important. If everything else about a light source remains unchanged but the light source is moved, or the angle of the subject to the light source is changed, then the resulting illumination will be different. Direction controls the formation of shadows. Shadows place emphasis on texture, form, and space while the lack of shadows diminishes this visual information. Direction directly affects the light and shade relationship — the visual evidence of the influence of light on the environment. While the eye can readily detect this influence, it is not easily verbalized. The effects of direction quality on the myriad surfaces and undulations of a subject exceed useful verbal description.

When direction quality is strongly stated in a photograph, the lighting achieves a visual importance in its own right. The result is clear and is often visually fascinating. Many books on lighting dwell on control of direction quality almost to the complete exclusion of the other five lighting qualities. This is shortsighted. The control of direction quality can be likened to a pitcher learning how to throw a baseball over the plate. It's an essential skill for the ballplayer, but it is not the only one he must master. He must also master finesse and style.

Interaction of Direction with Other Light Qualities. Specular light sources, with their sharply defined shadows, reveal the direction quality of light with precision. Diffuse sources, with their nebulous shadows, do not. Direction plays an

18

important role in determining the specular and diffuse qualities of surfaces. We already noted the example of driving down a diffuse-surface concrete highway and having it become specular because a setting sun skips light off it with little scattering straight into our eyes. In this case, it is the direction quality of the light that causes the change to specular quality to occur.

Direction quality can also modify brightness quality. When the light source is off to one side and the light it produces skims across a surface, that surface will appear less bright than when the light falls directly on it. The difference in brightness is due to a revelation of surface texture and its resulting myriad shadows. Conversely, when the light source is behind or above the subject and reflection of light skips off the surface into the camera lens with little scattering or absorption, the direction quality will cause that surface to appear much brighter. In other words, the brightness of a surface is dependent on direction quality.

Direction quality can also affect contrast quality. As more shadow textures are formed, local contrast increases; however, total contrast does not. This is a very useful technical point to remember. Even experienced photographers overlook the pictorial potentials of this simple principle. An increase in local contrast of surfaces better communicates what the surfaces feel like by making their textures more prominent.

Direction quality also affects color quality. As a surface becomes more specular because of direction quality, the color of that surface becomes desaturated, and the shinier the surface, the more pronounced this effect becomes.

Direction quality of light is self-evident to the trained eye, but it is not easy to control. Photography is an action art, and complex relationships are not easy to see within a limited period of time. To control direction quality, we need a sixth sense, much like a quarterback needs a sixth sense to spot receivers on a football field.

2

The Light and Shade Relationship

WHAT IS IT?

Light is necessary for vision. We cannot see without it. Our first instinct upon entering a darkened room is to reach for the light switch. If we are reading, or doing some careful work, we increase the brightness of the light to see more clearly. This is the role of light as an illuminator. But light has a more sophisticated role. It can also convey visual information about form, space, texture, and dimension. Light reveals this information by its alternate presence and absence – a condition known as the light and shade relationship.

The light and shade relationship exists because obstructions interrupt light rays, preventing some areas from receiving direct illumination: a tree casts a shadow on the lawn; a blade of grass throws its shadow on the soil; delicate undulations in the soil receive less light than adjacent illuminated areas. With a powerful magnifier, we can see further variations of tone, for example, an illuminated grain next to a shaded speck resulting in even more delicate nuances. The precision is exquisite. This relationship persists as far down into the microscopy of substance as our vision can travel, yet can be as vast as the mountain's shade of the valley and as far-reaching as the moon's obstruction of the sun's fiery disk.

The light and shade relationship exists because three-dimensional objects have many planes and undulating surfaces. Light is reflected off these facets in varying degrees of brightness simply because the angles of reflection vary. Even flat, frontal illumination will produce a delicate light and shade relationship.

The relationship exists because atmosphere is not always as transparent as we may imagine it to be. Heavy, humid air becomes visible as the sun steams off the moisture in swamp, lake, and lush landscape. The substance of light itself is revealed. We know this visual clue limits our horizon and yet defines an environment.

The light and shade relationship exists because the direction from which light comes, or the relative angle of the subject to the light, is changeable. The direction quality of light is the mechanism for molding the light and shade relationship.

The character of the light and shade relationship is related to the presence of specular or diffuse quality of the light. Specular sources produce sharply defined shadows that have a prominence of their own while diffuse sources produce nebulous shadows that defer to the environment in which they exist.

The relationship exists because visual communicators cause it to happen in their images. They can control the lighting environment to reveal maximum visual information about what a place or thing

feels like, the space it occupies, and the form it possesses. Or they can cause the light and shade relationship to reveal only that part of the subject which they desire — a mechanism for visual selection that reveals only a part of the whole and no other. Or they can create a new lighting environment, unique to their vision. As such, the light and shade relationship can become structure and exclamation point, content and life — a visual world of the artist's own creation.

A HISTORY OF RECORDING LIGHT AND SHADE

Our eyes can see all the subtleties of light and shade, but historically, artists have not always been technically able to translate the scheme of light and shade into their images. Artists first translated their visions into outlines, patterns, and colors. There were some good efforts at defining light and shade in Roman frescoes during the first few centuries after Christ, but then art turned again to traditional flat patterns, designs, and abstractions.

Giotto (1266 - 1337), a Florentine, worked out a scheme of light and shade in his paintings. His images allowed room for volume and space. Refinements of this vision continued, and by the fifteenth century most European painters used the techniques of light and shade. A young Italian, Masaccio (1401 - 1428), carried this sense of modeling to a bold and complete vision which the Italians called *chiaroscuro*: chiaro=bright; oscuro =dark. Other geniuses of the Renaissance practiced this technique of visualization, but none seemed to so thoroughly assimilate and systematize it as Leonardo da Vinci (1452 - 1519). He was able to add the illusion of deep space by atmospheric sugges- tion, to skillfully accent important figures in a group while subordinating minor ones, and to depict with great precision subtle modulations of surface and underlying structure.

The meticulous images of Giovanni Bellini (1430 - 1516), Jan van Eyck (1370 - 1440), Rogier van der Weyden (1399 - 1464), and Hans Holbein the Younger (1497 - 1543), among others, should be examined by photographers. The clarity of illumi- nation in their images — images suffused with a vibrant, glowing light and shade relationship — is instructive to us today. It is important for photographers to recognize how most of these visual translations of light and shade (*chiaroscuro*) were observed. The light source in the painter's studio was skylight from a nearby window — a relatively large, diffuse light source. When a subject was placed adjacent to the window, the direction quality of the light could be enhanced. Light reflected from walls and the influence of peripheral windows produced a high level of ambient light, thus reducing contrast to a level more amiable to subtle revelations of form than harsh specular, direct sunshine. Variations of this simple lighting situation have fascinated artists for centuries. Jan Vermeer's (1632 - 1675) glowing interiors probably epitomize a historical example in most of our minds because he often included the nearby window source in his paintings.

It is noteworthy that as early as the late sixteenth century, images were produced that had a strongly specular light quality, although the only artificial light sources convenient for indoor use were candles and oil lanterns — very feeble specular sources. Nevertheless, Jacopo Tintoretto (1518 - 1594), El Greco (1548 - 1614), and Caravaggio (1569 - 1609) depicted dramatic specular lighting effects obvious-

ly evolved from observation of the effects of these artificial specular sources. Tintoretto and El Greco tended to depict the effects as lighting fantasy while Caravaggio depicted the effects with photographic precision. The latter produced images having a specular quality of light and shade similar to the theatrical spotlight illumination common to cinematography and fashion photography in the decades between the 1920s and the 1950s. Caravaggio may have been the first artist to recognize and utilize the visual power of specular lighting effects.

His influence, in his lifetime and for some time after, was enormous. But because his paintings portrayed with naturalistic clarity the often unstructured, harsh light and shade relationships of specular light, he was later discredited by art historians. Perhaps this assessment should be changed, because we now recognize that Caravaggio first realized the visual power of specular light as Masaccio and Leonardo da Vinci first articulated the power of diffuse light.

The translation of light and shade through the application of paint is tedious and demanding, no matter how skillful the vision and techniques of the artist. With the invention of photography, the capacity of this new visual medium to easily and automatically render light and shade was regarded with as much excitement as photography's capacity to render optically fine detail and "perfect" perspective. Early photographic materials were not very light-sensitive and artificial illumination was not very bright, so photographers working indoors avoided artificial light and used the same light source employed by most visual artists of the past — a large window of diffuse skylight.

Large skylights were built into photographic studios to let in as much light from the sky as possible, and these produced other light qualities besides increased brightness. Because the skylight was very large, it produced a diffuse quality light. Its size, relative to the room environment, created a high level of ambient illumination, which served to reduce contrast. The direction quality could be controlled by orienting the subject in relation to the window and by manipulating window shades and screens. This served to modify the light and shade relationship and control local brightness, with the result that the lighting was soft and enveloping yet the light and shade relationship was controllable.

The contrast characteristic of early films was very high. This combination of soft light and high film contrast, with proper handling, yielded beautiful renderings of light and shade. So remarkable was the combination that it stands as a benchmark for photographic lighting even today.

Around the turn of the century, the studio skylight gradually was replaced with artificial light sources. Film sensitivity had increased, and brilliant artificial sources, such as the new carbon arc light, had been developed. The obvious convenience of constant brightness and the availability of illumination after sundown helped to start the switch to artificial light. When more convenient, portable, and adaptable tungsten lamps became available, the switch from natural skylight illumination was accelerated.

These new sources of illumination introduced more than mere convenience; they also introduced specular quality to photographic lighting. This was new and exciting. Small, bright light sources producing sharp, crisp highlights and shadows allowed for an individualized treatment of the light and shade relationship formerly rendered only with paint and brush. Cinematography, fashion photography, advertising photography, portrait photography, all plunged into examining specular quality

light. Instead of one large diffuse source, it was now possible to use several specular sources at one time.

Each light was given a role to play and names were assigned: key light, fill light, background light, hair light, cross light, kick light, rim light. The more desirable lighting recipes were given names too: Rembrandt lighting, glamour lighting, narrow lighting, broad lighting, high front lighting, X-lighting. This compartmentalization of light and lighting became so complex that the "why" of it disappeared under a staggering proliferation of facts relating to "how" and "what."

The merits of diffuse lighting have now been rediscovered, but we are still in the position of being overwhelmed with the specifics of "how" and "what" specular lighting recipes. We need to reexamine the light and shade relationship, not from specifics but from generalities. We need to assess not the roles of various light fixture positions but the roles of the various qualities of light itself.

LIGHT QUALITIES AND THE LIGHT AND SHADE RELATIONSHIP

GUIDELINES FOR INVESTIGATION AND DEFINITION OF TERMS

The light and shade relationship is primarily controlled by the three formative qualities of light — direction, specular, and diffuse — whereas the three comparative qualities play lesser roles. As a result the light and shade relationship must be considered before the film is exposed; alterations cannot be made in the darkroom. The influence of the qualities of light must be considered before the shutter is clicked, if we are to exert control over the light and shade relationship. Before proceeding, let's define five terms so that we are on a common verbal ground. These are: shape, pattern, form, space, and texture.

Shape and pattern depend on outline for identification. A silhouette is a shape; the leaves of a plant form patterns. Form and space depend on inherent structure and spacial relationships for identification. A human body with its characteristic undulations, appendages, and three dimensions is a form; a group of dancers on a stage defines a sense of space. Texture is the visual summation of a surface in terms of the many adjacent light and shade relationships revealed as light skims across that surface. Texture visually describes feelings of touch.

Specular Light Quality Effects. A specular light source, because its rays originate from one point, or because its rays are columnated into a beam of light, will cause, when the rays are interrupted, sharp-edged and distinct shadows to be formed. Even if the interrupting object is some distance from its shadow, the cast shadow will still be sharp and obvious. When the shadows have sharp edges and are quite distinct, the line of demarcation between light and shade becomes visually prominent. The change of tone is abrupt and obvious. When this edge of tone is just as visually important as the edges of the object itself, new shapes and patterns are formed. These new shapes and patterns may convey obvious visual repetitions, or they may become strong visual abstractions of major pictorial importance.

Because specular light comes from a small source, its rays are tangent to only a small area on rounded

surfaces. This creates a rather sharp line of demarcation between light and shade, even when the rounded surface does not have a sharp curve to it. As a result, the light and shade relationship of specular light is sharply defined even when the form and surfaces of the subject are not sharply rounded. This is significant to note: The sharp-edged, specular shadows on rounded objects are contrary to the actual form of the rounded objects.

It is sometimes difficult to grasp the fact that hard-edged, specular shadows tend to distort or destroy a visual sense of form. This happens because there are other visual clues, such as perspective, color, and logical shape, that also convey visual information about form. These clues may be so strong that specular, hard-edged shadows fail to overcome their influence. Nevertheless, the tendency is always there for specular shadows to distort form and it must not be ignored.

Diffuse Light Quality Effects. Conversely, a diffuse light source, because its rays originate from many adjacent points of light, and thus from many directions, does not produce sharply defined shadows. When its rays are interrupted, the resulting shadows have soft, nebulous edges. If the interrupting object is some distance from its shadow, the cast shadow will become even less distinct; it may become merely a soft, shapeless tone only slightly darker than the surrounding surface illumination.

When the shadows on a form or object have soft edges, when the edges of the shadows are barely noticeable at all because the change is so gradual, there ceases to be a line of demarcation between light and shade. The change is there, but no specific line can be found. When no line of demarcation can be noted, then any change at all is read by the

observer as being caused by the actual form of the object. And when the shadow is separated from the object, the cast shadow adds visual information about space without adding new patterns or abstract shapes. This happen because the shadows have no distinct edges and outlines to attract attention.

So we can state these generalities: A single specular light source producing hard-edged, sharp shadows tends to place visual emphasis on shape, texture, and pattern. A single diffuse light source producing soft-edged, nebulous shadows tends to place visual emphasis on form and space.

Direction Light Quality Effects. *Precision of Placement.* Shadows are formed because the illumination is interrupted by something. The chance of seeing these shadows is far greater if we are off to one side, not standing with the light source directly behind us. The direction quality control problem is to decide exactly where to place the light for the most desirable shadow formation.

To analyze this puzzle, let's first reexamine what has been said about shadows formed by specular and diffuse light sources. Specular sources produce sharp, distinct shadows; diffuse sources produce nebulous ones. It follows, therefore, that precision of placement is more necessary with specular light than it is with diffuse light.

A diffuse light source, especially a large one, usually just has to be "over there someplace." With a specular source, its location needs to be more exact because its light and shade effects are inherently sharp and precise. We will examine this problem in greater detail later in the book.

Distance as a Factor. Specular light sources require careful placement not only in regard to direction but

also to distance. The former is now apparent; the latter may be a surprise. The inverse-square law of illumination — illumination varies inversely by the square of the distance from the source — applies to specular light sources. While it applies directly to the brightness quality of illumination, it becomes additionally significant when an artificial specular source is used in a confined space.

If the light is placed much closer than six times the width of the set being illuminated, the falloff in brightness across the set may be objectionable. Thus a set that is 1.5 metres (5 feet) wide and is lit from one side by a specular light only 3 metres (10 feet) away results in a situation where the near side of the set will receive about one stop more light than the far side. To reduce the falloff in illumination across the set to an acceptable $1/3$ stop difference or less, the specular light should be a minimum of 9 metres (30 feet) from the near side of the set. Of course, other light sources, including ambient light, can moderate the situation, but it should be apparent that specular light used in confining spaces requires much more room than might be imagined.

Generalities About Direction Quality. A couple of generalities about direction quality apply equally to specular and diffuse sources in the light and shade relationship.

Light souces, even artificial ones, are normally located somewhere overhead or at eye level. The shadows created in such situations are viewed and interpreted normally. Visual logic seems to prevail. So direction quality should come from eye level or above to obtain a normal viewer response. When the light comes from below, however, this is not normal. Light from below causes visual confusion; for example, a bump in a smooth surface may look like a dent. An object lighted from below appears to be floating or suspended in a surrealistic environment. Or the object may appear to be surrounded by an unnatural illumination. Consequently, the photographer should not light from below unless there is a good visual reason to communicate in this manner.

Another generality about the direction quality of light is the law which states that the angle of incidence equals the angle of reflectance. This means that, like a banked billiard ball, light hitting a surface at a given angle will bounce off that surface at the same angle. The more specular the source and surface, the more likely that all rays will bounce off in only one specific direction. The more diffuse the surface and source, the more likely that the rays will tend to scatter. For example, a mirror will reflect the sun's rays with maximum blinding power, but the effects of this reflectance can only be noticed if the angle of the mirror is adjusted with great precision. A white sheet, on the other hand, will reflect the sun's rays with far less intensity than a mirror, but the sheet's reflectance of light can be noticed easily from many angles. The reason the mirror and the sheet differ in the percentage of light rays reflected in one specific direction is because the former is a highly specular surface and the latter a highly diffuse one.

A third generality about direction quality is that light skimming across a surface will reveal more about that surface's texture than light falling directly on it. The skimming light reveals the alternating light and shade effects caused by the surface irregularities. A fascinating example is one many of us have noticed. A large, outdoor wall surface, just before it goes completely in shade as the sun moves across the sky, will have rendered on its surface all of its tiniest irregularities and textures by the skimming sunlight. It is fascinating because only

in those few minutes do we see with such complete clarity those myriad textures which are otherwise almost invisible during the rest of the day.

Contrast Light Quality Effects. *Role of Ambient Light.* Contrast quality of light visually determines how strongly the light and shade relationship is stated. High contrast produces a more obvious difference in brightness between the light and the shade while low contrast reduces it.

This lighting contrast is controlled by the presence or absence of ambient light in the lighting environment. Ambient light, as we noted, is that illumination which is produced by light bouncing off all the many surfaces in and around any environment in which there is light. If there is much ambient light, the contrast between light and shade will be low; if there is insufficient ambient light, the contrast between light and shade will be high. Although ambient light can be increased in many ways, the most common techniques are to simulate its added presence by using a secondary source, a fill light, or by introducing nearby light-reflecting panels. These techniques are discussed in detail later.

Light Ratio. This contrast can be measured, and the measurement is called light ratio. Light ratio is important because of its multiplying effects on the tonal range of a scene and because film cannot "see into" shadows as easily as our eyes can. Our eyes automatically adapt themselves to brightness differences whereas film does not. If film responded to the contrast of light and shade exactly as our eyes do, we could care less about measuring light ratio. But film responds less well to lighting contrast, so we must be prepared to measure light ratio to enable us to predict the results of our photography.

Visual Effects of Contrast. Control of light ratio is examined later. But it is important to note that the contrast of light and shade is a visual clue about the lighting environment and that excessive contrast does not always need to be reduced. Much photographic literature dwells on the need for measuring and controlling light ratio so that the film will reproduce the scene "correctly." This correctness usually refers to a total revelation of visual detail in both light and shade. However, such total revelation is not always necessary. For visual communication, it is the visual message itself that determines the extent of tonal revelation. Sometimes, for the sake of visual communication, the contrast between light and shade should be strong and dramatic. At other times, the contrast should be even greater than our eyes perceive. Control of contrast need not always imply reduction; control can mean increasing contrast too.

Strong contrast between light and shade places visual emphasis on the light and shade relationship instead of merely on the subject being illuminated. Extremely strong contrast of light and shade creates new visual patterns and shapes that were not there before the light and shade relationship was introduced. These effects are analogous to the effects of specular quality — visual emphasis is placed on the line of demarcation between light and shade, which creates new patterns and shapes, diminishes feelings of form and space, and enables the visual communicator to produce visual abstractions instead of literal visual records of a scene. Such a technique is used for making photographic posters and photographic abstractions.

Strong contrast also enables us to make an ordinary visual statement more forceful. Contrast adds emphasis and makes the message more dramatic. Stronger contrast is an effective way of

emphasizing the normally weak light and shade relationship caused by diffuse quality light. Stronger contrast is also a way of reducing emphasis on irrelevant detail in the shaded areas of the light and shade relationship.

Total and Local Contrast. These are important factors to understand in the light and shade relationship. Local contrast can be introduced by using the direction quality of light to create myriad texture-revealing shadows. But this device need not alter the total contrast of the illumination. Total contrast is altered by changing the amount of ambient light — more ambient light reduces the total contrast while less ambient light increases it. Total and local contrast are independent visual phenomena. Because they are independent, we can increase texture-revealing local contrast without exceeding the total contrast requirements for film reproduction. This compartmentalization of contrast control in the light and shade relationship is especially significant for product photography and other documentary photographic illustrations where the photographer seeks visual impact without sacrificing significant detail in important areas of the scene.

Contrast Effects on Specular and Diffuse Qualities. Another aspect of contrast in the light and shade relationship is its capacity to modify the specular-diffuse qualities affecting light and shade. As total contrast increases, the nebulous, indistinct line of demarcation between light and shade caused by diffuse quality light becomes more distinct. Finally, depending on handling of the photographic process, the total contrast can be increased to a level where a sharp line of demarcation will be obtained between light and shade — even though the light source had a strongly diffuse quality. This situation can be obtained by using extremely high contrast film materials.

Conversely, a light and shade relationship with a strongly specular quality can be reduced in contrast. The sharp line of demarcation will not disappear, but it may become so insignificant that it no longer draws attention to itself.

The light and shade produced by specular and diffuse light quality can be made markedly different in visual effect when modified by controlling the total contrast. Diffuse light normally causes a soft light and shade relationship, but when contrast is greatly increased, the light and shade relationship becomes very strong. Conversely, specular light normally causes a hard light and shade relationship, but when contrast is greatly reduced, the light and shade relationship can become delicate, sparkling, and airy. In effect, the alteration of contrast brings some of the normally expected characteristics of one light quality to the other.

Brightness Light Quality Effects. Brightness quality, as noted earlier, has two roles. It is the second role, local brightness quality, that most strongly influences the light and shade relationship.

We have a tendency to believe that a single light source in an environment will uniformly flood that environment with its illumination. Of course, this is not the case. When we turn on a light in a room it appears to evenly flood the room with light because our eyes see easily into the far corners. In reality, however, the illumination brightness falls off rapidly. This fall-off is due to the Inverse Square Law of Illumination, and it produces a light and shade relationship that is readily recorded photographically. The localized brightness effects thus produced cannot be controlled by considering

overall brightness quality and adjusting camera exposure; they can be controlled only by thinking in terms of local brightness quality.

In actual practice, we seldom analyze the situation to this extent. Instead, we instinctively place the subject close to the illumination and allow the darker surroundings to act as a useful background.

Local brightness quality can be used in a much more sophisticated way to influence the light and shade relationship. By introducing shading devices, you can selectively restrict the brightness of local areas in the scene, causing these areas to recede in visual importance. And you can introduce secondary light sources to selectively lighten specific areas in the scene, giving them more visual prominence. Furthermore, when making enlargements you can lighten or darken areas in the photograph by dodging and burning. Thus, local brightness quality can be a mechanism for molding the light and shade relationship into the photographer's own choosing. Carried to its logical conclusion, you can think of local brightness control as painting with light. A bit fanciful, perhaps, but the potential is there. The options are limitless. I must hasten to add, however,

that more is not always better. This book emphasizes the use of one light because it is simplest and because it is quite capable of producing completely adequate and exquisite results. Local brightness control is not always necessary or even desirable in a great many of the lighting problems that are encountered.

Color Light Quality Effects. Modeling of light and shade is generally thought of as monochromatic values (*chiaroscuro*). But visual communicators can also use pure color. Paul Cézanne (1839 - 1906), the great French painter, is credited with the first systematic observation of how some colors recede and others advance in visual terms. He devoted his genius to developing a sense of form and substance without the use of the *chiaroscuro* light and shade relationship.

There is presently no clear group of photographic works in this unique area of color "light and shade." But a study of the post-impressionist painters — Cézanne, Van Gogh, Georges Seurat — shows the visual communication potential to be enormous and intriguing.

THE OBJECT AND THE LIGHT AND SHADE RELATIONSHIP

We must remember that both the source and the object being illuminated play roles in the light and shade relationship. The surface of the object contributes its own tones and brightnesses.

OBJECT IDENTITY

A convex object has a shadow of its own, regardless of light quality. A ball, for example, will

nearly always have a dark side, or a dark periphery, regardless of the specular, diffuse, or even direction quality of the light source. The only time the peripheral shadow will disappear is if the light source is a 360° evenly bright diffuse sphere surrounding the ball being illuminated.

Many objects have complex or undulating forms that produce their own light and shade relationships merely because light reflects off the many facets to a

greater or lesser degree. Sometimes these light and shade relationships can be destroyed by overpowering them with excess direction quality and contrast. The photographer can get preoccupied with light and lighting for powerful visual effects and overlook the subtlety of delicate light and shade relationships inherent in the object itself.

Also, an object may have differing tones on its surface that are so strong they can supplant in visual importance the light and shade relationship of lighting. A very simple illustration is a clown's face. The clown's makeup provides a synthetic light and shade relationship, which can be a powerful tool for illusion. It can also prevent a full depiction of underlying form and substance by lighting qualities. Surely this is one reason why a negligee is never made of a plaid fabric.

As we noted, specular and diffuse surfaces of objects will alter the quality of the light falling on them. A highly specular surface, such as glass, reflects all the light striking it with an optical precision. A specular light source is mirrored off as a pinpoint of brilliance while a large, diffuse light source is mirrored off as an area of brilliance. The surface of the glass, if it is undulating, will correspondingly distort the mirrored image of the large diffuse light source. In this latter case, the large glare of distorted diffuse light reflection serves to visually define the form of the glassware. The form of glassware cannot be revealed by the pinpoint reflections of specular light.

Conversely, a diffuse surface will reflect the light falling on it as scattered, diffuse light. Some areas may be lighter or darker because of changes in surface undulation, but there is no mirrored image of the light source. A diffuse surface will modify both specular and diffuse illumination into a diffuse light reflection.

Many surfaces combine qualities of specular and diffuse character. For example, skin, if it is moist or oily, becomes specular. Certainly the skin is not a mirror, but neither is it a dull, diffuse surface. With this example of combining diffuse and specular quality, we encounter one type of light and shade relationship that should be discussed separately.

SPECULAR HIGHLIGHTS

Specular highlights are brighter areas within the light areas. They are visual accents that add dimension and sparkle. The more brilliant and tiny the specular highlight, the more specularity present in the source and the surface. Have you ever eaten breakfast in the morning sunshine and noted the added succulence of a fruit compote, the sparkle in a shimmering cup of coffee? A portrait that has no catchlight in the eyes looks lifeless. What mountain stream dancing in the sunlight doesn't epitomize freshness and purity? A shiny, freshly washed car seems to drive better. The highlight on an apple stimulates our taste buds. Skin with a glisten looks supple and healthy and youthful.

The light and shade relationship can be strongly affected by the presence or absence of highlights. In many scenes, it is desirable to include highlights for that added sparkle and visual interest. Highlights give added dimension because they create an illusion of greater brilliance — a light tone will appear even more sparkling if within it there is an area of pure white. It is this juxtaposition of pure white highlights and light tonal values which provides the sense of sparkle and luminosity. Control of this situation requires consideration of both the source and the surface when using light. We shall return to this subject later.

THE LIGHT AND SHADE RELATIONSHIP
AND ITS PLACE IN VISUAL COMMUNICATION

The light and shade relationship has been used by visual artists for over seven hundred years and can play an important role in visual communication. Photography has heightened our awareness to this fascinating aspect of vision by providing an exquisite method for reproducing the light and shade effect in every subtle nuance. To learn more about controlling light, a photographer should try to diagnose the qualities of existing light and shade relationships, just as a dancer or actor observes ordinary people on the street. This a good way to polish perceptions and gain new insights.

In making this diagnosis, ask yourself these questions: Is the source specular or diffuse? Is there an effect of more than one light source? If so, what are the direction qualities? Is the light ratio high or low? Is there a color influence? What happens to direction quality as I rotate the object? What new direction effects have occurred? Can the brightness of the background be changed? Is brightness key playing a role in the light and shade relationship? If I like what I see, can I translate these visual experiences into studio lighting and achieve a similar result?

Keen observation begets control. The six qualities of light help systematize the analysis of those relationships which may be found if the photographer is willing to search for them. Traditionally, techniques of lighting control have separated photographic disciplines. The photo-journalist-documentor uses only available light, and the studio photographer uses only created light; neither is able to utilize the lighting discipline of the other. This need not be the case if the photographer is able to perceive and control the six qualities of light.

The next chapter attempts to bridge the gap of traditional photographic lighting disciplines, to better prepare the photographer for the final chapter concerning control of the six qualities of light and lighting.

3

Light and Emotion

LIGHT, AN AMAZING SUBSTANCE

Light is enormously important in our lives. Sunlight, directly and indirectly, provides us with virtually all our energy and food. Light reveals to us most of our information. Light even affects us in ways we don't understand. For example, recent newspaper accounts note that exposing premature babies to light prevents a form of jaundice. In Russia, the law requires that coal miners be exposed every day to ultraviolet light to help avoid black lung disease. The International Commission on Illumination has a study committee devoted to the extrasensory effects of light — those not perceived by senses of vision and touch.

Light affects us emotionally. Candlelight and moonlight can be romantic. Dull, overcast illumination for long periods is depressing. Red light is warm. Blue light is cool. Firelight is mesmerizing. Light added to other stimulants can be overwhelming, as experienced in the dark confines of the movie theater and, more extravagantly, in the discotheques of the 1960s.

Light, created billions of years ago by the stars, still exists. When we stare at the heavens, we are witnessing a history of light, much of it incredibly ancient. But we do not require galactic radiation to see a chronicle of light. Painters, with meticulous care, can choose to simulate its visual effects, or photographers, with optical precision, can preserve its effects for future generations to scrutinize.

Photography's explicit documentation of the effects of light generates a compelling fascination. In photography we have a unique heritage of light. But photography is controllable, malleable, and subject to precisions of deception. Its exactness is enthralling but it is nevertheless always modified by man's manipulation. Therefore, the heritage of light in photography can be controlled for good or ill.

Light is an actual substance in our lives — as much as food, water, and air. That a substance so pervasive, so significant, so motivating, so intriguing can be meticulously controlled is staggering to conceive. The control of light and related information represents power, nothing less. To assume that light merely illuminates is fatuous.

Light has an emotional role to play in visual communication. The role taken by lighting can greatly alter our feelings toward objects, although our casual, everyday manner of looking usually ignores the emotional potential of light. Our eyes only tell us, for instance: here are three steps to climb; I recognize this person coming toward me; this is my overcoat. As Ralph M. Evans notes in his book *Eye, Film and Camera in Color:* "Perhaps the most important fact to understand about vision is the extent to which we have trained ourselves from birth to see objects rather than light. We live in a

world in which the illumination falling on objects is constantly changing. Yet we believe that the objects themselves have fixed properties which are not affected by these changes." *

As photographers, it is precisely our role to be cognizant of the effects of light on objects. We must train ourselves to be aware of those relationships of lighting which others fail to recognize. And we must also be able to create lighting relationships that properly complete an intended visual statement.

EMOTIONALLY PASSIVE ILLUMINATION

A starting point for our investigation in the role of light in affecting how we feel about those things it illuminates is to recognize that light can play either a passive or an active emotional role. If the light is passive it merely illuminates. It does not draw attention to itself; it does not add any emotional overtone. The illumination is sufficient for information purposes but plays no dramatic role in the visual communication process. Some types of illumination tend to be more passive than others. For example, light on a dull, overcast day is usually passive, as is light with a weak direction quality. Passive illumination often has a neutral color quality, low contrast quality, and a uniform moderate brightness quality. Passive illumination often has large amounts of ambient light present. In other words, passive illumination does no more than to provide literal visual information. Passive information allows objects to display their own values without being affected by superimposed lighting values.

Everyday lighting is usually passive, examples of which are: ordinary daylight illumination, a single flash on the camera, ordinary office illumination, light in a sports arena, standard descriptive studio illumination. Passive illumination should not be construed as bad. In fact, it can be the better illumination in many situations. Examples: A photograph made in a gentle snowfall looks visually appropriate with passive illumination. A group portrait of several people is much easier to do with passive illumination. Documentary and informative photographs can be more honestly descriptive with passive illumination. A variety of objects, textures, or contrasting elements in a scene can be more clearly sorted out under passive illumination.

It may be deduced from the foregoing that the reader has been provided some faithful rules to follow. This is not true. It is very dangerous to take such a rigid viewpoint because we are only talking about tendencies, not absolutes. For example we noted that flash-on-camera light is usually passive. Casual photographers use the source merely for convenience. This form of lighting seems like an emotionally inactive light at best, but it is worth noting an exception to emphasize a point, namely, the style of lighting used by both Weegee and Diane Arbus. Their straightforward single-flash-on-camera visual statements explode like a fist in the face. With the beam of their flashlight, they search out the human scene, probing the dark and illuminating those areas which shock and fascinate. Their use of flash on camera is a deliberately chosen illumination that is an integral part of their visual

*Ralph M. Evans, *Eye, Film and Camera in Color Photography* (New York: John Wiley and Sons, 1959), pp. 57–58.

message. Their use of this simple frontal illumination is technically no better than anyone else's. The impact of their lighting is due precisely to the subjects they illuminate and to the straight-forward manner with which they choose to do it. They make a passive illumination emotionally active

EMOTIONALLY ACTIVE ILLUMINATION

Active illumination adds its own statement. It draws attention to itself. Sometimes active illumination can be the sole reason for the visual statement. A spectacular sunset is an obvious example of such a situation. Active illumination usually has qualities which passive illumination lacks. It has strong direction quality, strong contrast quality, definite brightness level (usually referred to as "key"), definite color quality, or combinations of several of these qualities. Specular light is usually more emotionally active than diffuse light.

Emotionally active illumination should be used with discretion. If the visual elements in a scene already have strong emotional roles, an inappropriate addition of emotionally active illumination can result in a cacophony of tonal relationships.

Since active illumination is dynamic, its characteristics are more complex than passive illumination. For this reason, most of our investigation into the emotional qualities of light will concern emotionally active illumination. A good way to begin is to consider the six qualities of light and the emotional visual tendencies that each might contribute.

THE CONTRIBUTION OF THE QUALITIES OF LIGHT TO EMOTIONAL FEELINGS

DIFFUSE QUALITY

Diffuse quality light is usually passive. Sometimes, however, emotional overtones can come through, for example, feelings of softness or expansiveness. Diffuse light can have a feeling of gentle envelopment: soft, warm light gently caressing an illuminated surface. Diffuse light can often contribute a feeling of inner glow, even an iridescence. Diffuse illumination on a seashell interior, or on an oil-slicked wet pavement, or a light object isolated against a dark background will tend to do this.

When a strong contrast quality is added to diffuse light, the latter becomes more active, but never with quite the same force as adding strong contrast to specular light.

SPECULAR QUALITY

Specular quality light with its sharp shadows can connote crispness and cleanliness, or it can be sharp and probing, or it can be harsh and unrelenting. Specular lighting encourages the formation of highlights which in turn lend their feelings of briskness, sparkle, and effervescence to a scene. Specular catchlights in a person's eyes always add a vitality and intensity to the person's expression. The absence of them signifies introspection and, sometimes, torpor or death.

DIRECTION QUALITY

Strong direction quality is emotionally active. There is an inference that the illumination comes from some specific place, anointing those objects warmed by its rays. Strong direction quality says: "Look at this!" It also encourages strong light and shade relationships. This conveys feelings of solidity, precision, definitive relationships. For example, it can elicit stronger character in a weathered face, make architecture look solid and precise, make textures of any surface seem more purposefully etched. (Remember that specular quality enhances the effects of direction while diffuse quality diminishes them.)

BRIGHTNESS QUALITY

Brightness quality can be rendered as an overall tonal key. A preponderance of one key or the other will lean toward overall feelings of darkness or lightness, as the case may be. The extremes in either direction are labeled as high key or low key. The former results when all the tones are lighter than a moderate gray, and the latter results when all the tones are darker than a moderate gray. High key connotes brightness, freshness, cleanliness, or purity; low key conveys darkness, dirtiness, mystery, or profundity.

Within an overall specific tonal key of brightness, an element of tonal contrast can be striking. This may contribute an ameliorating feeling, for example, dark eyes sparkling in contrast to an overall high-key environment. Or the tonal discord may produce a diametrically opposite emotion, for example, a slash of brightness in a low-key lighting situation can evoke a ray of hope whereas a dark shadow in a high-key environment can produce a sense of impending gloom.

CONTRAST QUALITY

Strong contrast adds feelings of precision and strength. It can also convey feelings of harshness, brittleness, and rigidity. In the appropriate circumstances, it will heighten descriptions of violence and conflict. Low contrast is an opposite emotion generator. It supports feelings of delicacy, fragility, and softness, and also enhances feelings of suppleness and of openness.

Remember that film does not see as great a range of tones as our eyes. Warm sunshine filtering in through a window seems soft and gentle because our eyes easily see into both the light and the shade. Film does not. It will record the shadows as black voids, creating an opposite emotional feeling of gloom and darkness. To record the feelings that our eyes and mind perceive requires intelligent control of the photographic process and/or manipulation of the light ratio.

COLOR QUALITY

Color quality has very complex emotion potential. Color is not an either/or type of quality, but rather has infinite facets and subtleties. In fact, the exploration of color alone is a lifetime search. Among painters of historic note, Cézanne, Van Gogh, Matisse, Seurat, and Gauguin did just that.

We can make some broad observations about color and emotion, clichés really. Reds and yellows are "warm" colors; blues and greens are "cool" colors. Magenta, a color that is not a part of the electromagnetic spectrum, can convey feelings of optimism (looking at the world through rose-colored glasses) or, since it is an unnatural color, moods that are bizarre. Even soft hues or pastels can convey rich emotional feelings — sometimes more profoundly than the vivid hues.

It is important to recognize other emotional qualities of color. Vivid colors tend to be solid, sculptural, graphic, and independent. Vivid colors are active emotionally. Muted colors tend to defer to the objects beneath their hue, dependent upon them for existence. They are passive emotionally.

But maybe we can go too far afield into symbolism with the subject of color emotion. We have already noted that color is enchanting. Enchantment is often sufficient, allowing each viewer to conjure up his own symbolism in the sensuous, visual world of color.

In traditional color photography, we cannot add photographically local, specific nuances of color as are available in the techniques of the painter. To modify color, photographers are dependent on the objects themselves, the color potential of the film, and the color balance of the light. Photographic changes affect the whole image, or large areas, not just minute areas within the image. As a result, photographers are restricted to controls of overall color balance or controls of color modulation of relatively large areas within the scene. See Eliot Elisofon's *Color Photography* (1961) and Alexander Liberman's *The Art and Technique of Color Photography* (1951) for an examination of the subject of color as visual communication, not as scientific discipline.

NATURAL AND ARTIFICIAL LIGHT

Light can be either natural or unnatural; it can be related to the sun and nature or it can be related to man and artificial environment. Artificial light is a relatively new source of illumination to man who has always experienced the sun's light. Thus we cannot avoid an emotional reaction to differences between the two types of illumination.

Natural light comes from above or from one side. When illumination in a scene comes from below, we sense its unnaturalness and the object thus illuminated acquires unique qualities: it may seem surreal or mysterious, feelings of form may be distorted, and it may even seem to float in space. Natural light comes from one source — the sun. When a scene is illuminated by several sources, we instinctively recognize it as an unnatural situation. Normal senses of form and structure can be distorted in the viewer's mind when he sees objects illuminated indiscriminately by more than one light source. For example, a face that is lit by two lights equally distant on either side will produce two nose shadows. This is not natural. The viewer is apt to see them not as normal shadows, but rather as smudges or dirt marks on the cheeks.

Unnatural light bears the imprint of man as surely as squared edges and plumbed verticals. The distinction between natural and unnatural light was clearly illustrated in the movie *2001: A Space Odyssey*. Exterior views of the space flight and docking maneuver were lit convincingly by one highly specular source (simulating solar light) while the interiors were handled with a contrasting feeling of light panels and multiple source of illumination (artificial light). This clear-cut lighting distinction strongly supported audience feelings of actuality and real-life experience. The lighting also helped set the stage for the extraordinary visual effects and supernatural adventures that followed.

The photographer must be emotionally aware of the distinctions between natural light and artificial light. Each can possess all six qualities of light, but emotionally the two lighting situations are different. A fault of many photographers is that they fail to recognize the emotional difference and permit superficial technical considerations to take precedence while allowing visual conflicts to occur.

Two problem areas prevail. First, for purposes of expediency, attempts to acquire a natural-light feeling are often made with artificial illumination in the studio. It is possible to do so, but only with a clear understanding of what natural light really looks like in terms of the six qualities of light. The second problem area occurs in adding artificial light to natural light solely for technical reasons. The result must completely disguise the dichotomy, or the result will be inept and disturbingly artificial.

AVAILABLE AND CONTROLLED LIGHT

Available light, whether natural or artificial, implies no manipulation by the photographer. Controlled light, on the other hand, says that the photographer imposed his will on the environment. The distinction may appear trivial because in the resulting photograph a sense of control may not be immediately apparent. Yet it is not trivial, because emotional undertones can occur.

AVAILABLE LIGHT

An evidence of imposition on the lighting environment can carry a visual message. A simple news situation can be used as an example: A political office-seeker is photographed assisting some needy people. Was the photograph spontaneously candid or was the event carefully staged? Perhaps only an experienced photographer could articulate the differences, but even a layman could sense them. If the lighting was seemingly spontaneous, even erratic, the visual message would be more politically effective. If the lighting was polished and "professionally" handled, an intervention for editorial comment would seem to be apparent. Thus a photographer, acting primarily as a disinterested observer, might better serve communication by allowing poor lighting relationships —certainly available lighting relationships — to exist unaltered.

The use of available lighting is a discipline that has emotional consequences. The message is reality, truth. Lighting is not so much controlled as it is observed. The illumination is a consequence of the environment itself; it is an integral part. The experienced photojournalist learns to work within these parameters. He observes the scene from several angles, choosing the one where light and subject best complement one another. The photographer may sometimes add his own lighting — as dictated by technical photographic image requirements — but *always* within relationships consistent with actuality. Evidence of intrusion is poor lighting craftsmanship. The visual and emotional aim is viewer involvement and the viewer is encouraged to participate in the visual message. Environmental light feeling says: "This is just how it was!"

CONTROLLED LIGHT

Controlled lighting imposes itself on the environment. By so doing it creates a new environment or a lighting environment that is very precisely defined. A photographer's studio is a controlled environment. It is blank space until he exerts his will upon it. Emotionally, the photographer rules this milieu

with absolute authority and responsibility. No happy accidents here, no spontaneity — unless the photographer wills it.

Controlled lighting can exist outside the studio too, although what really happens is that the studio is merely moved to a new location. The photographer, exerting control, packs his environment and takes it with him, along with the necessary photographic tools.

The big problem, inevitably, becomes overcontrol. The effects of overcontrol document inept dictatorial power. Control must be exercised with precision.

EMOTIONAL DIFFERENCES BETWEEN AVAILABLE AND CONTROLLED LIGHT

These differences are so profound that they literally delineate different areas of photographic communication. Thus few photographers can leap from one discipline to the other. Available-light discipline attracts the hunter. He senses nuances and potentials that others do not. He is patient for possible change and is instantly ready for that which may disappear forever, catching it before it does. Controlled-light disciplines attract the analyzer and the inventor. He envisions new relationships, yet unknown, and contrives to put them into substantive reality. He accumulates notes and experiences so that he can recreate effects to suit an occasion. He does not capture fleeting change; he makes it happen.

Both lighting disciplines are challenging and infinitely varied, but they are emotionally different, and the skillful photographer must be aware of the subtleties.

EMOTION OF LIGHT AND ITS PLACE IN VISUAL COMMUNICATION

The emotional qualities of light must be recognized for good lighting craftsmanship. Even if the photographer is unaware of it, the emotional content of lighting is a summation of all the visual decisions applied in making the photograph. If the photographer considers only technical problems, and ignores emotional qualities, his visual message may fail to communicate properly.

Unfortunately, good uses of the emotional quality of light cannot be formulated. This is frustrating knowledge for the student, a continuing conundrum for the expert. Emotional awareness must come from more than photography. The photographer must be aware of the life around him; aware of the other arts, even those not essentially visual; aware of nature; aware of phenomena not yet understood. He must file away the visual relationships; search, sort, and synthesize. Each individual has his or her own unique view to communicate. This viewpoint is the single most important visual tool for emotional awareness and good lighting craftsmanship.

Trying to express an emotion to another person is an art, not a science. Not all of us have the talent to do so. Furthermore, emotionally active illumination is not always necessary, as we noted. But regardless of whether or not the photographer may wish to convey emotional insights or create emotional involvement in visual communication, he must not ignore the emotional potential of light.

4

Control of Light

METHODS AND PROCEDURES FOR CONTROL

The most effective way to control light is to control its six qualities. This control enables the photographer to fit lighting methods to light source and subject matter rather than the other way around. For example, many photographers learn to light with certain kinds of sources but fail to understand the fundamental principles involved and, as a result, are unable to transfer that control to different sources. Or they may learn all about portrait lighting and yet find themselves unable to adequately light small products for advertising purposes (and thus lose out on a potential source of added income for their studio). Some photographers are skillful in discovering exquisite existing light relationships but are unable to construct a lighting plan from scratch in the studio. But when the photographer understands how to control the six qualities of light, he can solve lighting problems regardless of the light source or subject matter.

There are other benefits in controlling the six qualities of light. It allows the photographer to compartmentalize lighting problems, enabling him to solve them more efficiently. Understanding the six qualities of light provides a richer atmosphere for developing a lighting style. The photographer is not then at the mercy of specific lighting equipment to create a given effect. In this way, style can become the final arbiter of control. A keen awareness of the six qualities of light enables the photographer to more clearly see the advantages and disadvantages of the various light sources, so that decisions about light sources come from needs for visual communication rather than from inhibiting technical considerations.

This approach toward lighting control is not traditional. It is not based on learning how to light for specific subject matter or learning the eccentricities of controlling given light sources. Yet it provides the photographer with greater versatility and more confident control. It allows the photographer to control light rather than to be controlled by it.

A PHILOSOPHY ABOUT CONTROL

Do not consider control as an end in itself. Lighting control for its own sake, no matter how clever, eventually becomes boring. Rather, learn to exercise lighting control in the interest of good visual communication. Control should be geared to a practical working method, as excessive concern

about control retards spontaneity and saps energy. For example, avoid complicated lighting procedures when simpler ones will suffice. Complicated lighting procedures are tempting to the photographer who has gained some lighting expertise, but try to resist them.

Control must never preempt intuition. When intuition is stifled, an enormous potential source of knowledge is closed off. Serendipity cannot happen when control is inflexible. There is almost always more than one way to do something, so keep an open mind about other possibilities. This open-mindedness could suggest a solution when standard procedures fail.

Try not to be trapped by control limitations, however logical they may seem. Rules and regulations about specific light sources and subject matter are nothing more than someone's opinion or experience. No matter how valid their judgment or esteemed their reputation, there will always be other rules and other methods.

Control should be appropriate. But appropriateness cannot be generalized into a set of rules to cover all situations; it is dependent on specifics. For example, cookbook technical standards for lighting control are appropriate only when the photographic message is intended to be a substitute for the real thing: catalog photography, most ordinary snapshots, record-type portraiture, scientific instrumentation, most factual documentation, and so on. But when the photographic message contains an emotional intent or bears an individual viewpoint, standards for appropriate lighting control are dependent not on a set of fixed standards but on the visual message itself. (If the message is clear, the lighting standards may be judged appropriate; if the message is unclear, the lighting standards may be inappropriate.)

This brief philosophy about lighting control is intended to provide a learning perspective for the beginner. But many, because they are still struggling to understand even the simplest basics about a new skill, are completely turned off by philosophical comments. What they want is facts, not hot air! However, as experience accumulates and they gain the control they seek, they come to realize that the greatest control comes to those who continue to struggle to understand why.

DIRECT AND INDIRECT CONTROL OF LIGHT

It is important to recognize that full control of the six qualities of light is not contingent upon the photographer working in a well-equipped photographic studio. Indirect control of these qualities in natural and available-light situations can be equally effective.

Indirect control of light may seem to be an inadequate control method; it is not. The photographer can indirectly control light very effectively by waiting for a change to take place, relocating in relation to the subject, or taking the subject to a different lighting environment. (The movie industry indirectly controlled light by moving the industry from the cloudy East Coast to sunny southern California in the early part of this century.) Photographers sometimes overlook indirect control of light, so let's examine this method of control of each of the six qualities of light.

Specular-diffuse qualities of light can be indirectly controlled if the photographer is aware of the changes that naturally occur in daylight. Direct sunshine is specular. But when the sun's influence is reduced and the sky's influence is increased — as in open shade, at dawn, and at dusk — diffuse quality predominates. An overcast sky is also a diffuse source. For indirect control of specular-diffuse

qualities in daylight, the photographer merely has to wait or take the subject to a location that is in or out of the shade. In any light, whether natural or artificial, the shaded portions of the subject are lit by diffuse ambient light rather than direct, and possibly specular, light. For example, photographing people with the light source behind them places their faces in shade. Because the illumination in shade is almost always naturally diffuse ambient light, the photographer can often obtain diffuse or specular quality light on the subject by merely relocating the camera viewpoint in relation to the subject and the light falling on it.

The color quality of most lighting can be indirectly controlled through choice of film, processing controls, and natural changes of color in the existing environment — for example, the changes in a color throughout the day as a result of sunlight upon it as it moves across the sky.

Contrast quality of light (light ratio) also changes throughout the day. It is low at dawn and dusk and much greater during full daylight hours. In any light, if the subject is mostly in shade the lighting contrast is much less than when directly illuminated.

Brightness too is indirectly controlled by photographic procedures. Exposure of film and printing materials affects the reproduction of brightness quality. Brightness is also indirectly controlled by working in either shade or direct light or by waiting for weather conditions to change.

Direction control is obtained indirectly if the photograper repositions himself or his subject in relation to the light source. He can also wait for the sun's direction influence to change as it moves across the sky. In aritificial light situations, positioning oneself in relation to the predominant light source is just as effective as moving the source itself.

These examples of indirect control may seem absurdly obvious, but they are easily overlooked. It is a good practice to quickly analyze an existing light situation in terms of the six qualities of light. If one or more qualities are inappropriate for the subject matter, next consider whether waiting or repositioning will improve the situation. Often such a simple analysis can provide full lighting control for effective visual communication. Such an analysis of the six qualities of light in existing-light situations is a good self-teaching device. Careful analysis of real-life experiences can be an invaluable idea source for direct control of light in the studio. Photographers should file away mental notes about observations of existing- and natural-light situations for later application to direct control lighting techniques.

A WORKING PROCEDURE FOR BOTH DIRECT AND INDIRECT CONTROL OF LIGHT

Before examining the control of each light quality, it is important to consider a working procedure. This provides a step-by-step plan for analyzing lighting problems.

First, decide whether a distinctly specular or diffuse quality light is required. A deliberate choice of one or the other dictates the character of the light and shade relationship. The photographer cannot always directly control this step. After all, he cannot command direct sunshine when the day is overcast; he can only wait for it to happen.

Second, decide on color quality — whether to strive for a neutral color balance or to create a color effect.

Third, consider direction influence for the light. Which direction should the light come from? Should I control this by moving the light source, moving myself, or rotating the subject in relation to the source? If one light source seems inadequate, consider whether the need for additional light is due to contrast requirements or visual emphasis. If contrast is the problem, it can be decided upon in the next step; if visual emphasis is the problem, it should be deferred until later.

Fourth, ascertain the total contrast of light — whether to use a low light ratio for purposes of full visual information or a high light ratio for purposes of visual impact. Control at this step is determined by evaluation of the amount of ambient light required to do the job photographically. Also evaluate this step in terms of emotional impact, because our eyes sense the contrast of light differently than film, which usually records a much higher sense of total contrast.

Contrast evaluation consists of total contrast, which we have considered, and local contrast, which we shall now examine. This latter consideration is primarily a function of controlling the formative qualities of light — specular, diffuse, and direction — but is also affected by consideration for local brightness control and visual emphasis.

If, up to this point in the working procedure, the local contrast still looks good, we can leave well enough alone. But if it requires alteration we must begin again at step one and consider local contrast at each step. Control of local contrast is a complex process, but logically it usually works best to defer decisions about its control until now.

Fifth, consider brightness control. This may mean nothing more than a light meter measurement and camera exposure adjustment. (If in doubt, bracket exposures. Even for professional photogra-phers there are imponderables at this step which defy skilled judgment.) Or it may involve considerations for local brightness control if the photographer feels a need to control visual emphasis, as noted in step three. Local brightness control is also a complex process. Control can be exerted by directly controlling the light or by deferring control until the darkroom. In the latter case, darkroom control is relatively simple if the film is negative film, but more complex if it is positive film. Rather sophisticated darkroom procedures are required for positive film. For this reason, local brightness control with positive film materials in the darkroom is not a viable control alternative.

Control of local brightness is achieved by using secondary light sources and/or shading devices. It is indirectly accomplished by dodging and burning when making the photographic print in the dark-room.

Control of brightness key is also considered at this last step. If low brightness key seems desirable, it can often be accomplished in printing or, if reversal film is used, by exposure adjustment. But if high brightness key seems desirable, you must start again at step one and consider the influence of each light quality.

These steps and their sequence are not inviolate. Working methods, subject matter, equipment eccentricities, as well as personal rapport with events, timing, and personalities, may suggest different working procedures. But, as in any skill, a working procedure is an invaluable aid. It frees the photographer from being bogged down by myriad details and sharpens his intuitive response to changing events. It may be helpful to refer back to this working procedure as you learn more about controlling the six qualities of light.

CONTROL OF SPECULAR-DIFFUSE QUALITIES

BASIC CONTROL

Specular-diffuse qualities are important elements in controlling the light and shade relationship. Specular light produces sharp, distinct shadows and tight, brilliant highlights which tend to place visual emphasis on pattern, shape, and texture. Diffuse light produces nebulous shadows and broad highlights which tend to place visual emphasis on form. Shadows caused by diffuse light do not draw attention to themselves, and this allows the inherent character of the illuminated subject to be clearly seen without external influence of disturbing shadows.

The basic control for specular-diffuse qualities is the relative size of the light source. The smaller the source, the more specular; the larger the source, the more diffuse. The control is simple. Nevertheless, specular-diffuse qualities of light have not always been fully utilized or even understood by photographers. This is due in part to a lack of understanding about the pictorial potentials, in part to perceived technical limitations of equipment and materials, and in part to influences of contemporary feelings about what is fashionable in lighting.

Photographers have always used both light qualities, although in many cases without design and without full control. The earliest photographers used only natural light—specular sunshine, natural diffuse light produced by a cloudy day, or skylight coming in through an open window. But when artificial electric light sources were invented, the use of diffuse light, at least indoors, began to go out of fashion. For one thing, these new sources and their specular light quality were an exciting new tool for photography. It became fashionable to use theatrical specular lighting effects. Besides, window light was an uncertain source and was awkward to use compared to the always ready and portable artificial electric light sources. Photographers generally gave up using diffuse quality light and concentrated on understanding how to use the complex lighting relationships of multiple specular sources. It wasn't until the 1950s, when photographers like Irving Penn and Bert Stern began to use window skylight, that diffuse quality light again came into more general use.

This reexamination was accelerated when a new artificial light source—super-powerful electronic flash lighting—was introduced. Its power was so great that most of it could be "thrown away" to create bounced diffuse lighting and still provide ample light output. The exciting character of this new light source initiated an extensive reappraisal of diffuse quality illumination. Photographers began to examine the many facets of diffuse light as carefully as they had previously examined the intricacies of specular light. Gradually, photographers realized that bounced diffuse light and transmitted diffuse light had different contrast potentials. Transmitted diffuse light, especially when produced by a self-contained box-light fixture that restricts spill light, can achieve the contrast impact of specular light without the logistical problems of sharp-edged specular shadows. Phil Marco was one of the first to fully exploit the contrast potentials of transmitted diffuse light. In addition, there was the contribution of the much faster, fine-grained film materials, which allowed photographers to use light of either quality even when the illumination was low.

Today, with modern lighting equipment and film materials plus a heritage of practical working experience on which to draw, photographers should be technically able to utilize the full visual potential of both specular and diffuse qualities of light. They must recognize that control of specular and diffuse qualities of light is just as important as controlling the other qualities.

SPECULAR-DIFFUSE (S-D) QUALITY PROGRESSION

There is an infinite progression of specularity or diffuseness between the most specular point source and the most diffuse big source. For our purposes, however, we need mention only six, because they enable the photographer to effectively control specular and diffuse quality with six different and discernible light and shade relationships.

In the meantime, remember that nearly all primary light sources are specular by nature (the sun, light bulbs, electronic flashtubes). To create diffuse light, the photographer must modify primary light sources either by bouncing the light off a large, light diffuse surface or by transmitting it through a large diffuse piece of translucent material. Diffuse light is only produced by large light sources.

1—Point Source. The most specular source is a point source. This is purely theoretical because a point, by definition, has no measurable dimension. The tiniest source is a zirconium arc, created by incandescence of a pool of molten zirconium that is as small as .013 mm (.005 inches) in diameter. The extremely specular quality of a point light source can be closely approximated by using very small light sources at distances of many metres (feet). The farther the source, the smaller its relative size. Small light sources in this category include bare light bulbs, slide projector lamps, quartz lamps, carbon arcs, and xenon arcs. Be extremely cautious in using such sources! The exposed light bulb makes the source dangerous because of the possibility of burns and breakage. Also beware of the high ultraviolet radiation of arcs and the possibility of sunburn.

The specular light and shade effects of such tiny light sources are startling. Any object interrupting the light rays casts a very sharp shadow for great distances. Such shadow formation is pictorially suited for vivid depictions of abstract light and shade effects as well as pop art or comic strip symbolization of shadows.

2—Small Sources and Optically Focused Sources. This step in the S-D progression consists of an enormous variety of light sources, from the sun and small electronic flash units to studio spotlights. They vary in size from those which subtend about a degree of arc to those which subtend a few degrees. They also begin to have a fairly measurable degree of dimension. Small light sources and optically focused light sources are highly specular, but because they have measurable dimension, the shadows they cast lose their sharp edges. If carefully examined, the shadows will contain both an umbra and a penumbra when cast for any distance. This lack of edge sharpness is evidence that the light source is not a point source.

Spotlights have an additional characteristic that is extremely useful. While the edges of shadows cast by them may lack edge sharpness, the edges of their light beams can be extremely sharp. The latter can be made optically sharp because their optical system can sharply focus an image of an internally situated opaque mask. You can make this mask any shape to produce the corresponding light beam. The edges of the beam can be sharply focused on a given flat

surface to produce a very precise area of illumination. It enables you to precisely illuminate a given area without spillover. But remember, the precision of the light beam does nothing to make sharper-edged *cast* shadows. These are determined only by the relative size of the light source—in this instance the size of the spotlight lens from which the light exits.

In both steps one and two of the S-D progression, all the light sources project sharp shadows for short distances. However, only point sources cast sharp shadows for great distances.

3—Reflector Sources. Reflectors begin to add a more noticeable dimension to the primary source and are thus the next step in the S-D progression. In this category, reflectors for lamps vary in size from about 15 cm (6″) to about 51 cm (20″) in diameter. Reflector size and shape are determined by requirements for brightness efficiency, evenness of illumination, spread of illumination, and bulb size and shape.

Each of these factors plays a role, however subtle, in the specular-diffuse quality of the light, with reflector size the most significant. A shiny, spherical reflector tends to cause a hot spot in the center of its illumination, enhancing the specularity of the illumination. Conversely a matte-finish parabolic reflector tends *not* to cause a hot spot, enhancing the diffuseness of the illumination.

The grouping of nearly all reflector sources into one step in the S-D progression is arguable, but it is my experience that to do otherwise leaves the photographer prone to use specular-diffuse quality control in ways too subtle to be visually meaningful. It is possible to contest this viewpoint by pointing out experience with lighting small subjects. Such critics are correct in this regard, but they overlook the fact that it is the relative size of the source that counts, not the actual size. Portrait photographers often demonstrate meaningful differences in specular-diffuse quality by using different styles of reflectors and lamps. But I submit that the human face is a small subject, and a photographer should not translate experience with this relatively small subject to other situations when considering specular and diffuse qualities.

The use of a fitted "diffuser" over a reflector source produces only a modest difference in specular-diffuse quality. The diffuser reduces brightness and removes the hot spot in the illumination and also the specular presence of the light bulb, but it does not increase the size of the light source and hence does little to increase diffuseness. Many photographers exaggerate the effectiveness of fitted diffusers.

4—Umbrellas and Pan Reflectors. Bouncing the light from a primary source into an umbrella is an ingenious means for creating a diffuse source. Umbrellas are portable, simple to use, come in a variety of sizes, and have a reasonably high brightness efficiency. The two most notable characteristics of umbrellas are size and the presence or absence of a hot spot in the illumination. Size controls the quality of diffuseness. The presence of a hot spot enables the photographer to utilize feathering techniques (see Section on "Direction Quality Control") while its absence is desirable to illuminate an area evenly, especially on those occasions when an umbrella is used with flash because the photographer cannot observe the illumination effects before exposure.

Compared to an efficient reflector source, all umbrella sources, even the most efficient, lose at least two stops in brightness. A shiny, crinkled,

aluminum-fabric umbrella is 2 stops less bright than an efficient reflector source. A matte aluminum-fabric umbrella and a white opaque-fabric umbrella are 2½ to 3 stops less bright while a white translucent-fabric umbrella is 3 to 3½ stops less bright. (Remember, however, that an umbrella is a convenient means for producing a diffuse source. The sacrifice in brightness is a small price to pay for the effects produced.)

A white translucent-fabric umbrella has the least hot spot and the most even illumination. At 3 metres (10 feet), it will cover an area 3.7 metres (12 feet) in diameter with only ½ stop brightness loss at the edge of the illumination; the white opaque-fabric umbrella is only slightly less even with about $2/_3$ stop loss at the edge of illumination. A matte aluminum-fabric umbrella will lose at least 1 stop in brightness at the edge of a 3.7-metre (12-foot) illuminated area, and a crinkled aluminum-fabric unit will lose 1½ stops. Crinkled aluminum-fabric umbrellas have as much falloff in off-axis illumination as do most of the efficient reflector sources.

The foregoing observations are based on round spherical-shaped umbrellas with a diameter of about 1 metre (40 inches). Umbrellas with different diameters and "flatter" umbrellas will have slightly different characteristics. Some umbrellas open up flat. Normally, these are square or rectangular and can be propped upright by using the shaft as a resting support. They have less brightness efficiency than ordinary umbrellas and their illumination cannot be made as directional. Round umbrellas are rather directional sources; this is important to note, because most bounce-light diffuse sources are not. Round umbrellas possess a good degree of directional quality because the umbrella partly wraps itself around the primary source and there is little spill light.

One problem with umbrellas is that the primary source, its reflector, stand, and wires get in the way of the bounced illumination. As a consequence, umbrellas cannot be used for illumination of mirror surfaces, such as shiny automobiles or silverware, without reflecting all the lighting paraphernalia. It is also an annoyance when the light fixture and umbrella shaft protrude into the photographic set, getting in the way.

A pan reflector eliminates this problem because it is large and the primary source, or sources, are hidden behind a lip along its periphery. The light from the lamp, or lamps, is bounced out onto a large white pan that is usually somewhat concave in shape, hence illumination on its surface is as bright at the center and the far edges of the pan as it is at the area near the lamps. The result is an even pane of light that is not only very diffuse but is also unencumbered with outlines of reflectors and wires. As such, it is ideally suited to illuminating highly specular surfaces, such as silverware, glass, or plastic. Most pan reflectors utilize quartz lamps instead of electronic flashtubes because the latter are not readily hidden by the narrow lip on the periphery of the reflector.

Pan reflectors are generally no larger than umbrellas and thus are in the same category of diffuseness. But they are much more durable, heavier, and rather expensive. The large pan reflectors, used in big photographic and movie studios, draw around 100 amps-power necessitating special wiring. Smaller units are only handy for lighting small objects; if used at great distances to illuminate large sets, they begin to assume the specular quality of reflector sources but without their advantage of higher brightness efficiency.

At this step in the S-D progression, we have moved away from specular quality into a pro-

nounced diffuse quality light. The shadows are decidedly nebulous and become much more so as the umbrella or pan light source is brought in close to the subject being illuminated. The only specularity that occurs with these sources is a sharpening of shadow edges as the sources are used at considerable distance from the subject or when the umbrellas and pans are small. In this latter regard, it is worth mentioning that umbrellas and pans less than .61 m (2 feet) wide begin to produce a specular light and shade relationship similar to that of large reflector sources, and their worth as diffuse sources is questionable.

Some small, portable electronic flash units have accessory attachments that utilize small, white flat cards or aluminized-fabric panels that are about a foot wide. These reflecting panels are noticeably more diffuse than the direct light from the electronic flash unit but are not nearly as diffuse as even a two-foot umbrella. The photographer must decide whether the small umbrella isn't worth the slight added inconvenience to produce a more definite diffuseness to the illumination.

Don't use too large a primary source to illuminate the umbrella. If a large reflector source is used, too much of the bounced light is blocked and brightness is unnecessarily reduced.

5—Light Panels. These are big — 1.2 × 1.2 m (4′ × 4′) or larger — and are created by bouncing a primary light source illumination off a large white panel or by transmitting a primary source light through a large panel of translucent diffusing material. They produce a decidedly diffuse quality light, and the shadows caused by them can be quite nebulous. Nevertheless, despite their size, they still retain some direction quality to their light.

Light panels are ideally suited for producing a form-revealing light and shade relationship. Their illumination is similar to that produced by a window skylight, with the added convenience that they can be turned on and off at will.

There is an inherent contrast difference between bounced and transmitted light panels. Bounced diffuse light normally produces more spill light and thus more ambient light than transmitted diffuse light. Consequently, transmitted diffuse light can produce a higher contrast quality light. This added contrast adds visual emphasis but does not occur at the expense of revelation of form because the shadows still retain their nebulous edges. Therefore, transmitted diffuse light panels can produce a very vigorous and dramatic light and shade relationship while retaining good form-revealing characteristics.

Today, transmitted light panels are the standard professional studio light source, just as specular reflector sources were 30 or 40 years ago. Their diffuse quality light and shade characteristic and their ease of use make them an essential light tool to have on hand for almost any type of photographic studio work. Many professional photographers, using their own ingenuity in construction and rigging, have built huge transmitted diffuse light sources in their studios. Usually, it is a 2.4 × 2.4 m (8′ × 8′) light panel with electronic flash and tungsten halogen lamps as primary sources, and it generally hangs from the ceiling on four pulleys. By adjusting the pulleys, it can be raised or lowered or made vertical to the floor. A large diffuse source such as this is an extremely useful lighting tool and its cumbersome size belies its ease of use. Construction of light panels is discussed later.

Bounced light panels are important diffuse light sources too. They are ideal as fill-light sources for lowering light ratio. Also, because they produce much spill light (and thus ambient light), their contrast potential is very low unless used in a black

room. Their direction quality is weak too, although direction quality can be increased when two are taped together to form a V-shaped corner. Bounced light panels are usually more portable than transmitted diffuse panels. You can use white cloth to make a bounced light panel. I always carry a 1.8 × 1.8 m (6′ × 6′) white vinyl cloth folded up in my gadget bag. It is an indispensable accessory for location work.

6—Nondirectional Sources. These sources are so large and so diffuse that their illumination has no discernible direction quality. Ambient light is a nondirectional diffuse source, as is skylight outdoors, and the light from the sky on a dull, overcast day. The reflected light in a small room is also a nondirectional diffuse source.

Photographers whose specialty is photographing silverware are particularly concerned with creating a nondirectional diffuse source. Some make large semi-hemispheres out of white translucent Plexiglas that, when externally illuminated, produce an uninterrupted internal nondirectional diffuse illumination. This is particularly handy for photographing concave and convex surfaces of shiny silverware, and is infinitely superior to coating the silverware with a waxy diffusing substance that removes the mirror reflections by physically altering the surface of the subject. The photographer can also closely simulate a nondirectional diffuse source by placing a very large translucent diffuse light panel extremely close to the subject being photographed. When this occurs, the light panel is relatively so huge that it is almost the same as a hemisphere of light.

An ingenious solution for creating a nondirectional diffuse illumination was developed for the traveling art exhibit "Treasures of Tutankhamun."

The gold pieces were placed inside cubes made of thick Plexiglas panels and displayed in black rooms. Light was directed onto the cubes from overhead by small spotlights. These lit the top surface of the cubes while the plastic effectively piped the illumination onto all surfaces of the gold treasures by means of internal reflections within the cubes. In effect, the walls of the plastic cubes were mirrors because of the black walls of the museum environment in which the treasures were displayed. The internal reflections within the cubes transformed the external specular spotlight illumination into internal diffuse illumination. Since the light from the spotlights was concentrated on the top of the cubes, no light was reflected off the outside surfaces of the cubes. As a result, viewers could carefully examine the mirrored gold surfaces of the treasures in nondirectional diffuse light without the presence of annoying external reflections on the outside of the cubes.

It is possible to go one step further with nondirectional diffuse lighting by placing the object on a translucent surface table that is lit from below. In this case, even the shadow beneath the object disappears as it appears to float in space. This technique is common in "exploded" views of disassembled machine parts to show proper assembly orientation. It is also common in catalog illustrations of fragile glassware and objects where even the delicate smudge of shadow on a support might be distracting.

These, then, are the six major steps in specular-diffuse quality progression. With the foregoing description of their effects and how they are produced, you should have a fairly clear understanding about controlling the diffuseness or specularity of light. Specular-diffuse qualities are essential elements in controlling the light and shade

relationship. They can be controlled by merely controlling the relative size of the light source used to illuminate the subject.

CONSTRUCTION EXAMPLES OF DIFFUSE SOURCES

To reiterate, primary sources are specular by nature; they must be modified to create diffuse sources. The following describes how to construct diffuse sources. The products mentioned are those which I have used; needless to say, there are others that may work equally well (or better or more cheaply), but these examples can get you started.

To construct a bounced diffuse source, find suitable reflecting material with a clean, white matte surface, for example, white paper or white cardboard. Another material is a lightweight 1.2 × 2.4 m (4′ × 8′) white foam-core panel, which is sufficiently rigid so that it can stand up by itself. By taping two of these panels together, on the long dimension, you create a corner-flat that is not only a self-supporting diffuse source but one that can be opened or closed for greater or lesser concentration of illumination. This is a handy control which increases direction quality potential.

To create a nondirectional diffuse light source, construct a small room out of foam-core panels by making an oversized "house of cards." Another way to make a small room is to put up three rolls of white seamless paper to form three walls, with the ceiling constructed of foam-core panels. The open wall is a suitable opening for the camera.

A handy, portable diffuse lighting tool is a white cloth sheet. Liteline, made by Maharam Fabrics, is particularly satisfactory. It is a white vinyl cloth with cotton liner. It can be folded many times without cracking yet is sufficiently heavy so that it does not blow away in the wind, and it retains its whiteness. It costs approximately $3 per yard in most fabric or drapery stores. A 1.8 × 1.8 m (6′ × 6′) piece will fold nicely into a small gadget bag.

Another handy diffuse lighting tool is the collapsible flat umbrella. Its rod becomes an effective support so that it can be propped up in a free-standing manner. Ordinary photographic umbrellas are also ideal for producing directional bounced diffuse light.

Transmitted diffuse light panels are made of plastic sheeting material. The diffusion material must mask the presence of the primary source, even when the latter is only a foot or two away from the diffuser, and yet not be so opaque as to greatly reduce the brightness of the light supplied by the source. One such material is white W-2447 Plexiglas. W-2447 works well as a diffuser and yet transmits 47 percent of the light generated by the primary source. It is available at plastic supply houses in sizes up to 1.2 × 3 m (4′ × 10′), or even larger on special order.

A lighter-weight plastic that works almost as well, and is flexible, is Flexiglas sheeting distributed by Studio Specialties Ltd., in Chicago, Los Angeles, and Montreal. It comes in 1.73 m (68″) widths. A similar product, Trans Lum, available in 1.37 m (54″) widths, is distributed by B. D. Co. of Erie, Pennsylvania. Both products can be taped together with translucent matte-finish pressure-sensitive tape to create larger panels. (B. D. also makes a new transparent diffusing material called Dif-fuse, available in 2.3 m (92″) widths. It is a nonwoven polyester material that appears suitable for making large light panels.) Flexible plastic sheeting can be rolled up into a tube and later unrolled on location and stretched between two light stands to form a very handy, portable transmitted diffuse light screen suitable for use with any portable artificial

light source. It's much like a portable skylight.

This lightweight plastic sheeting can also be stretched permanently on a 1.2 × 1.2 m (4′ × 4′) wooden frame made of 3.13 × 7.6 mm (1¼″ × 3″) pine molding. The frame is lightweight and surprisingly strong. When the diffuser frame is C-clamped to a free-standing upright 50 × 100mm (2″ × 4″) post, the unit becomes a handy studio lighting tool. The light panel can be C-clamped in any position and at any height on the 50 × 100mm stand. The diffuser panel can even be cantilevered out, parallel to the floor, without tipping over or breaking. This panel looks very flimsy and fragile, yet is rugged and stable. To increase stability when used in a cantilevered manner, use a small sandbag to weight the base.

The primary concern for a suitable diffusing material is that it should equally scatter all wavelengths of light. Ralph Evans notes in *An Introduction to Color:* "When light passes through a medium that contains large numbers of exceedingly fine particles, the direction of the light that strikes each particle is somewhat changed. If the diameters of the particles are many times as large as a single wavelength of the light, there is only this change in direction and nothing more. The action is then described as 'diffusion' and the action is non-selective." * In other words, an unequal scattering of the wavelengths of light does not occur. When it does, the color of the light is no longer neutral. Flexible diffuse plastic sheeting produces a modest pink coloration, especially at that point where the primary source light is concentrated. This can be a problem when photographing some mirror surfaces. White W-2447 Plexiglas is a better diffuser because it does not produce such color effects.

*Ralph M. Evans, *An Introduction to Color* (New York: John Wiley and Sons, 1948), p. 65.

Cinematographers often use white china silk stretched on a frame as a diffusion material. It is lightweight and readily portable, although not as diffuse a material as the plastic sheeting described above. A hot spot on its surface is discernible directly in front of the primary source, and it can be strong enough to act as a separate and rather specular source. This is not always bad because a combination of specular and diffuse qualities can produce a unique light and shade relationship. Such an effect occurs when sunlight penetrates cloud cover or when the sun in the sky is extremely weak, as it is very late in the day. This combination of specular-diffuse qualities deserves special attention and is discussed separately.

COMBINING SPECULAR-DIFFUSE QUALITIES

When a diffuse and a specular source are combined more or less equally, a new, singular source is produced — one that combines the precise light and shade relationship of specular light with the form-revealing light and shade relationship of diffuse light in a symbiotic way that retains most of the benefits of each quality in juxtaposition. Such a combination occurs late in the day when sunlight and skylight are approximately equal in brightness. Light from this combined source is memorable if a photographer has experienced it on a beach in a warm climate or on a lush farm landscape when everything is green and fresh. It is this same lighting situation which is sought by automobile advertising photographers to illuminate their dazzling and seductive machinery — usually on some desolate sunbaked salt flat in Utah as the sun sets.

The specular-diffuse combination can also be created in the studio. One of the more common ways is to use a single, bare-bulb light source in a

small, totally white room. You can easily construct the room out of white seamless paper and foam-core panels, as noted earlier. It is the ideal source for illuminating a model holding a product for advertising. The high level of ambient diffuse light reveals all necessary detail in the product while the bare-bulb specular light adds a touch of sparkle and visual impact without overpowering the diffuse light qualities.

Another way to create the specular-diffuse combination is by placing a bare-bulb primary specular source in front of an umbrella or in front of a large transmitted diffuse light panel. This creates a similar specular-diffuse quality combination source which can be effective for combining the strong form-revelation potential of diffuse quality light with the strong texture-revelation potential of specular quality light. The specular component also causes specular highlights that effectively provide visual clues about specular surfaces which diffuse illumination alone often fails to do.

Any diffuse source that has a hot spot in its illumination will have added specularity. Such conditions normally occur when a primary source is placed very close to the material used to produce diffuse light, or when bounced diffuse illumination is produced by a spotlight instead of a large reflector source, such as a floodlight, or when an aluminized-fabric umbrella is used instead of a white-fabric umbrella.

The hot spot adds a subtle degree of specularity that can be attractive in subtly diminishing the very flat effects of pure diffuse light. It is especially useful when photographing semispecular surfaces, such as moist, healthy skin, because it adds an extra touch of tonal vitality. It adds extra highlights to satin cloth, jewelry, and a model's eyes and lips, which pure diffuse light alone cannot do. Note how often

aluminized umbrellas are used for fashion photography by observing the starlike catchlights in the model's eyes caused by the shiny configuration of the umbrella fabric.

Photographers who use portable electronic flash lights for bounce illumination in small rooms might consider the advantages of introducing some specularity. Taping a piece of white cardboard to the flash unit so that the cardboard sticks up behind it a few inches accomplishes this. Most of the flash illumination will go straight up to the ceiling to provide the bounced diffuse illumination, but some will spill onto the projected surface of the white card. This creates a brilliant spot of light to introduce some specular quality. It is wise to test out variations on this technique before doing it on an important job. Make comparison tests to see if the added specularity is sufficient and desirable.

WHICH QUALITY TO USE — SPECULAR OR DIFFUSE?

We have already mentioned that specular quality light produces a sharply defined light and shade relationship because the edge between the light and the shade is sharply delineated whereas diffuse quality light and shade relationship has a nebulous line of demarcation that cannot be exactly noted. As a consequence, specular quality light and shade tend to place as much visual emphasis on the shadows as on the subject while diffuse quality light and shade defer emphasis to the subject alone. Specular quality shadows become abstract shapes whereas diffuse ones are seen as the actual form of the subject and not as separate visual entities. The visual characteristics of the two qualities help the photographer decide which quality to use.

To create additional visual patterns and shapes for visual interest, choose a highly specular quality

light. Even if the camera viewpoint is such that the visual patterns and shapes of cast shadows are not within view, specular quality light will still create a vivid light and shade relationship. Edges of nearby shadows will be crisp and highlights strong and sharp. This forcefulness demands attention.

To place strong visual emphasis on the subject and its actual form, choose diffuse quality light. The light and shade relationship does not draw attention to itself; instead it strongly supports other visual clues about the subject. Diffuse quality light is useful for supporting existing visual information about the subject. It enhances the form of the subject and allows intricacies of subject detail to be readily seen without visual confusion. It reveals the form of even extremely shiny subjects because the reflections of diffuse light are large and gently follow the undulating surface of the subject.

Diffuse quality light does not require as great care in direction quality control as its specular counterpart. Consequently, diffuse quality light is ideal for large groups of people or for subjects likely to move quickly and unexpectedly, for example, children and animals. Diffuse quality is good for documen-

tary information, for photographing specular surfaces, such as glassware and automobiles, and for any subjects that contain complex form and textures which could be obscured by the hard, sharp shadows of specular light.

Specular quality light is useful for dramatic, theatrical effects. It is good for revealing subtle textures and for adding tonal sparkle. It is suitable for careful and precise control of local brightness quality when used with multiple-source techniques. When the specular light is sunshine, its mere presence indicates clear skies, cleanliness, and feelings of added brightness. Specular quality connotes precision. It therefore requires great care in direction quality control. Specular quality light is also good for dramatic news events, for action sports, for magazine cover impact, and for product photography where the salient feature is texture.

The foregoing reasons for using specular or diffuse quality light are only guidelines. You, the photographer should always keep your eyes open to new insights. The worst thing you could do would be to slavishly follow these suggestions and fail to discover new visual possibilities that might exist.

CONTROL OF COLOR QUALITY

Color is a complex and unique visual phenomenon. Photographic reproduction of color is also complex. A photographer cannot control the color quality of light without also controlling color photographic materials and processes. For these reasons, the color quality of light can be considered in terms of casual or deliberate control.

CASUAL CONTROL OF COLOR

For most color photography, the use of photographic materials based on manufacturing stand-

ards and of standard processing procedures results in good color reproduction. Indeed, the simple expedient of matching a given type color film to a given type illumination is satisfactory for most color photography and many very competent photographers exercise only this limited control. Manufacturing parameters and normal processing standards become an intuitive part of the photographer's visual awareness. The colors of the scene are translated into a familiar color photographic response in the experienced photographer's brain

even before the camera shutter is released. This casual control usually produces excellent results. It is particularly true for color reversal (transparency) film, although in recent years many photographers have extended their intuitive awareness to color negative and color printing materials too.

Of course, this casual control may also result in unexpectedly bad results, leading the photographer to ask: What went wrong? Why is the color "off"? Why are my intuitive expectations unfulfilled? What can be done to control the problem? Sometimes these questions are not easily answered. Not only are color materials and processes sensitive and intricate, but color itself is a special phenomenon spanning such great divisions of human knowledge and experience as physics, physiology, psychology, and human emotion. Color is a subject that defies compartmentalization or easy definition, and in many respects the only valid definition of color is its actual visual presence.

As a result, control over color is merely a process of selection for many photographers. Splendid color reproductions are jewels to be cherished while those which didn't work out are discarded without further analysis. This selection process automatically adjusts for all the imponderable complexities of color control: It saves the best and discards the rest.

Casual control of color quality is a valid procedure. For all its inefficiencies, it can produce exquisite results. But there are other controls of color. These we refer to as deliberate control.

DELIBERATE CONTROL OF COLOR

Deliberate control of color must also be related to careful consideration of light sources and materials and processes. In addition, evaluation of results also plays an extremely important role. Results must be competently evaluated so that exacting improvements can be achieved. In casual control, the photographer depends on normal manufacturing standards of film and processing procedures to produce a color image that is satisfactory. In deliberate control of color, he goes one step further, carefully evaluating standard results to see if additional color improvement can be achieved. If improvement is desired, and the proper steps are taken, the photographer must see to it that all initial influences are exactly repeated so that expected changes will occur properly. When exercising deliberate control, he must apply at least the same care as that exercised by the manufacturer and processor of the film. Deliberate control of color can tax the skills of even the most methodical photographer.

Deliberate control of color has one of two objectives: to balance the color of the reproduction to an exacting neutral, or to alter the balance of the reproduction to create color effects. Of these, the intent to create color effects is the simpler to achieve because color effects are easily generalized and less exacting control is required.

THE TOOLS FOR CONTROL: COLOR FILTERS

To equally relate color control of light and control of materials and processes, the photographer must think in terms of the six primary photographic colors: red, green, blue, cyan, magenta, and yellow. Filters in these colors are the cornerstone to exacting control of color balance.

One or more Color-Compensating (CC) filters simultaneously corrects for lighting neutrality and for material process neutrality. (*This assumes that the film is being used in the type of illumination for which it is balanced.* When color film — especially

reversal film — is used in illumination other than that for which it is balanced, the quantity of CC filters needed to achieve an exacting color balance may be excessive. To achieve an exacting neutral, the photographer must at least take the first step of matching color film type to illumination type.)

CC filters are the primary tools for color control for a neutral. There are other color filters — light-balancing filters, color-conversion filters, color-contrast filters — but these have secondary roles.

Light-balancing filters adjust film to varying color temperatures of light. This control is useful with light sources that are good black-body radiators, such as tungsten and quartz lamps, but are of no use with such light sources as fluorescent lamps, which are not good black-body radiators. In fact, even ordinary daylight and electronic flash, while often assigned specific color temperatures, are not really ideal black-body radiators. Light-balancing filters may not adjust their color temperature as accurately as the photographer might desire. Furthermore, balancing the color temperature of the light source does nothing to compensate for lack of neutrality in color materials and processes.

It has been my experience that light-balancing filters have a limited role to play in color balance for a neutral. Color photography has standardized on two types of light sources: those with a color temperature of 5400 K, approximating daylight; and those with a color temperature of 3200 K, approximating tungsten light. Artificial versions of light sources in these two color temperatures, electronic flash and quartz lamps, are consistent and repetitive sources. This lack of color variability lessens the need for light-balancing adjustment. Moreover, other sources of varying color temperature produce color effects that we have come to

expect as "normal." For example, a candle is expected to produce a warm color illumination, not a neutral one. Consequently, an extensive examination of light-balancing filters is not warranted. The variability normally encountered can be compensated for by judicious use of CC filters in most cases.

Color-conversion filters are convenience tools in that they convert color film to illumination of a different type. This conversion produces a pleasing result, not an exacting one. Subtle color changes occur which usually defy exact conversion. The color-conversion filters most commonly used are: the 85B, which converts 3200 K balanced film to daylight; and the 80A which converts daylight-balanced film to 3200 K. These and other conversion filters are noted in the data sheets supplied with most color films along with necessary exposure compensation information.

Color-contrast filters are not normally used for an exacting neutral balance, although it is possible to do so. Tri-color red, green, and blue color-contrast filters are used for neutral balance in some types of color printing, for example. Color separation negatives are made with tri-color filters too, but normally color-contrast filters are used only to achieve vivid color effects.

To repeat, Color-Compensating filters in the six primary photographic colors are the most important tools for controlling color quality for an exacting neutral. However, the photographer must develop a visual sensitivity in order to recognize the subtle color corrections needed. Evaluation is a difficult process, as we shall see.

COLOR INFLUENCE OF MATERIALS AND PROCESSES

This book does not dwell on materials and processes — the topic is too large — but following

are some general statements inasmuch as materials and processes play an equal role in color quality.

One crucial aspect is repeatability. For an exacting neutral balance, use the same emulsion number of film for both tests and final shooting. Processing must also be dependable. Good processing is valuable and worth the extra expense that extra care requires. Color film, because it is perishable, must be stored with care to avoid excessive heat, and should be used before the expiration date unless stored in a freezer. Finally, experience with a given product is extremely useful in enabling the photographer to develop an instinctive awareness for its normal reproduction eccentricities.

Color balance is closely tied with the kind of color film used — reversal (transparency) or negative (for color prints) materials. Each kind has a different disposition toward control for a neutral color balance. With color reversal film, correction for neutrality must be made at the time of exposure, and the photographer must depend on close processing tolerances for precisely repeatable results. Color evaluation rests solely in the hands of the photographer. With color negative film, correction may be deferred to the printing stage in the darkroom. Color evaluation may rest in the hands of a second party. (In fact, I have never detected any mandatory need for color balance correction at the time of exposure with negative film, even when using conversion filters, although their use is usually a desirable convenience when the prints are made.)

Either type of color film will produce superb color results under the most demanding conditions and expectations. Some professional photographers insist that reversal (transparency) film will always produce better color results, and they can make very persuasive arguments to substantiate their position. However, I have not been dissuaded from the opinion that color reversal films offer only one advantage, namely, the photographer can exercise total control over color evaluation without involvement by a second party.

For an exacting neutral color balance with reversal film, it is necessary to follow a careful testing procedure. A given emulsion number of film is exposed, processed, and evaluated. If improvement is required, a second test is made, and if care was exercised, a predictable result can be expected. Correction is self-evident once it is achieved. The photographer who is a skilled evaluator can obtain exquisitely precise results following this method.

With color negative film, there need be no test procedure. If the film is properly exposed (it has an amazing tolerance of one stop underexposure to at least three stops overexposure!) and is processed according to instructions, the photographer can be assured that all color information has been duly recorded. It can be fully retrieved in the printing stage at leisure any time in the future and with the same precision possible with color reversal film. There is only one problem, namely, evaluation — who is to make it and how good are they at it. There is no immediate image for comparative evaluation, nor is there any built-in manufacturing standard available as a point of departure. The problem may get worse if a second party makes the print and the photographer is not available for consultation. (This problem of color evaluation at the printing stage is less severe when only casual color balance is required.)

It is curious to note the reactions of many photographers to the color quality produced by reversal and negative color films. Many photogra-

phers will accept casual color balance without reservation regarding color reversal films yet will be exceedingly fussy about color balance in color negative film prints.

Perhaps the profound difference in color evaluation between the two kinds of film is due to timing. Unless the photographer is working under very controlled circumstances, it is difficult to test, evaluate, and reexpose with reversal film. However, with color negative film, this careful testing is deferred to the darkroom during printing. Here time is of no consequence as far as the subject is concerned. The image has been permanently captured on film and the only problem is retrieval. With this opportunity to correct at leisure, a photographer can become very fussy indeed about achieving an exacting neutral color balance.

My experience with printing color negative film is that practice is necessary in order to achieve acceptable results. Because there is no built-in manufacturing standard of color reproduction, the photographer must develop an intuitive sense of color evaluation. Beginning results can be rather frustrating, even when using special color metering devices. But once he gains a feel for the negative color printing process, the photographer finds this to be a very exciting way to make color images. Control over color exists apart from technical demands at the time of exposure.

This book concentrates on achieving exacting neutral color balance with reversal film; we do not get involved with darkroom procedures. But let me reiterate that both reversal and negative films can produce superb color images. My use of color reversal film for purposes of illustration is solely due to its need for exacting correction at the time of exposure.

THE MEANING OF NEUTRALITY

Color neutrality is achieved when the whites, grays, and blacks of an image show no color influence. When this happens, all colors are seen in their best state of reproduction. Color neutrality provides a point of reference for all coloration. It is especially important in color reproduction because an exacting neutral visually implies the existence of the best possible color reproduction.

Usually we think of light as being white, or non-colored. To our eyes, most light sources appear to give off white light because we cannot identify any color in them — unless we make side-by-side comparisons. When we do, brighter lights usually seem whiter; for example, a light bulb seems whiter than a candle and the sun seems whiter than a light bulb. However, none of these light sources is white in a perfect sense. Whiteness, or neutrality, is relative. There is no such thing as absolutely white light. Fortunately, for our presence of mind, our vision is remarkably adaptable to this variability. When we see something lit solely by a given light source, our eyes and brain accommodate themselves to see the illumination as white and neutral. Whites seem white, grays seem gray, blacks seem black, and all colors are seen in their relative relationships. Even if the source changes color gradually, our eyes blissfully ignore the change and continue to see things in a neutral state. It is only when the color of the light changes dramatically that our eyes finally say to us: "Hey, you're looking at a scene lit by colored light!"

Color film, however, is not so deceived and any change is noted with precision. It is only after the film is processed that our eyes sometimes angrily note the differences they had previously ignored.

In color balance for a neutral, we have to consider how fussy we need to be, how to measure color balance at the time of exposure, and how to properly evaluate the results.

How Fussy Do We Have to Be? Color is enchanting. Its mere presence is usually enough to convey useful visual information. A child draws a green blob on top of a black stick and we immediately sense the visual communication of "tree," although we know that tree leaves vary enormously in their green coloration depending on the type of tree and the season. We know that to photograph a tree for purposes of botanical information, the green coloration of the tree must be more precisely stated.

Fussiness of color balance depends on the use to be made of the photograph: an ordinary snapshot record requires a pleasing approximation of color; an illustration-type photograph may require slightly more precise color balance to suit the communication needs of the photographer; a catalog-type photograph requires exacting color balance because it is intended as a substitute for the object itself.

Fortunately, most color photography will be satisfactorily neutral in color balance if a given type of color film is used with the illumination for which it is balanced. There are several reasons why we are usually satisfied with color results when we conform to this rather simple rule. One is that in most color photography the image includes some of the environment as well as the main subject. Thus the viewer sees the environment and its color effects on the subject with a sense of visual logic. Another reason is that color is enchanting, and a good approximation of coloration is ample for most visual communication. Yet another reason is that we usually photograph colorful subjects because

they appeal to our sense of vision. Scenes with a good variety of color or with a predominance of color can tolerate greater deviations in color balance than those with more neutral situations or with subtle, pastel colors.

Furthermore, today's film materials and artificial light sources are far superior in color balance characteristics than those of earlier years and produce color images much closer to our perception of reality. For instance, color film dye characteristics enable closer color reproduction accuracy than formerly; electronic flash illumination is an extremely consistent, repeatable light source; the recently introduced quartz lamp is superior in consistency of color balance to the older, ordinary tungsten lamp.

For a majority of photographic situations, therefore, we do not have to be extremely fussy about an exacting balance for neutrality. However, we do have to be fussy if the color photograph is intended to duplicate as closely as possible the original colors in the scene, as in catalog photography and much advertising photography, or the photographer feels that an exacting neutral color balance is needed for good visual communication.

Measuring Color Balance of Illumination. We have noted that our eyes are not dependable evaluators of color neutrality. With considerable experience, a trained observer can develop an intuitive sense of color balance, enabling him to note reasonably large color influences. But even the trained eye is not satisfactory for measuring an exacting color balance if it cannot make direct comparisons. This presents a formidable technical problem to the photographer who can only depend on casual control to make an initial test and then evaluate it with CC filters to see if correction is

necessary. This cumbersome procedure works well if the photographer can exercise complete control and can redo the photography, if necessary, to achieve the desired results.

Color temperature meters were devised to help solve this problem, but their use is greatly limited. Tabulation of expected illumination coloration helps but is really too crude for exacting control. In recent years a color meter, called a Three-Color Meter, has been devised, which holds promise for solving this problem. I am familiar with the Spectra* TriColor* meter, developed by the Photo Research division of Kollmorgen Corporation. It received an Academy Award from the Academy of Motion Picture Arts and Sciences.

This three-color metering device measures the combination of two different spectral color ratios of light — red-blue and red-green. With this information, the photographer can determine useful color information about any light source, including fluorescent, and apply corrections to color film by using CC filters. It is a photographic system of color illumination measurement; that is, the information supplied by the meter is directly related to the six primary photographic colors.

My experience shows that the meter can supply color balance information accurate to a ± CC05 filter once the photographer has acquired practical working experience with the meter. This experience is necessary because different color films require different aim points on the meter calculating dial. Once the aim point for a given color film, such as Kodak Kodachrome Film, Daylight Type, is determined, the meter is very easy to use. The photographer merely points it at the source and reads two numbers — the red-blue ratio number and the red-green ratio number. These two numbers are then transferred to a pocket dial-type calculator which gives an exacting neutral color balance in terms of the required CC filters to be placed in front of the camera lens.

The meter performs commendably in almost any light. The light does not have to be bright to make a reading. The meter provides useful readings for even very unusual color light sources, such as fluorescent and arc lamps. The meter is expensive and requires some experience for proper use. However, it is the first color meter for practical evaluation of the color balance of illumination. I recommend it for any photographer who does professional photography on location. The meter soon pays for itself in more consistent color reproduction.

Of course, if the photographer is working in a studio and has complete control over all phases of the photographic process a Three-Color Meter is not essential to measure the color balance of illumination; the studio photographer becomes accustomed to working with known light sources. As we noted, today's artificial light sources are very dependable in terms of color balance. Electronic flash is so dependable that it can be used for thousands of flashes for many years with very little change in color balance. It is the standard light source in many photographic studios, even for still-life photography. Quartz lamps are also very dependable. However, the major problem in using this source is voltage fluctuation; this must be monitored or controlled for consistent results. But because the studio photographer works under conditions of considerable control with known light sources, measurement of color balance of light is not a big problem even for exacting color balance requirements. Neutral color balance is assumed and

*Trademark © Kollmorgen Corporation.

the photographer is more concerned with variables of different emulsion batches of color film. A given emulsion number of film is tested under studio lighting conditions and any necessary CC filter correction is noted and applied for all subsequent photography in the studio under those lighting conditions. An exacting color balance can normally be expected for all future photography with the same emulsion number film and CC filter combination.

Evaluation. This is the third factor in control of neutrality. Of course, all photography is casually evaluated. What we are concerned with here is careful evaluation for an exacting neutral color balance. Evaluation of tests and final results for exacting neutrality requires a standard light source for such evaluation; otherwise, our eyes will be fooled by subtle color shifts, thereby destroying our careful evaluations. This standard viewing source should be consistent with the way in which the final color photograph will be viewed. Obviously, there are many variables here which are beyond the control of the photographer. Nevertheless, if the photographer is sure that the photographs will be viewed in normal tungsten illumination, he should evaluate tests and final results in normal tungsten illumination. Likewise, if the sole use of the photography is for slide projection, then the color should be evaluated by projection or by a tungsten illuminator of the same color temperature as the projector lamp (3200 K is normal).

Various organizations, such as the Photographic Society of America, have devised their own standard viewing conditions; so too have photographers in various disciplines. At present, professional photographers and the graphic arts industry have agreed upon a color temperature standard of about 5000 K and a Color Rendering Index of 90 - 100. Illuminators with this standard light source are found in most professional photographic studios, advertising agencies, and printing houses. The ANSI (American National Standards Institute) Standard PH2.31 covers the direct viewing conditions for evaluating photographic color transparencies.* The commonly used Macbeth Prooflite 5000 Standard Viewer, PLT-214, conforms to this standard.

A standard viewing source is only the first step in evaluating color images for an exacting neutral color balance. The manner of evaluation is also important.

Evaluate the transparency by looking through an appropriate CC filter that appears to provide a neutral appearance to the near-neutral midtone areas of the transparency. Do not evaluate the highlights or shadows; evaluation of highlights will suggest insufficient correction, and evaluation of shadows will suggest excessive correction. This evaluation takes skill. Staring through the filter will cause color fatigue and the eye will improperly adjust to the change. Instead, look through the filter only briefly and then remove it. Judge in this way whether the necessary correction is being applied. Take care to concentrate on a near-neutral area. If the area being evaluated is a strong color, the eye will not be able to make a valid judgment. All this takes viewing discipline and experience.

In addition, the photographer must understand the function of the CC filter(s). They should be considered on the basis of their color absorption, not just on their obvious color appearance. There is a good reason for this. If the transparency is judged

*This standard is available from American National Standards Institute, 1430 Broadway, New York, N.Y. 10018.

to be too blue, the photographer must know that the excess blue must be removed by absorbing it through use of an appropriately dense complementary color filter — in this case, a filter that has a yellow color. The function of the filters is to absorb excess color so that neutrals appear as such in the final photograph. See the following table:

Cyan absorbs red. Magenta absorbs green.
 Yellow absorbs blue.
Red absorbs blue and green (or cyan).
 Green absorbs red and blue (or magenta).
Blue absorbs red and green (or yellow).

Color evaluation for an exacting neutral color balance involves very subtle colorations. For example, it is often very difficult to note whether the correction needed is a blue or a cyan; red and magenta are also difficult to differentiate, as are yellow and green. Sometimes two very competent evaluators will not agree on the best correction to use. When evaluation becomes this fine, the photographer is the one to best judge the situation. Subtle corrections are based on subjective judgment.

Color is a subjective phenomenon, an emotional phenomenon, and our tastes will change for unexplained reasons. For example, when a photographer sets aside several transparencies that have failed to measure up to critical color evaluations and looks at them separately a few weeks later, he is usually astonished to note that the color differences were not nearly as bad as originally perceived. Even worse, given two color balances to choose from, an individual will nearly always decide that the best balance is somewhere in the middle of the two. Thus color evaluation is not easy, even for the skilled and experienced photographer.

Finally, an exacting color balance is not always based on achieving an exact neutral! For example, a scene with plenty of green foliage may look better when the neutral balance is shifted slightly toward yellow. Do not make achievement of an exact neutral the sole technical criterion for judging color balance. For one, there is no such thing as an exact neutral. Subtle colorations of a neutral balance are inevitable because of individual judgments as to whether a cool gray or a warm gray looks more neutral. For another, a scene with a preponderance of one color may look much better when neutral color balance is shifted slightly away from what is perceived as a perfect neutral.

USING COLOR-COMPENSATING FILTERS

The CC filter, or filters, that appear to provide the best neutral color balance in the near-neutral midtone areas of the transparency are placed in front of the lens for subsequent photography. A set consisting of six CC05 and six CC10 filters will provide at least 75% of your needs. However, you may wish to add a CC20 red, a CC20 magenta, and a CC30 magenta because these are handy for fluorescent light corrections. (Remember that an exacting neutral cannot be achieved with fluorescent light: only a pleasantly acceptable result. Film and light manufacturers give varying recommendations. Try one and then further refine the result to suit your personal preference. In standard cool white fluorescent light, I like a 30R with Kodak Ektachrome 160T Film.)

CC filters are made of gelatin and, if clean, produce no optical effect when used singly or in pairs. To avoid optical problems, three is the maximum number of filters that should be used together. They can be taped to the lens or held in place by a filter holder. A lens shade, such as the

Hasselblad Professional Lens Shade, is an excellent holder because it allows the lens shade to function normally. A lens shade is a must with CC filters because unwanted flare is a commonly encountered problem.

Combining the smallest number of CC filters requires patient thought to determine the correct answer. First of all, the photographer should recognize that the additive colors — red, green, and blue — are equal to the effects of two combined filters from the subtractive colors — cyan, magenta, and yellow. In other words, the effect of a CC10B filter is the same as a combined set of CC10M + CC10C; a CC10G is the same as CC10C + CC10Y; and a CC10R is the same as CC10M + CC10Y. As far as the color film is concerned, therefore, a CC10R looks and produces exactly the same result as a CC10M + CC10Y.

The mathematical logic of using CC filters in the smallest combination is worth knowing, but practical application dictates that you not spend considerable time calculating the optimum answer. Further, it is seldom that strong correction for good neutral balance is required, so a few filters usually provide all the control needed. The *Kodak Color Dataguide, R-19,* provides additional information on the logic of combining CC filters in the smallest possible combination.

Exposure compensation with CC filters is important, although it is sometimes a bother to compute the correction required. I usually place the filter pack in front of a meter and note the exposure shift. This is a sufficiently accurate and convenient system and it avoids leaving behind a trail of notepaper covered with scribbled mathematical calculations.

CC filters are fragile. They accumulate dust and scratch easily. I always replace mine in the paper envelopes in which they are sold after discarding the tissue paper. Some of my CC filters are several years old and they still perform well enough. It is possible that they have faded slightly, but my everyday use of them prepares me for expected effects.

If all this information about achieving exacting color balance seems complicated, you are correct. Precise control can sometimes lead to heroic effort. Perhaps it is understandable why many photographers opt only for casual control, which saves the best and discards the rest. To this I would add that the advantages of deferring exacting control of color balance to the darkroom are one reason why more and more photographers are investigating the use of color negative materials.

COLOR EFFECTS

Local and Collective Roles of Color Effects. The local role of color quality involves color of individual objects themselves and the manner in which those colors are reproduced by various brands of color film. These can be altered by local darkroom techniques and by local color illumination effects. The collective role of color quality involves overall color balance of the photograph. This is affected by the type of color film or color illumination used, by the use of CC filters over the camera lens, and by manufacturing tolerances of a given brand of color film. Adjustment of color to a neutral balance can adjust collective color effects to a neutral, but local color effects remain a separate visual entity. Color effects relate to emotional and individualized effects produced by color, not to some technical standard as implied by balancing color film to a neutral. Color effects are chosen for reasons of visual communication and may not be related in any way to technical standards for color balance.

Color Effects with Light. These are achieved by controlling the light source itself or by placing colored gels over the lens for an overall effect. (We will arbitrarily omit manual effects done by hand manipulation, such as color tinting and dyeing.)

Controlling the Light Source. Colored gels over selected multiple light sources in studio lighting is a common way of achieving color effects. The result is unnatural because sunlight doesn't do such coloration, but it can easily simulate an available-light situation normally encountered on a city street at night. Color effects can also be achieved by using fluorescing materials with ultraviolet (UV) light. The UV light cannot be seen, but its radiation onto certain surfaces converts the UV radiation into visible colored light. This is common with UV illumination on pop-art posters and UV stage illumination of performers wearing specially treated costumes that glow when lit by UV radiation. Carbon arc lamps generate much UV light, and by merely blocking out the visible wavelengths of light with a special filter it is possible to create a high level of "black" light.

Infrared and ultraviolet radiation have special applications in medicine, documentation, and scientific investigation. Extensive literature is available on the subject, including Kodak's Infrared and Ultraviolet Photography, M-27.

Color effects can be achieved by controlling the light source — using a nonstandard source or waiting for illumination color to change, as in the case of sunshine early or late in the day. The color of sources can be mixed too, for example, tungsten used in combination with daylight. Color effects of different light sources carry an inherent emotional appeal which the photographer should not always try to correct for a neutral balance. Sunshine early and late in the day has a commonly recognized and appealing warmth of color. It is not a simple mixture either. Weak, warm sun rays mix with cool skylight illumination to create attractive juxtapositions of color that become especially evident on specular-surface subjects. It is an enchanting time of the day and well worth waiting for, for color effects.

Mixing different color light sources together can produce interesting visual results. The cliche' of warm, yellowish artificial light emanating from a house surrounded by the cool, blue chill of a snowy winter evening is a case in point. Color makes the cold-warm contrast visually persuasive. Other examples are the mixture of environmental lights on a rainy city street or the intrusion of blue skylight into a red-rock western canyon glowing with warm ambient reflections. Fluorescent light has a greenish cast when photographed. The omnipresent fluorescent illumination in slick, modern office buildings symbolizes cool, detached efficiency when the greenish coloration adds its visual message.

These and other coloration characteristics are normally rendered by film even when our eyes fail to recognize them. Off-color results are not always disagreeable, however; many times they are enchanting and are one reason why color film is so intriguing. In the interests of control and repeatable results, however, it is worthwhile to note such situations in order to watch for them again. Try to analyze why such colorations occur so that you can exert control over them.

Color Effects with Filters and Film. Using CC filters is a common way to influence the color balance and thus the color effects that can be achieved. The filters can be subtle, such as CC10 or CC20 filters, for delicate colorations that heighten a visual feeling without actually drawing attention to the colora-

tion. A pink early-morning sky can be made more vivid with a CC10M or CC20M filter. A woodland scene can be bathed in warming light by using a CC10Y filter. A city skyline at night can look crisper by using a CC20B filter.

Strong color-contrast filters, normally used with black-and-white film, can be used for posterish effects. The vivid colorations can actually change color film images into a color monochromatic situation. There are also dual filters with two different polarized elements for pop-art, multi-colored effects. Color film will usually depict the result more dramatically than our eyes will notice when viewing through the filter.

Film has its own color effects. Each brand of color film has a color characteristic that is fairly distinctive. In some cases, colors are more muted; in others, more vivid. Such coloration can be used to enhance the visual message. Of course, there are also "odd" color films, such as Kodak Infrared Ektachrome, where infrared radiation is shown as red coloration. The color effects of such film are dramatically altered by using special filters.

Color effects, no matter how accomplished, affect the feelings of illumination. Neutral balance allows the colors of the scene to dominate while color effects draw attention to themselves. Color effects are enchanting but are easily overdone. The days of "including red in all color photographs" are over, thank goodness, but excess coloration for its own sake is a trap to be avoided. Use color effects to support your visual message, not overpower it.

CONTROL OF DIRECTION QUALITY

BASIC CONTROLS

Direction quality is controlled by moving the light source, changing the camera position relative to the light source, reorienting the subject to the light source, or by a combination of these controls. The procedures for controlling direction quality are simple to state, but it is often difficult to imagine a good result when faced with a subject in front of the lens, waiting to be revealed by light.

Controlling direction quality is an instinctive process; there are no special rules to follow. Beginners, however, long to discover special rules or guidelines and are therefore attracted to lighting plans, looking upon them as ideals. Such plans are often made available for outstanding or striking photographs that appear in magazines and books. Unfortunately, lighting plans are much like architectural plans — good information, but generally fully comprehendable only by those already experienced in the field. Besides, the photographer should be able to devise his own plans, not always follow the directions of others. Instead of reiterating lighting plans in this book, I wish to direct attention to fundamental observations about direction quality. Fundamentals are better guidelines.

Direction quality is a formative quality of light; it is the primary light quality for depicting dimension. The beginner in lighting techniques usually uses direction quality only to achieve maximum brightness. The more advanced student uses direction quality to produce a specific light and shade relationship. It is this relationship which enables light to convey visual information about form and space and dimension and texture.

Our eyes can clearly see the effects of direction quality of light on the subject. However, the full

effects of direction quality are often not fully perceived even by experienced photographers. This is because photography is an action art and direction quality effects on myriad surfaces and forms of a subject are seldom fully comprehended before the photographer feels the urge to click the shutter. An experienced photographer tends to fill in these gaps of visual awareness with intuitive mental closure; the beginner finds this difficult to do. It requires a developed instinct that takes time and practice and experience.

Most skills require constant practice. This is because intuition and coordination play a large role in most skills. Therefore, the following comments about controlling direction quality cannot be merely set to memory. You must also continue to practice using them so as to remain sharp and alert.

DIRECTION QUALITY WITH ONE LIGHT

We begin with, and generally emphasize, the direction effects and controls for one light source. The reasons are these: First, we are comfortable with the existence of only one natural source in our world — the sun. Our human experience prepares us for the lighting effects of a single source. One source, plus an adequate level of ambient light, will serve to produce all six qualities of light. This simple lighting situation can provide all the requirements for most visual communication needs. Second, no matter how many light sources we may finally wish to use in a lighting plan, it is wise to subordinate secondary sources to a single, main light source. This assists in visual cohesion according to our human experience. Third, when, for effect, we wish to light with several sources, each light should have a logical role to play, so that each can be analyzed as if it were operating alone.

Philippe Halsman, in his book-feature "Psychological Portraiture," stressed the advantages of one light in portraiture: "The more lights one uses, the more complicated it is for the beginner to control them and to avoid the accidents that they produce, like overlapping shadows and disturbing highlights."* Halsman stated that his best work was often done with one light plus a large fill light near the camera lens (simulating added ambient light): "I . . . use one light in many of my portraits. It has an unusual force and it translates the three-dimensional forms of my subject with an extraordinary plasticity."**

It is easy for us to direct our thinking into accepting more for better. Try not to be swayed by the temptation of using many lights just because you have seen superb examples of multiple lighting. The use of many lights can be done very well, for example, Steichen, Karsh, cinematography of the 1930s, but it is an extremely demanding lighting technique. Begin by learning to use one light competently, not just because it is easier, but because it provides excellent experience in fundamentals and because it is often the best solution.

Angle of Incidence Equals Angle of Reflectance. A helpful learning device for predicting direction quality of one light and its effects is the law: Angle of incidence equals angle of reflectance — a law that applies to the physics of light. Light moves in straight lines. Therefore, as rays of light hit a surface, their reflection from that surface can be predicted. If the surface is highly specular, the reflection of all the light rays can be described with

*Philippe Halsman, "Psychological Portraiture," *Popular Photography* (December 1958), p. 130.
**Ibid. p. 129.

optical precision. If the surface is highly diffuse, the reflection can only be generally described because of scattering effects, but the tendency will always be toward that described for more specular surfaces.

The angle of incidence law is useful in predicting the path of light and its resulting effects. It aids a studio photographer in deciding where to place a light source to reflect brightness off a particular surface for maximum or minimum effect as seen from the camera. It also provides clues to the available-light photographer about where to move himself to take best advantage of the existing direction quality of the illumination. But we need more than a pool shark's ability to predict the path of light — we also need fundamental understanding about direction quality and the light and shade relationship.

Extreme Angles of Influence. Some direction effects produce obvious light and shade relationships. These are the extremes of angular influence: full front, silhouette, and 90° from one side, above or below, as seen from the camera viewpoint. The human face is a good subject to demonstrate these extremes; it has dimension and form, is interesting, is a typical photographic subject, and observations of the light and shade relationship on it are translatable to other subjects.

Full Front Direction Influence. This influence is that which comes directly from the camera angle of view. It produces a minimum area of shadow and a maximum area of brightness, and revelations of texture and form are at a minimum. Since there is little area of shadow, except those subtle reflection differences caused by various planes and undulations of the subject, the inherent tones of the subject remain uninfluenced by cast shadows. The eyes are fully revealed, the pattern of eyebrows and eyelashes is clearly seen, and the shape of the lips and hair is clearly delineated.

Full front direction influence does not produce a strong form-revealing light and shade relationship but can be a useful direction influence to choose for revealing the inherent tones and patterns of the subject itself. When a subject has a complex structure with many intricate surfaces, such as the insides of machinery, frontal direction influence can be the best solution because the intricacy of the machinery is not further complicated by an introduction of confusing shadows.

Silhouette Direction Influence. Silhouette is the opposite of full front in that the light comes from directly behind the subject. This direction influence produces a minimum area of brightness and a maximum area of shadow on the subject. Silhouette direction influence places a maximum emphasis on the shape, or outline, of the subject (when the background is lighter in tone than the subject or when the subject is outlined with a rim of brightness).

An interesting halo effect sometimes occurs with silhouette direction influence. This happens when the subject has tiny, light-catching protrusions, such as facial hair, and the background is relatively dark. The effect is often used for glamorized photographs of people, especially women, because it highlights the hair with a brilliant lustre that is both attractive and attention-provoking. (Of course, a high level of ambient light or an additional light is needed to illuminate the shaded front of the face.)

90° Directions Influence. Light direction 90° from one side, above or below, skims across the subject. If the subject is flat, this skimming light reveals a

maximum of surface texture. If the subject is round, as a face, the skimming light is tangent to the surface only in a small area. The more diffuse the light, the larger the area; and the more specular the light, the smaller the area. This is a significant point to understand, because it is the reason why "soft" and enveloping diffuse light produces a form-revealing light and shade relationship while "hard" and nonenveloping specular light produces an abstract and anti-form-revealing light and shade relationship.

The area of shadow to light is about 50-50, so the overall reflected brightness from the subject averages out to be darker than that produced by full front light and lighter than that produced by silhouette illumination. Light direction influence of 90°, because it is an extreme angle of influence, is not always the best for revealing form. For example, when the direction is from below, the texture and form are rendered in an unnatural manner because this is a light direction which is not normally experienced in nature. And when the direction is from one side, depending on the angle of the human face, the shadows may bear little relevance to the actual form of the face. Nose and ear shadows become excessively prominent while skeletal structure remains obscure. When the direction is directly overhead, the skeletal form is strongly revealed but minor depressions become excessively prominent and the eyes are lost in the black voids of their sockets — a form revelation perhaps useful for anthropology but not for portraiture.

Intermediate Angles of Influence. There are other angles of direction influence that can function well for revelation of form. In fact, there are so many that the choices can seem overwhelming. Fortunately, if we split the difference on the extremes of

angular influence, we come up with six direction influences that produce nearly all the basic light and shade relationships a photographer would normally wish to use. And when one of these six is not quite adequate, a subtle shift is all that is generally needed for perfection. These six influences are the intermediate angles of influence.

Intermediate Frontal. We have already ascertained that light from below is unnatural. Therefore, that direction quality is not worth expanded investigation. We will therefore consider only frontal angles of influence that are above the camera lens axis. We have also seen the effects of light from 90° angles of influence — above and to one side — and the effects of light from full front — a 0° angle of influence. For the three intermediate frontal angles of influence, we split the differences of these extremes, resulting in a 45° direction from directly above the lens axis; 45° above the lens axis from the left; and 45° above the lens axis from the right.

These three 45° intermediate frontal angles of influence are effective compromises to the extremes of angular influence. They produce good light and shade relationships with adequate texture revelation and good revelation of form. The two intermediate angles to left and right produce a stronger light and shade relationship than the intermediate angle directly above the camera and are effective compromise lighting direction solutions for a majority of photographic subjects.

On the human face, the intermediate angle directly above the camera reveals some form and very little texture — especially around the eyes, nose, and mouth. This makes this direction influence a flattering one for women and is often used in fashion photography. A diffuse source with this direction influence further diminishes textural

revelation without sacrifice in revelation of form. This is the standard direction influence for an umbrella source in the typical portraits used on the covers of women's magazines.

When considering the direction quality of light, remember that specular light produces a more sharply defined light and shade relationship than diffuse light, and that specular light requires more care in controlling direction quality than diffuse light.

Intermediate Rearward. The 45° rearward angles of influence tend to place the subject largely in shadow; only irregular bulges and projections will catch the illumination. Therefore, these three angles of influence are seldom used alone without additional lighting information provided by adequate ambient light or secondary light sources.

The edge effects of rearward angles of influence provide interesting lighting accents. These accents can be used to emphasize significant portions of the subject, and they aid in separating subject from background. Rearward angles of influence on the subject cause a brighter reflection of light, given the same intensity of illumination, than the frontal angles of influence because the light rays skip off the edge surfaces of the subject with little loss due to absorption and scattering effects. In other words, relatively bright edge lighting can be produced by relatively weak sources of illumination.

In available-light photography, dull, indoor illumination can be enhanced by choosing a camera viewpoint where rearward angles of influence are present to pep up the light and shade relationship. These rearward angles need not emanate from bright sources; a small window, a distant light source, or a light wall can produce effective local brightness effects. Most experienced photojournal-ists instinctively seek out these little accent light sources to gain tonal separation on the subject and thus enhance visual emphasis for the printed page.

Again, as with other direction influences, specular and diffuse qualities play an additive role in rearward angles of influence. Diffuse light tends to influence a greater length of the edge of the subject than specular light while specular light usually makes the affected edge much brighter than diffuse light.

A lighting perimeter of diffuse light is a useful lighting technique. The contiguous nature of a U-shaped, rearward direction quality of a light source produces a total light-edge effect on the perimeter of a subject. This technique has been used with distinction by Norman Rockwell in his paintings as well as by photographers for great visual effectiveness in human-situation illustrations similar to those so deftly handled by Rockwell.

One technical warning about rearward angles of influence: Always use a precise lens shade, unless pictorial flare is a desired element in the visual message. A precise lens shade is an adjustable bellows-type, such as the Hasselblad Professional Lens Shade. Without it, shadow detail begins to disappear in a veil of lens flare.

Feathering the Light. Generally, when using a light source indoors or in a confined space, do not aim it directly at the subject, otherwise there is a tendency for illumination brightness to be excessive at the edge of the scene nearest to the source. While this excess of brightness may not be recognized visually, except to the trained eye, it will be picked up on film. Excess brightness at one side of a scene over the other becomes visually annoying when a reproduction of the scene is framed and isolated from its environment, as in a photographic print.

When the light source has a hot spot in its illumination, feathering the light is even more important because the hot spot tends to enhance the aforementioned annoying brightness of one side over the other.

To feather a light source, point the center of the illumination, or beam, toward an imaginary point somewhere between the camera and the subject. This moves the brightest part of the illumination in toward the center of the scene and away from the edge of the scene nearest the source. Feathering does not influence the effects of light from point sources. Such sources cannot be feathered because a point source has no dimension. But you can feather reflector sources, even small ones, because they have a measurable dimension.

Experienced photographers instinctively feather the light source. It provides an extra touch of lighting craftsmanship and usually eliminates unnecessary darkroom manipulation in the printing stage.

Combining Direction Quality Controls. Given one of the aforementioned angles of influence for the light source, you can introduce added control by changing the angle of the subject relative to the source. This can result in new and interesting light and shade relationships. (Remember that control of direction quality can be readily achieved by a combination of the three direction quality controls mentioned initially.) For example, if the angle of influence for the source is 90° from one side, the light and shade effect can be altered if the subject turns his or her head. If the head is directed toward the light, the profile will be illuminated — an agreeable lighting effect. The light and shade effect visually suggests a bas-relief sense of form, like that displayed by a profile on a coin.

Combination of direction quality controls is commonly used in studio photography. The photographer sets up a given direction influence for the light source and then turns the subject in relation to it. This is an effective lighting technique — one often overlooked by the beginner who may often struggle for new lighting relationships by moving the light and then running back to the camera to see the effect instead of merely rotating the subject slightly in relation to the source.

However, these combined direction controls can be overdone. Do not get so enraptured with lighting effects on people that you twist them into idiotic, pretzel-like poses. This happens so often in portraiture that the photographer should be supersensitive to the problem. It is better to allow empathy with the subject to dictate lighting effects than to permit lighting technique to distort rapport between photographer and subject.

DIRECTION QUALITY WITH MORE THAN ONE LIGHT

This book emphasizes the value of using only one light plus, if necessary, added ambient light for contrast control. However, do not infer from this that multiple-source lighting is either improper or out of date. Direction quality with multiple sources is a difficult technique. There is an inherent tendency to cause confusing, multiple light and shade relationships with many light sources. But multiple sources provide extra direction control that can be achieved no other way, hence it is essential that every photographer learns how to use them. Multiple-source lighting can be a powerful visual tool.

To control multiple-source lighting, first review the reasons given for using just one light source.

These are the beginning steps for controlling multiple direction quality. Next recall how we actually obtain visual and mental information about form and space. We obtain this information as a summation of visual and tactile experiences: the stereoscopic vision of two eyes, the added visual information of seeing things from many angles, depictions of perspective, relative sizes of known objects, familiar pattern relationships, and the tactile data obtained by handling an object or walking around it. Full visual revelation of form and substance is a summation of experiences.

With one light source, you can choose only one direction influence for your photographic lighting. This single influence allows only one light and shade relationship to convey its visual information. However, with multiple sources, you have an opportunity to produce several lighting influences, which can add up to a greater sum of form-revealing light and shade relationships. Multiple sources, therefore, provide the visual communicator with greater control over the light and shade relationship than can be obtained with the singular influence of one light source.

Because multiple-source lighting reveals more than single-source lighting, and because multiple-source lighting introduces novel and unnatural light and shade relationships, it opens up possibilities for unique light and shade effects. Thus direction quality control with multiple sources has two visual aims: to more completely control the light and shade relationship so as to reveal more visual information than a single source can provide; and to create multiple light and shade relationships that are uniquely the photographer's own vision and which transform the subject or scene into an entirely new and novel identity. This latter aim has been extensively explored by visual artists in the movies and in studio still photography of the twenties, thirties, and forties. Today, few photographers explore this fascinating lighting discipline of multiple-source lighting.

Direction Quality of Several Sources. This is a fascinating area of lighting, one where you can exercise great control over the lighting effect. The control comes not only from the use of multiple sources but also from limiting the influence of each source — a situation typically exploited in the theater where many spotlights are mounted above and around the proscenium arch.

In multiple-source lighting, every source should have a role to play. This discipline is important because it adds purpose to the lighting plan. The main roles are: key light, fill light, background light, and edge light. Once you know the main roles for multiple light sources, you will begin to recognize the other possibilities.

Roles of Light Sources. These roles are determined by deciding what areas of the scene should be illuminated. The first light is the key light. Its effects produce the main light and shade relationship, and the other lights should be subordinate to it. When the lights are placed, you must carefully watch the shadows they cast. Cast shadows cannot be erased by other lights; bad shadows must be avoided in the first place. If a bad shadow is cast, and you cannot figure out how to remove it, substitute the offending light source with a more diffuse one. This will provide a more nebulous shadow and may solve the problem. A specular source will add confined illumination and a distinct set of shadows; a diffuse source will add generalized illumination and nebulous shadows. The logistical problem with multiple-source lighting is to juggle these effects

around until you obtain an effective combination.

Multiple-source lighting techniques usually utilize specular quality sources instead of diffuse ones because the former can be easily controlled to produce limited areas of illumination. But do not overlook the obvious advantage of selecting diffuse sources to play some of the roles and of adding illumination without adding another set of competing shadows. Remember that umbrella light sources and corner-flats have fairly adequate direction control compared to other diffuse sources. In addition, you can restrict the light from these sources by means of shading devices.

Key Light. The main light source is the key light. It establishes the primary light and shade relationship. It normally possesses one of the ten basic direction influences previously mentioned. The key light, when it is specular, can create problems with cast shadows. When used in confined quarters, a cast shadow of the subject usually falls on the background. This cast shadow can be a disturbing element and a distraction, especially when the background is a plain wall. It cannot be erased by adding more lights to the background; it must be avoided in the first place. To do so, position the subject ten feet or more from the background. In this way, the shadow usually falls beyond the view of the camera or will be low enough and small enough to be less conspicuous.

The problem of shadows on the background caused by specular sources was a constant visual problem in the vivid multiple-light techniques of the twenties, thirties, and forties. In advertising illustration, it was common practice to airbrush them out. A glance through magazine ads of 30 and 40 years ago will generally reveal incongruous diffuse shadows or heavy-handed erasures of

shadows when other lighting logistics failed to solve the problem. (Photographers should have used diffuse key light sources , but the weaker brightness of diffuse sources added insurmountable exposure problems with the old, slower films.)

Shadows of the subject on the background can be used as a pictorial element, although this is very tricky to do successfully. One of the more successful practitioners of this technique was Edward Steichen. Several examples appear in his book *A Life in Photography*.

On large sets, there can be more than one key light. Individual, separated areas can each have their own key light source. This complex lighting situation is more common in cinematography where movement takes place during filming. It is occasionally used in still photography when the set is large and more than one area of a scene has important visual emphasis, for example, a room of furniture for catalog illustration or a theatrical scene with more than one person on stage.

X-lighting is another occasion for using more than one key light. In this case, four lights are used, one in each corner of a room. This is a common lighting plan used for sporting events, such as basketball, in large auditoriums. Electronic flash is used and each light is set off in synch by radio control. It is an ideal plan for lighting capricious movement where the effect of a key light cannot be predicted or anticipated. Two of the lights act as frontal key lights and the other two as rearward influence accent lights. One or two of the lights may actually appear in the photograph, and the shadows of the front two lights will cast awkward shadows, but the presence of strong accent lighting, the ambience of the auditorium itself, and the haphazard nature of the sports action easily compensate for the visual problems of dual key lights.

Fill Light. Another role for a multiple light source is that of reducing light ratio by simulating added ambient light. Consequently, this role is admirably filled by diffuse light. When the background is nearby and plain, a diffuse fill light is essential to avoid unwanted, sharp cast shadows. Remember that diffuse fill light often functions best when it is off to one side of the camera lens axis, on the same side as the key light. When placed in this manner, the fill light tends to produce a rounding, three-dimensional effect as it adds ambient light.

A current lighting trick in fashion photography depends on sharp shadows of the subject on the background, caused by a specular fill light, to add a pictorial element. This technique adds a rim of outline shadow around the subject and often conveys a visual impression of sudden, surprising, flashlighted discovery. The communicative role of the fill light in this case is not to merely reduce lighting contrast but to add additional pictorial influences. It is a good example of using lighting to produce newer visual roles for light sources than those traditionally imagined. Although this book emphasizes the traditional roles for multiple light sources, do not take this to mean that other interesting possibilities do not exist.

Background Light. A light source can be assigned the role of illuminating the background, causing it to be a separate visual element in the photograph and providing a more distinct visual separation between the background and the subject. This is the role of the background light. In traditional studio portraiture, the background light is commonly a small source on a low light stand placed behind the subject, hiding it from the camera view. The illumination is kept low, illuminating an area directly behind the subject, with falloff in illumina-

tion occurring toward the top and edges of the image area. This produces an effective visual accent — the brightest illumination on the background falls behind the subject and creates a visual bull's-eye. The background light is commonly used in advertising illustration too because the bull's-eye draws attention to the product being advertised.

A similar lighting bull's-eye of background illumination can also be achieved by using a spotlight placed high in the air and shining down over the subject onto the background. Take care to keep the spotlight's spill from touching any area of the subject.

The background light does not always have to be as obvious as a lighting bull's-eye. In many cases, the normal ambient light from other sources and surfaces sufficiently illuminates the background to a level desirable for some visual detail though not enough to cause distracting attention. In large sets, several sources may be needed to light specific areas in the background — a common circumstance in cinematography. This involves great care and patience for precise effects that are supportive yet not dominating.

Background lighting can also be used very selectively — where the background is only partially revealed and the viewer's imagination is allowed to fill in the gaps. A typical example of selective background illumination is that used in a mystery movie. The background is only partially illuminated to make the environment more mysterious and spooky. Selective illumination need not convey mysteriousness, however; it can be used merely to provide selective control so that the illumination will simplify background clutter and distraction.

There is an extremely fine line between necessary and unnecessary control. This challenge is a constant factor in all forms of lighting and

especially in controlling background lighting with multiple light sources for precise effects.

Edge Light. This role serves to add brightness to the edges of objects in the scene. This is a supportive role which controls visual emphasis and enhances separation between subject and background. Edge lights usually have a rearward direction quality and can be employed to achieve myriad specific effects.

In portraiture, one of these lights can be assigned to lighten the hair because hair usually photographs much darker than it appears to our eyes. In product illustration, this light is sometimes called a top light. Other sources are sometimes used to add light to the sides of the subject for further visual separation, and these are usually called accent lights. It is possible to overdo these edge light effects; after all, not every edge has pictorial importance.

Edge light can also be used to lighten edges that are already light. This particular source is often called a kick light. This may seem a redundant control, but it can be an effective way to enhance the light and shade relationship. Placing a lighter tone, often referred to as a specular highlight, within an already light tone is an attractive technique for enhancing tonal dimension, strengthening depiction of form by the light and shade relationship, and pleasantly increasing feelings of tonal sparkle.

The direction influence for the kick light is to place the source on the same side of the subject as its lighted area but toward the rear, so that its rearward influence skips light off the already light area. This adds extra brightness within a selected part of the light area. It is the juxtaposition of white on light that produces the increased tonal effect. This kick light effect is often used in portraiture and product illustration.

Other Roles for Light Sources. In an elaborate set consisting of many parts, multiple sources can be assigned many specific roles. This is the situation in most theatrical lighting — many lights are located around the stage and each has a specific role to play. In large sets used to display furniture for catalog photography, the use of many sources for each of several furniture pieces is a typical lighting situation. And in movie sets where motion is to take place over a large area, many light sources are assigned separate roles. It is not possible to name all these roles; their reason for existence depends only on the specific lighting problems at hand. Nevertheless, all the roles assigned follow the fundamental thinking about direction control.

The beginner is generally overwhelmed by the sight of dozens of lights on a set and wonders how there could possibly be need for such a complicated setup. But there is, and each source is put into position using the fundamentals outlined above.

Remember that multiple-source lighting is unnatural. However, it is a lighting environment that can be unique and dramatic. But if it is to successfully support a visual message, it must conform to visual logic and that logic is based on the fundamentals we have explored.

CONTROL OF CONTRAST QUALITY

THE TWO TYPES OF LIGHTING CONTRAST

As we noted, the photographer must control two types of lighting contrast: total and local. These two contrasts are independent visual phenomena which may act together but not necessarily. Total contrast is alterable at all stages of the photographic process,

from controlling light ratio through the materials and processes of photography. Local contrast is only controlled in part by these factors and is more directly controlled by the formative qualities of light. It is very important to recognize the distinctions between the two types of contrast, otherwise you may obtain unwanted visual effects.

When flash on camera was the standard light source, newspaper photographers were constantly exhorted by their editors to get more contrast in their images. Veteran photographers knew what the editors wanted, even though the latter were inept with their verbal plaints, but rookie photographers thought only to rush back to the darkroom, print on a more contrasty grade of paper, and made matters worse. The contrast the editors sought was not total but local contrast, which could be achieved by introducing some direction influence (by holding the flash away from the camera) and by improving the contrast of local, adjacent tones by using a lower contrast grade of paper.

There is a tendency, especially among beginners, to overemphasize total contrast control and to be unaware of local contrast control. Perhaps this is because photographic literature often fails to relate the two types of contrast; either the two controls are not discussed in the same context, or control of total contrast in processing and in light ratio is overemphasized. It is only when you gain experience that you intuitively comprehend the importance of local contrast control. (It is interesting to note that in painting — another field of visual communication — the student often has the reverse problem. There, the artist constructs the image brush stroke by brush stroke. Control of local contrast is automatic. By being overly absorbed in minutiae, the student often overlooks the importance of total contrast control. As a result, the painting lacks overall visual impact.)

CONTROL OF TOTAL CONTRAST

Influence of Light Ratio on Total Contrast. To properly control total contrast, we must recognize the photographic effects of light ratio. If photography responded to light and shade exactly as our eyes do, we could care less about measuring light ratio. What we see is what we would get. But this is not the case. Light ratio exerts a multiplying influence on the tones of objects in the scene. This multiplying influence can quickly place the extremes of tone in the scene beyond the reproduction capacity of the photographic process, especially if the end result is a print instead of a transparency.

Let's assume, for example, that we are photographing various sizes of dark walnut and light birch wood blocks. The illumination is flat and the light ratio is low — close to 1:1. A reflected-light meter would probably indicate a reading off the lightest part of the birch blocks as about five stops lighter in tone than off the darkest part of the walnut blocks. A photographic print can normally reproduce a scene that has a seven-stop brightness range between the darkest significant tones in the scene and the lightest. So our imaginary scene of wood blocks is well within reproduction limits.

Now let's introduce a strong light and shade effect with a light ratio of 16:1 — not uncommon on a very clear, sunny day with no nearby light-reflecting surfaces. Shadows cast by the big wood blocks will fall on the smaller ones, some of them dark walnut. The placement of dark-toned objects in shade greatly increases the tonal range of the scene. It will now extend from light birch blocks in full sunshine to dark walnut blocks in shade. The light ratio of 16:1 applies its multiplying effects. Where formerly a 5-stop brightness difference occurred, with the

light blocks 32 times lighter than the dark blocks, we now have a brightness range that is 16 times greater. The lightest part of the birch blocks is now 500 times lighter than the darkest part of the walnut blocks (32 × 16). The range of tones in the scene has expanded from five stops to nine stops—well beyond the normal limits of photographic reproduction. Some parts of the dark walnut blocks will be lost in solid black tones and some parts of the light birch blocks will be lost in solid white tones when reproduced photographically.

Because this scene is a very simple one, the loss of tonal information in some areas of the scene presents no real visual communication problem. Our visual frame of reference is strong and the visual repetitions are obvious enough that, even though we cannot reproduce full tonal detail in all areas of all blocks, we instinctively know that it is there.

But let's change the objects in the scene from simple wood blocks to complex objects — portable radios — some black and some white, and both styles are to be illustrated in one photograph for a sales catalog.

To show full visual detail in all parts of both styles of radios, we cannot allow a 16:1 light ratio. Too much useful sales information will be lost. As we saw, a seven-stop range of tones can be reproduced by photography. The radios will probably have a tonal range greater than the wood blocks — probably about a six-stop range as measured by a reflected-light meter. Therefore, if we add the tonal influence of light and shade to the tones of the subjects themselves, we cannot afford a light ratio much higher than 2:1 — a one-stop difference between light and shade. The one-stop difference in light ratio added to the six-stop difference in subject tones produces a seven-stop range of tones. (Adding

f-stops is the same as multiplying light ratio because f-stops are a logarithmic function.)

These examples point out two things that you should note: First, light ratio is a significant measurement for determining whether or not all tones in a scene can be reproduced; second, light ratio measurement is only as necessary as your requirements for full visual information in the finished photograph. The following examples are guidelines for using light ratio controls with scenes of average tonal range. (By average tonal range I mean that the scene is neither a snowman in a snowstorm nor a black cat in the proverbial coal pile.)

Less than a 2:1 light ratio is the lowest total contrast of light and shade. Light and shade influence will be at a minimum. Any cast shadows that may be produced are so feeble that they cannot obscure any areas of the subject. Minimum light ratio is useful in photographing intricate machinery to depict complex visual information about repair and maintenance. Because light and shade are at a minimum, the forms and textures of objects depend solely on their own inherent tonal characteristics, including the subtle reflections of light off varying angles of planes and surfaces. Optimum image sharpness is required for the photograph to depict this subtle visual information.

A 2:1 light ratio (one-stop difference between light and shade) is very low but is generally strong enough to reveal the direction influence of the light source and its resulting light and shade effects. This light ratio is often used for catalog illustration; high-key lighting effects; fashion photography, where the emphasis is on makeup; and so on. A 2:1 light ratio depicts form and texture in a delicate manner with little likelihood of obscuring any areas in the scene.

A 4:1 light ratio (two-stop difference between

light and shade) reproduces photographically as an average total contrast even though it looks much weaker than that to the untrained eye. It is strong enough to convey very definite feelings about the directional influence of the light source. A stronger light ratio is seldom required for most situations. For some scenes that have an inherently wide range of tones in the objects themselves, a 4:1 light ratio will place some of the tones beyond the capacity of the photographic process. Therefore, a 4:1 light ratio is generally too strong for catalog photography or subjects where stronger cast shadows will obscure full visual information in some areas of the subject.

An 8:1 light ratio (three-stop difference between light and shade) is typical of ordinary outdoor sunshine. However, it is a very high light ratio for photography because for most subjects some areas in the scene will be placed beyond the reproduction limits of photography. This light ratio is extremely forceful and is excessive for many subjects, even though it will not seem so to the untrained eye. It is a light ratio that may be used for very emphatic visual statements where dramatic overall impact is desired.

When light ratios of 16:1 or higher (more than four-stop difference) are used, a significant percentage of tones in the average scene will fall beyond the reproduction capacity of photography. It is seldom that the photographer would want such extreme contrast. Shadows will have only abstract identities. On rare occasions, this extreme contrast can be interesting because of the vivid visual impact.

While light ratios higher than 16:1 produce a light and shade effect well beyond reproduction capacity, it is not beyond the limits of normal vision. Our eyes are rapidly selective and easily see, without conscious thought, a far greater range of tones than

the fixed, limited vision of photography. For this reason, you must train yourself to interpret light ratio the way film does. The best method is to use an incident-light meter to measure light ratio instead of just guessing. (Experienced photographers sometimes use a monochromatic viewing filter.)

To read light ratio, use an incident-light meter to make two readings: one of the full illumination falling on the subject, the other of the ambient light that illuminates the shaded side of the subject. It is usually quite satisfactory to shade the direct illumination falling on the meter to simulate the amount of illumination in the shaded areas of the subject. The difference between these two readings in f-stops allows you to determine the light ratio. A one-stop difference indicates a 2:1 light ratio; two stops, a 4:1 ratio; three stops, an 8:1 ratio; four stops, a 16:1 ratio; five stops, a 32:1 ratio; and so on.

To bring the light ratio to the desired measure, add or subtract ambient light (or simulated ambient light) until the two readings reach the desired difference in f-stops.

Total Contrast and Emotional Influences. Total contrast control involves more than just intellectual decisions about the extent of visual information that the photographer wishes to reveal. Control of total contrast is also closely tied to emotional feelings. When the photographic reproduction doesn't follow the contrast which our vision and emotional nature perceive, then there is visual conflict. For example, sunshine pouring in an open window seems emotionally bright and airy and cheerful. But this is an extremely high light ratio situation which will record at a far higher contrast than our emotions sense it to be. As a result, the photographic reproduction will probably look harsh and gloomy. This is a case where the

photographer must greatly increase the level of ambient light to photographically record what is emotionally felt. (This control requires finesse because evidence of technical intrusion will add emotional influences of its own.)

Lowest light ratios, of about 2:1 and less, support emotional feelings of lightness, airiness, freshness, and gaiety. Light ratios around 4:1 and 6:1 support visual feelings of strength and profundity. Very high light ratios of 8:1 and higher become an ever more emphatic pictorial element. If the lighting is specular, very high light ratios produce feelings of harshness with rigid, graphic light and shade effects. If the lighting is diffuse, these harsh effects are ameliorated because the edges of the shadows are not sharply defined. In fact, lower light ratios with diffuse light can change the emotional feelings completely to dullness and drabness. The reason is that both the edges of the shadows and the light ratio lack contrast and this double loss of visual information is uninteresting. Specular quality and diffuse quality therefore play important supportive roles in the emotional character of light ratio (total lighting contrast). Naturally, all these emotional effects depend in part on other factors, including subject matter. (These comments on lighting contrast only relate to tendencies, not absolutes.)

Control of Light Ratio. Because ambient light is a natural lighting element, the control of light ratio is usually best achieved by actually altering the presence of ambient light or by simulating a change in its presence. The use of a secondary source for obvious fill-in illumination is seldom satisfactory because this artifice draws attention to itself.

Since ambient light is the illumination produced by all the reflecting surfaces in any lighting environment, its presence is altered by altering the reflecting surfaces. Adding large white reflecting surfaces to a scene increases ambient light. Removing them, or introducing large black non-reflecting surfaces, reduces ambient light.

Some light sources normally generate much ambient light: bounce-light diffuse sources; and bare-bulb specular sources, when the environment contains a lot of light-reflecting surfaces. Sometimes on movie sets and in television studios where a forest of lighting fixtures is used, the mere proliferation generates added ambient light.

Other light sources normally generate less ambient light: reflector sources and transmitted-light diffuse sources. Narrow-beam spotlights generate the least.

Controlling ambient light can present logistical problems, especially when shooting on location and outdoors. It isn't easy to transport and handle bulky reflecting panels (although the collapsible flat umbrella is an ingenious portable solution). Simulating added ambient light with a small, portable secondary light source — referred to as a fill light — is an attractive solution when working on location and outdoors. But a small, portable fill light has its problems when it comes to simulating added ambient light. Its directional effects can be disturbingly evident. Personally, I avoid its use, with one exception.

For convenience outdoors, a portable electronic flash as a fill light is hard to beat. It's easy to vary its relative light output to produce a given light ratio, but its highly specular presence is a problem. This can be reduced by placing the flash reflector as close as possible to the camera lens (I rest mine on my lens shade, not on a bracket alongside the camera body) and by not using it at distances closer than ten feet. Otherwise even the slight off-axis location next to

the lens shade is too great an angular influence.

Contrary to most recommendations, I prefer balancing the electronic flash to a 4:1 light ratio, not 3:1 or 2:1, as some suggest. Sunlight and electronic flash-fill calculation for a 4:1 light ratio is not difficult. With a little experience, you can do it in your head.

Before beginning the calculation, remember the rule which states that the exposure effect of the sunlight is controlled by variation in shutter speed while the exposure effect of the electronic flash is controlled by variation in the *f*-stop. The reason for this rule is that electronic flash is usually much faster than the highest shutter speed. This difference allows you to compartmentalize the calculation.

With the rule in mind, compose your photograph. Let's assume you like what you see of your subject at a distance of 10 feet. Your first calculation will be to find the *f*-stop to use by dividing 10 feet into the "4:1 Flash Guide Number" for your flash and film combination.

The 4:1 Flash Guide Number is not provided by the manufacturer but you can determine it for your own flash quite easily. Just multiply the normal guide number (that you have found from experience to be correct for your flash unit) by 2. If your flash unit has a guide number of 80 for a film speed of 100, multiply 80 by 2 to obtain the 4:1 Flash Guide Number. In this case, it is 160. The 4:1 Flash Guide Number of 160 divided by 10 feet equals *f*/16. The *f*-stop to use is *f*/16.

Next you want to find the shutter speed necessary at that *f*-stop to obtain correct sunshine exposure. In most cases, this will be 1/film speed at *f*/16 because sunshine during midday hours is a very constant light source. In this example, therefore, the shutter speed will be 1/100 sec.

With experience, you will be able to do the flash-fill calculation quickly and mentally. There are a few variables to consider, however. For one thing, most focal-plane shutters will not synch at speeds over 1/100 sec. This will present a problem when your calculation calls for a higher shutter speed. The solution is to reduce the power of the electronic flash by placing a handkerchief over the flash. One thickness will reduce it about one stop and two thicknesses will reduce it about two stops, equivalent, in the example given, of going to 1/200 sec. and 1/400 sec. shutter speeds respectively. To be more precise about power reduction, cover the electronic flash with a neutral density (N.D.) filter. A .3 N.D. will reduce output by one stop; .6 N.D., by two stops; .9 N.D., by three stops; and so on.

Another variable will be personal judgment about correct sunshine exposure. When using negative film materials, I tend to expose for shadow detail, not for sunshine. In the case of a 4:1 flash-fill ratio, this produces too weak detail in the shadows for my taste. Therefore, I use the equivalent of one stop slower shutter speed for the *f*-stop that I determine by means of the 4:1 Flash Guide Number. In the example given previously, I would use 1/50 sec. instead of 1/100 sec. This provides greater sunshine exposure while still retaining the contrast effects of the 4:1 light ratio.

Mathematicians will quarrel with some of my calculations, pointing out that my calculations produce a 5:1 light ratio, not 4:1. True. But I defy them to show me a photograph that clearly depicts the visual difference between a 4:1 and a 5:1 ratio. Further, the mathematics involved is far more precise than the effects produced. You will find that for most situations in which you choose to use flash fill, the flash-on-camera-to-subject distance will be relatively similar and the flash-fill calculation will be the same time after time. With experience, you

will discard all calculation and use the electronic flash as a fill-in source simply by intuition.

This example is based on a flash-fill guide number of 160. Your equipment may vary, but the principle is the same. You can save future bother with calculations by taping a piece of paper to your flash unit with distances and apertures written out. The flash unit and full sunshine are constant factors, so the few calculations required can be made in advance. I use direct electronic flash fill only for photographing people or pets. If the subject is an architectural interior or a complex scene of many parts, I prefer to simulate ambient light by using reflectors or umbrella flash. Direct flash fill is a handy expedient, but it lacks lighting finesse.

A large diffuse reflector works best for simulating an added presence of ambient light. Because the reflector creates light that is diffuse and has a weak directional quality, it does not have to be extremely close to the lens axis as direct specular fill light. In fact, a desirable location for a white reflector is off to one side of the camera, on the same side as the key light. A reflecting panel placed in this location tends to add roundness to three-dimensional objects at the same time that it adds fill light.

A very handy and portable large diffuse reflector for location work is a 1.8 × 1.8 m (6′ × 6′) piece of white vinyl-covered cloth (referred to earlier). It easily fits in a gadget bag and a photographer should never be without it on location.

A flat umbrella works very well too. Its advantage is that it can be propped up and made semirigid, yet it is almost as portable as the white cloth reflector.

Bounced electronic flash off an umbrella is a good simulator of ambient light. It works best when placed directly behind the camera on the lens axis. (Don't worry, the camera will not cast a shadow on the subject because the umbrella is a diffuse source.)

For complex subjects, such as architectural interiors with sunlight coming in the windows, direct flash fill is seldom desirable. Instead, bounce the flash light off the ceiling or walls or white panels brought along for this purpose. However, even with today's modern, powerful electronic flash units, you may not achieve sufficient ambient light with bounced light.

Large blue flashbulbs are an ideal flash source. One or two tiny 22½-volt batteries is all the power needed to flash several lamps. Few electronic flash units deliver as much light as one #22B flashbulb. You can use two #22B bulbs for twice the light, or four for four times the light. In architectural interiors, with sunlight coming in the window, it is seldom that more than four #22B flash lamps bounced off the ceiling or white panels are needed for a sufficient level of ambient light.

Adding ambient light with bounced flash is a tricky exposure situation. My preference is to always determine exposure and lighting on the basis of an instant color picture test shot. Any other method offers calculation problems and other vagaries that are unacceptable considering all the time and trouble involved in achieving satisfactory lighting effects for professional work.

So far in controlling light ratio, we have emphasized the *addition* of ambient light. To decrease ambient light, remove light-reflecting panels or add black nonreflecting panels and use light sources that produce lower levels of ambient light. I have come to the conclusion that a black-ceilinged, black-walled studio has some merits worth considering. I mention this because many photographers work in white rooms with diffuse light. As we have seen, diffuse light creates a lot of ambient light and this can lead to flat, uninteresting lighting. However, if diffuse light, especially

transmitted diffuse light, is used in a dark room, you can achieve light ratios that are very high and which have the impact of strong specular light — but without the form-distorting, hard-edged shadows of specular light. Another advantage of having a black ceiling is the absence of annoying reflections off shiny surfaces. An advantage of a black wall as a background is that you can add precisely the amount of background light you desire. With a white wall as background, the addition of any background light is usually excessive.

Removing ambient light outdoors is not easily done. Nevertheless, it can be effective for increasing the contrast of lighting on a dull day or in open shade. This can be desirable for outdoor portraiture where the almost 1:1 light ratio of such light is too uninteresting. Black, flat umbrellas work very nicely to remove ambient light for a 2:1 or 4:1 light ratio for portraiture on a cloudy day. The photographer places the "minus reflector" to one side of the face and moves in until a sufficiently dark shading effect is produced.

Recently I've seen ads for a device constructed out of metal tubes and cloth which forms a large arch about ten feet wide, seven feet high, and three feet deep. A bit cumbersome perhaps, but you can insert black panels or translucent diffuse panels in the arch to control the local effects of natural daylight with a high degree of finesse in order to achieve effects in portraiture that can be achieved no other way. For example, you can obtain diffuse light on a subject with a controllable light ratio in full sunshine and on location without using direct electronic flash fill — a neat trick used with aplomb by visual artists of the Renaissance. Note how often they painted portraits of people outdoors in sunny landscapes where the illumination on the subject was diffuse. Nature doesn't work that way, but the visual effect is very appealing. This juxtaposition of diffuse and specular light was used by Leonardo in the "Mona Lisa" and by Raphael in the "Alba Madonna."

Control of Ambient Light by Exposure and Processing. Ambient light exists in almost all lighting situations. Its influence will be increased if the photographer exposes for it instead of exposing for the directly illuminated areas — a tactic which overexposes the directly illuminated areas in the scene. However, if the latter areas are small in proportion to the shaded ones, the loss of visual information is acceptable. This situation occurs outdoors when the sun is behind the subject; the face is in shadow, lit by the ambient light of the sky and nearby reflecting surfaces.

There are at least two pictorial advantages to this situation: the subject faces away from the bright sun, which reduces the problem of squinting; also, the subject is backlit and the rim of sunlight on the hair and shoulders creates visual separation between subject and background. This latter circumstance is enhanced when the background is relatively dark and out of focus, a situation that is easily produced using a telephoto lens with its limited angle of view. In fact, this whole procedure works so well that it is a technique *de rigueur* for almost all ordinary outdoor fashion photography. It is an excellent technique for any casual photograph of people outdoors because the results are usually pleasant and flattering. Introducing a reflecting panel, such as a flat umbrella or white cloth, adds a subtle sparkle to the eyes and skin, which bluish skylight sometimes fails to do.

When you can control film processing (as with black-and-white films), the influence of ambient light can be increased further. The reason is that

lowered processing contrast compensates for excessive lighting contrast. The film is custom-processed so that its density range fits the limits of tone reproduction in the photographic print. It is the seasoned maxim followed by photographers for generations, namely: Expose for the shadows and develop for the highlights. Reduction of film development can be precisely determined by using the Contrast Control Nomographs provided in the publication *Kodak Professional Black-and-White Films, F-5.*

I have found that rating the film speed at half the manufacturer's recommendation, exposing for the shadows if they occupy an important area of the scene, and developing the film for .7 times (70%) the manufacturer's recommendations produces an excellent result for a wide range of subjects, especially with roll film. I prefer Developers D-76 or HC-110 for this technique. (This applies to such black-and-white films as Kodak Tri-X Pan and Plus-X Pan.)

With color transparency materials, such as Kodak Ektachrome Films, time in the first developer can be lessened for reduced contrast; this lowers film speed and alters color balance. Make tests to determine the best procedure. However, this procedure is somewhat esoteric because transparencies usually show a greater tonal range than prints. Color negative materials can be masked for contrast control in printing. This sounds complicated but is really a simple, canned procedure. To do it, place the negative and panchromatic masking film base to base for exposure of the mask. The mask becomes fuzzy and out of focus. When processed and dried, place it in register (easily done because the out-of-focus mask does not require extreme precision of register) with the color negative and print as a sandwich.

If you are disinclined to darkroom procedures such as this, but use color negative film, you can control film contrast by choosing different films: Kodak Vericolor II Professional Film, Type S, a lower contrast color negative film, and Kodak Vericolor II Professional Film, Type L, a higher contrast color negative film. Each works very well in light of opposite color balance if you use a color-conversion filter.

Control of ambient light by processing has its limits. If contrast reduction is carried too far, the entire image will look flat and lifeless. Conversely, processing to an excessive contrast limits full tonal reproduction such that the result looks chemical rather than natural. Do not expect processing to correct all total contrast problems.

CONTROL OF LOCAL CONTRAST

Local contrast — the awareness of adjacent tones — is primarily controlled by the formative qualities of light. Processing and exposure alterations do little to enhance local contrast effects if light hasn't first revealed them. Some photographers will vehemently contest this viewpoint and will spend hours in the darkroom making one print to prove it.

Local contrast quality begins with the subject. For example, a stiff bristle brush will photograph with good local contrast even in a snowstorm; so will a checkerboard or a clown's face. But many subjects lack inherent local contrast and the only way to photographically capture all their subtle tones is to meticulously record them on 8″ × 10″ film. This technique produces the most exquisite image that photography can produce, but it is obviously not the answer to every visual communication problem.

The photographer must enhance local contrast quality of lighting in the following instances: when

he uses a smaller-format camera and the subject is not bold or colorful; when the final reproduction of the photograph will be degraded compared to the original; when photographing products for sales purposes; and when he merely wishes to produce an image with greater visual information. Extremely vivid local contrast effects are a technical challenge to the photographer; the photographic image evolves all at once, not piecemeal as in painting. Consequently, in photography it is difficult to exert individualized control over local areas. When great local contrast is achieved, there is often a surrealistic feeling — a *trompe-l'oeil,* or trick of the eye — because the viewer sees more in the photograph than the eye expects to see.

Light Qualities and Local Contrast of Light. Directional influence of light is the most important single control of local contrast of lighting. When directional influence is strong, tiny adjacent shadows caused by textured surfaces are revealed, as are small undulations of form and textural differences. Objects are visually set apart — big ones as well as tiny ones. It's not simply a matter of obvious tonal differences, but that the differences which might otherwise be invisible are rendered visible.

The directional influence of a light source on local contrast is strongly affected by the specularity or diffuseness of the source. However, the effects are not quite as simple as one might suspect.

Specularity enhances the local contrast effects of directional light because specular shadows have sharply defined edges. But this enhancement is effective only on flat surfaces. Because specular quality light is produced by a point source or a columnated beam of light, its rays are tangent to only a small surface area on rounded objects.

Specularity does not enhance the local contrast effects of directional light on rounded surfaces; it doesn't fall on enough of the surface to do any good.

Diffuseness reduces the local contrast effects of light because diffuse shadows have nebulous, undefined edges. However, when directional diffuse light falls on rounded surfaces, it affects a much larger surface area than specular light. Because it falls on a much larger surface area, directional diffuse light has a potential advantage over specular light for local contrast effects which can be realized if the total contrast of the illumination (light ratio) is very high.

The effects of specularity and diffuseness are as follows: specular quality light enhances local contrast only on flat surfaces. Diffuse quality light reduces local contrast on all surfaces unless the total contrast (light ratio) is very high. When the light ratio is high, contrasty directional diffuse light is the best choice for high local contrast on a variety of surfaces.

High total contrast enhances the local contrast effects of diffuse light but does not always do so for specular light. Because specular light has sharp shadows, a high total contrast may be excessive for good local contrast. Specular light works best at low light ratios while diffuse light works best at high light ratios for good local contrast effects.

The other qualities of light play a role in local contrast too. Color differentiation between light and shade enhances local contrast. You can see this in the winter when blue shadows are seen in juxtaposition with more neutral sunshine highlights in the texture of snowdrifts. It is also achieved with artificial light when ambient illumination is slightly colored compared to the direct light. In photomicroscopy, color differentiation is strongly stated when you use Rheinberg illumination. Painters

often use color for local contrast in the textural application of pigments.

Because of the complexities of controlling local contrast, the photographer can exert more control by using several light sources, especially if specular quality lights are used. Today, with the penchant for using a single, large diffuse source for most studio work, some photographers may be unaware of the complex multiple-source lighting schemes of the past. Edward Steichen's *A Life in Photography* reveals many superb examples of this lighting technique. Certainly the studio photographer has the greatest potential lighting control over local contrast quality.

But we said that direction influence is the single most important control over local contrast. Even using one light source, or carefully observing available light for direction quality, will provide great control over local contrast. Those who have done this superbly over the years include W. Eugene Smith, Alfred Eisenstaedt, and Ansel Adams. These photographers have a knack for producing excellent local contrast in their images even though they generally do not work in the studio and use only available or natural light.

Local Contrast and Photographic Materials and Processes. Local contrast quality of light can be thought of as part of the tone reproduction process itself. Therefore, it is important to discuss photographic materials and processes.

Local contrast quality influences the tiniest portions of the photographic image. Consequently, elements that degrade the photographic image degrade this light quality too. Unsharpness is the biggest offender, and the main problem — aside from a photographer's poor eyesight — is camera movement. Having lived through the inception of electronic flash, it was interesting to me to note how photographers were awed by gains in sharpness when they used this illumination source. The obvious reason was that the speed of the flash eliminated casual camera movement. There are some who can get crisp images at slow shutter speeds, but this takes concentration and a degree of luck. When I use a handheld camera at slow shutter speeds, I often bracket for sharpness by exposing several frames for a given subject.

A larger-format film enhances local contrast quality effects, but only if you can get adequate focus in all the important parts of the image. If this is impossible because of depth of field or other limitations, then use a smaller format. The miniature films manufactured today are miracles of precision, and smaller-format cameras will always outperform larger ones if, for whatever technical reasons, you are unable to achieve adequate depth-of-field sharpness with the larger-format camera.

Lens flare is another technical bugaboo. With modern lens coating, lens flare is deemed an irrelevant technical factor. This is nonsense. Flare degrades shadow detail and reproduction of shadow detail is always less than desired because it falls on the toe of the film's characteristic curve and on the shoulder of the print's characteristic curve. Shadow areas need all the help they can get for adequate tonal separation, and removal of even tiny amounts of lens flare is helpful. I always use an adjustable bellows lens hood for telephoto and normal lenses. With wide-angle lenses, the flare factor is less of a problem because the great angle of view seldom includes large shadow areas.

The sharpness difference (with black-and-white films) between a diffusion and a condenser-type enlarger is also a factor. I prefer the condenser type even though dust may be a problem. However, if the

photographer is meticulous enough to demand maximum sharpness, he should be prepared to work cleanly and handle negatives with respect.

Photographic materials and processes play a significant role in photography's reproduction of the local contrast effects of lighting. Many of these influences may disappear when the photograph is reproduced on the printed page, and this book is proof. But the original photograph, when it is the culmination of impeccable craftsmanship, is an object of exquisite precision that is quite capable of recording all the care lavished in its creation.

CONTROL OF BRIGHTNESS QUALITY

THE MANY SIDES OF BRIGHTNESS CONTROL

Brightness control involves more than the use of a light meter; it involves decisions about overall and local effects as well as brightness key. Overall brightness quality is controlled by appropriate use of a light meter and, sometimes, by adjustment of the illumination. Local brightness quality control involves decisions about pictorial emphasis — which parts of the scene are to be shaded and which are to be illuminated. Absence of light is as significant as its presence. Brightness key control is a decision concerning the preponderance of tones in the scene — should there be a preponderance of light or dark tones? This control permits the photograph to convey visual and emotional commentary about brightness level.

OVERALL BRIGHTNESS CONTROL.

Brightness measurement and exposure control are essential elements in the control of the brightness quality of light because there is a direct relationship between brightness and photographic response.

Historically, exposure control was one of the most bothersome technical problems in photography. There were so many uncharted variables that techniques for exposure control assumed an arcane aura of alchemy. All that has changed. Today, we have dependable film emulsions with meaningful film speeds. We have easy-to-use, reliable light meters and even fully automated in-camera metering systems. A novice photographer can readily acquire the technical rudiments of brightness measurement and exposure control.

In discussing this topic, I do not wish to rehash technical trivia. It is my hope that the controls mentioned here will help simplify your approach to exposure control, and that you will recognize that exposure control is only *one* element in the control of brightness quality of light.

Light Meters. These measure brightness by measuring the illumination falling on the meter from the light source (incident type) or by measuring the light reflected off the subject (reflected type).

An incident-light meter assumes the subject to be of "average" reflectance—the standard used is 18% reflectance. Its reading is based solely on changes in the illumination and not on changes in the subject. Such readings are useful for determining light ratio and assessing the general brightness of the illumination.

Conversely, a reflected-light meter measures the light reflected off the area of the subject that is being metered. This information provides exposure data

which results in a standard photographic response to the area that was metered. A reflected-light meter is useful for assessing the general brightness of the subject. A reflected-light meter with a relatively narrow angle of acceptance, coupled with an accurate viewfinder for aiming, can be used to measure small significant areas in the scene. These readings are useful for determining the brightness range of the scene.

It is worth noting that an incident-light meter assumes a standard subject whereas a reflected-light meter provides a standard response (for a given reading). There are two schools of thought on which type of meter is best. There are those who say that if a subject is lighter or darker than average, it should be recorded as such (incident) whereas others say that the average subject concept can result in exposure information beyond the capacity of the film to record and, therefore, a standard response is best (reflected).

Each view can be justified by specific situations and examples, and my preference is for a meter incorporating both methods of measurement. It is my experience that either method is satisfactory in a majority of situations.

Built-in camera metering systems are of the reflected type. Usually these are center-weighted so that metering response will provide, statistically, a high percentage of acceptable results. I prefer an in-camera system that allows manual control. Being old-fashioned, I tend to look with suspicion on automated machinery, although I will also admit that those automated systems which I used have performed commendably in most situations.

Using Light Meters. Reasonable use of any light meter system will produce generally acceptable results. Certainly, the most important consideration is to use a method that rewards your individual habits with dependable and repeatable results. Careful use of a reliable meter is better than a constant search for a "more accurate" system. As a working professional, I face the practical necessity of getting results, regardless of variables. For this reason, I relate exposure control to the type of film being used. If it is a reversal film, such as Kodachrome or Kodak Ektachrome Films, I bracket my exposures with two half-stop variations. When this is impossible, I bias the exposure information toward slight underexposure. Conversely, with negative film, such as Kodak Tri-X Pan or Vericolor Films, I tend toward modest overexposure—up to one stop. Thus with reversal materials I want to avoid overexposure, and with negative materials I want to avoid underexposure.

These methods assure me a high percentage of usable visual information at the slight risk of giving up a little bit of additional visual information obtainable with aim-point exposure perfection. When these tactics are applied with finesse, I can nearly eliminate loss of good images due to gross exposure errors.

There is an additional desirable feature in bracketing exposures with reversal film. Because there are times when our own best judgment is not sufficient to anticipate all the variables of recording brightness quality, by bracketing exposures with reversal films, the photographer can often record lovely, unforeseen brightness quality relationships.

Because photography is an action art, I prefer to use more film at the time of the photographic event and to defer some of the control to the leisure of selection at the editing stage or in the darkroom. This is an attitude not shared by all photographers, some of whom prefer a more disciplined approach to control, feeling that a greater integrity is

maintained between the photographer and the subject. As you gain experience, you will probably come to accept the attitude most compatible to your own manner of visual communication. However, this is not to advocate sloppiness. Bracketing exposures can become an unrestrained expedient instead of a useful control.

In summary, my approach to brightness measurement and exposure control is to spend less effort at achieving aim-point perfection so that more energy is available for the other demands of good visual communication.

Effect of Brightness Measurement on Brightness Quality. To visually communicate information about the brightness quality of light, the photographer must be prepared to deviate from standardized technical considerations. Individualized control over film response to brightness is a useful means for conveying visual feelings about brightness quality and light. Two photographs in the control section ("The Street in Isfahan," page 183) convey what I mean.

One photograph is technically correct while the other is more emotionally appropriate. One has a full tonal scale while the tonal scale on the other is limited. One depicts literal details of the scene while the other conveys visual feelings about heat, dryness, and blinding solar ambience. The only difference between the two is photographic interpretation of the brightness quality of the light.

The control applied in these photographs is reduced print exposure because the original film was a negative. However, the same visual logic would apply to camera exposure if the original film were reversal material. (In this case, you would use more exposure for the lighter image. An incident-meter reading would likely produce such a result

because the largest area in this scene is much lighter than the 18% standard reflectance for which all incident meters are calibrated.)

Brightness Adjustment of the Illumination. It is normal in photography to adjust exposure to the overall brightness of the illumination. Yet there are times when the reverse must be applied—when brightness of the illumination must be adjusted toward a given level of exposure; in other words, the overall brightness of the illumination must be increased or decreased for technical reasons. With today's fast, fine-grained films and miniature cameras, an increase in the overall brightness illumination in a scene may seem an anachronistic control. Not so. There will always be situations when the photographer will need a small lens aperture (for increased depth of field and sharpness) while maintaining a short exposure time. Some examples are: cinematography, where shutter speed is a constant factor; action photography; and carefully rendered illustrations of human activity occurring within a sharply defined environment. An example of the latter is advertising illustration where spontaneity and overall crisp detail are required simultaneously.

There are many ways to increase the overall brightness of the illumination. The most obvious solution is to simply switch on more lights. It is also the worst. Adding more lights always changes the other five light qualities. Thus in solving one problem the photographer creates five new ones. Sometimes the brightness of the illumination must be decreased. The controls here are equally important to understand so as not to become ensnarled with unwanted problems.

Before examining brightness adjustment, three points should be made relative to these controls:

First, we will assume that the existing light quality relationships are good. We merely want to change brightness without altering the other five light qualities. Second, artificial light sources are more amenable to overall brightness adjustment than natural light; hence most of what is said will relate to artificial light sources. Third, brightness adjustment for diffuse or specular illumination involves different techniques because the light and shade relationships caused by each quality of light are distinctly different. For this reason, we will consider total brightness adjustment with specular and diffuse light as separate topics.

Increasing Brightness of Specular Illumination.
Amplification. The best method for control is to amplify or brighten the light output of the existing source, thus increasing its illumination on the subject. Electronic flash illumination is readily amplified if more power can be directed to the flash lamp. This is easily achieved with the more expensive electronic flash units. More power can be directed to the light by merely flipping a power-control switch or by adding more power capacity with additional condensers. The more sophisticated electronic light sources are unique in their built-in ability to amplify their output. The only solution for increasing the brightness in a simpler electronic flash unit without built-in amplification ability is to substitute a more powerful unit for the weaker one.

Studio-type electronic flash units offer unique advantages in controlling amplification of the light source. This is the main reason why professional photographers are willing to invest so much money in them. Electronic flash is the standard source of illumination in many professional photographic studios. (In fact, I often use electronic flash for still-lifes because there are fewer color balance and exposure problems compared to long exposures with incandescent sources.)

Flashbulbs are not as commonly used now, but their increase in brightness through a range of bulb size classifications is handy for solving brightness adjustment problems. For example, compared to a tiny AG-1B, an M3B is 1½ stops brighter; a #11B or #40B, two stops brighter; a #2B or #22B, more than three stops brighter; and a #3B or #50B, more than four stops brighter. Flashbulbs still offer the most light for the least power of any artificial light source and their portability for location work is unmatched.

When the illumination is incandescent light, more powerful globes or fixtures can be substituted for weaker ones. Remember, however, that incandescent lamps normally change color when their brightness is changed electrically. If color balance is important, be sure to note the rated Kelvin temperature of the stronger source compared to the weaker one so that compensation can be made.

Sometimes a more efficient reflector—one that allows less light to be lost by light scattering—can be substituted for an existing one. It can add about one stop more light output than a less efficient unit.

Safe electrical practice is mandatory in all these amplification procedures.

Other Methods for Increasing Brightness of Specular Illumination. Further increases in the overall brightness of specular illumination may require some light quality trade-offs. Light sources can be moved closer to the subject. Depending on the original distance, this can be effective with specular sources. The light increase occurs because specular light sources follow with reasonable accuracy the inverse-square law of illumination which states that illumination increases or decreases

by the square of the distance between the source and the subject. Moving a specular source from 6.1 metres (20 feet) to 4.6 metres (15 feet) will double the illumination; from 6.1 metres (20 feet) to 3 metres (10 feet) will quadruple it (two stops).

But the inverse-square law is a good-news - bad-news influence. The trouble is that the part of the subject closest to the light source increases in brightness at a greater rate than the part farthest away. The result is an unevenness of illumination which tends to draw attention to itself. As a rule of thumb, when the light source is closer than five to six times the width of the subject being illuminated, the unevenness becomes apparent — perhaps not to an untrained eye, but it will record disturbingly well in the photographic image. Therefore, moving a specular light closer to the subject provides only a limited useful increase in brightness.

Another means for increasing overall brightness is to increase the ambient light level. This will reduce the contrast quality, but in many cases this is an acceptable or even desirable situation. An increase of ambient light level effectively increases the relative brightness because increased ambient light lightens the shadows. Adequate exposure, as defined by ANSI, means adequate detail in the shadows. So an increase in the brightness of the shadows effectively produces an overall increase in brightness of the illumination. For example, a given lighting plan can be increased in overall brightness if the light ratio is lowered. In terms of exposure detail in the shadow areas, a 4:1 light ratio lowered to a 2:1 light ratio will effectively provide one stop more light. The original light and shade relationship will remain intact except that the contrast of the illumination is lower. This is possible because ambient light by definition does not produce a conflicting light and shade relationship.

One way to increase ambient light is to move large white reflectors close to the subject in such a way that they bounce additional light into the shadows. Remember the angle of incidence equals the angle of reflectance law when arranging the reflectors. When the subject is backlit, place the reflectors in an upright position near the camera. When the subject is more or less frontlighted, the reflectors must be judiciously angled or placed on the ground. If the bounced light from these reflectors is insufficient, they can be made brighter by bouncing secondary illumination off them. This increases the ambient illumination very nicely.

Until the advent of more modern film technology and improved lighting and camera equipment beginning around the 1950s, it was quite common to increase overall brightness by adding more lights. In some cases, it was the only solution. We tend to forget the formidable technical problems of using only slow films with large-format cameras. Powerful electronic flash had not yet been invented and small-format cameras with fast lenses were seldom employed because excessive grain prevented the full, detailed enlargements that we take for granted today.

Increasing the overall brightness by means of many specular light sources is still done occasionally — in cinematography and in lighting large interiors, for example. This procedure requires finesse and style to be effective. Start by lighting only what is important and leave the rest in shadow. Thus each light source is given only a small area to illuminate, which greatly increases the brightness efficiency of each light. Then, if you have enough lights and power at your disposal, add extra lights to selectively illuminate shadow areas. Finally, you can add accent lights to enhance the brightness of areas already illuminated. Gradually, the scene is

illuminated to maximum brightness. The result must simulate the effects of the normal influences of available artificial light.

Beginners are often startled to see movie sets using giant spotlights, strategically located, simulating normal artificial-light situations; they find it difficult to perceive that such apparent overt lighting control can be very effective at raising brightness level without destroying illusions of normalcy. Once the frame of reference is restricted to the camera angle of view, however, the illusion of normalcy can become quite effective indeed.

Always bear in mind an appropriate illusion and the fact that the areas of lighting responsibility should not overlap in a disturbing manner.

Multiple lighting setups for increased brightness with specular quality light are used frequently for lighting movie sets and large interiors for still photography. It is also a technique used for theatrical illumination. For a more complete examination of the techniques of multiple-source lighting, refer to the sections on "Direction Quality," "Local Brightness Quality," and "Local Contrast Quality."

Increasing Brightness of Diffuse Illumination. *Amplification.* As with specular illumination, amplification also works best with diffuse illumination. If the diffusing material remains unaltered, more lights can be added behind the diffusing material without influencing the other five light qualities. For example, if one lamp is used behind a 1.2 × 1.2 m (4′ × 4′) translucent diffusion screen, three more lamps can be added to quadruple the light output. Because the screen remains unaltered, the other five light qualities remain unaffected. This is a form of amplification because the diffusion screen is large enough to physically allow the

addition of more lamps, even dozens, if there is enough room.

When the diffuse source is bounced light instead of transmitted light, adding more lights becomes more complicated. For one thing, all the lamps, cords, and reflectors get in the way between the subject and the illumination. For another, bounced light automatically creates a lot of ambient light, and adding more lights further reduces contrast. This can be a problem with bounced diffuse light because it is inherently a low-contrast light source.

Other Methods for Increasing Brightness of Diffuse Sources. Ambient light level can be raised, as with specular light, for instance. But diffuse light is usually rather low in contrast, especially bounced diffuse light. Further increase of ambient light, especially with bounced diffuse light, seriously reduces contrast and weakens direction quality. The photographer cannot count on more than one stop added brightness when the technique of increased ambient light is applied to diffuse illumination. Moving the light closer will not do much either. Diffuse light does not follow the inverse-square law. A large source, moved closer, does little to increase brightness—usually less than ½ stop in most normal studio conditions.

(There is a useful feature here, however. The good-news - bad-news feature of specular light doesn't occur—therefore the bad news of uneven illumination doesn't show up. The useful feature is that the relative size of the source can be greatly increased without adverse affect. A very large diffuse source tends to wrap its light around the objects it illuminates, creating a lovely form-enhancing illumination.)

In summary, both specular and diffuse illumination can be made brighter without adversely

affecting the other five light qualities. But specular light requires more care than diffuse light, because the specular light and shade relationship is more precisely defined. Brightness should be increased by amplification whenever possible because this control does not influence the other five light qualities.

Decreasing Brightness of Specular and Diffuse Illumination. While this is not a common lighting problem, it must be controlled in a way that does not affect the other five light qualities. The simplest solution is to use a neutral density (N.D.) filter over the lens. These are supplied in specific densities, noted with appropriate logarithmic numbers. A .3 N.D. will reduce light by one stop; .6 N.D., two stops; .9 N.D., three stops; and so on. There are neutral density filters available that can reduce light by as much as ten stops—3.0. However, these denser filters tend to reduce image sharpness while adding yellowish coloration. The practical limit, in my experience, is a neutral density of 1.5. This produces a five-stop reduction in brightness when used over the camera lens.

Other filters, such as pola-screens and color-contrast filters, reduce brightness selectively. Thus they cannot be considered as a tool for overall brightness adjustment.

With specular light, the photographer needs only to move the source farther away to decrease brightness, following the logic of the inverse-square law of illumination. This is a very effective control for specular sources though not for diffuse ones. First of all, diffuse sources do not follow the inverse-square law and thus do not diminish in intensity as the distance increases. And, more importantly, once a diffuse source is moved far enough to begin to reduce its brightness, it is effectively changed into a specular source.

Rheostats are another method of reducing brightness, especially with incandescent lamps. However, this electrical control greatly increases the yellow color of the light and is not a useful photographic control unless black-and-white film is used.

Many small electronic flash units come with "diffusers" to reduce brightness for certain flash-fill situations or for use with wide-angle lenses. These diffusers do not create diffuse light because they are no larger than the source itself. What they do is to reduce brightness (usually by one stop), and remove the illumination hot spot generally present in the light beam. (The hot spot is quite apparent when using wide-angle lenses because they see all of the light beam—not just the center portion as would be the case with a normal or longer-focal-length lens.)

An inexpensive expedient for reducing brightness of a small electronic flash, or regular flash, is to cover it with the thickness of one handkerchief, usually resulting in one stop less light.

LOCAL BRIGHTNESS CONTROL

This is an extremely useful lighting technique. Controlling the brightness of specific areas in a scene allows the photographer to place visual emphasis where he wants it. This is accomplished by shading certain areas to make them less bright and less prominent, and/or by adding secondary light sources and reflectors in other areas to make these more prominent. Local brightness control is used in almost all studio photography. It can also be used in natural-light and available-light photography, as we shall see.

Controlling Local Brightness and Visual Emphasis. Local brightness control is used to embellish the effects of a given lighting plan and to direct the

viewer's attention to some areas and not to others.

Here the absence of light is visually just as significant as its presence; secondary light sources and shading devices play equal roles. This manipulation of light and shade functions best when it does not draw attention to itself; it should blend into the lighting plan as if it were an expected result of that plan. If the local brightness control draws attention to itself, there is a tendency toward visual confusion.

Because we are altering the light and shade relationship, specular-diffuse qualities also play a significant role: hard-edged specular illumination and shadows draw attention to themselves; nebulous diffuse illumination and shadows defer to the existing lighting plan and do not attract attention. Consequently, diffuse secondary sources and soft-edged shadows work best for local brightness control.

There are times, however, when specular light is useful for local brightness control. If in the scene the areas which need control have a definite shape, and the light is to be confined to that specific local area, only a specular light source or hard-edged shading will work. In this situation, a photographer often uses optical spotlights because of their precise light beams.

The direction quality of secondary sources and shading devices plays an important role too. An understanding of the angle of incidence equals the angle of reflectance law helps to predict optimum local brightness effects. Because the lighting and shading devices must be moved carefully, it helps to have an assistant make the adjustment while the photographer watches from the camera viewpoint. If this is impossible, placing a mirror directly in front of the camera lens enables the photographer to see effects while moving a secondary light source or shading device.

There are times when local brightness control can be intricate and extensive. This usually occurs when photographing objects for advertising purposes. Here every fragment has sales interest because the photograph is intended as a substitute for reality. Sometimes a studio set for advertising illustration may contain a forest of secondary lighting sources, reflectors, and shading devices. Yet even here the finished result must look as if no obvious local brightness control was exercised so that the viewer's attention remains on the product and not on the lighting effects.

Local brightness control is primarily the province of the studio photographer, but the possibilities should not be ignored in natural-light and existing-light situations. For a landscape photographer, the judicious shading of a passing cloud can often be worth a very long wait. In an existing-light situation, it is often possible to wait for natural shading effects to occur, to search for different vantage points that may produce them, or to perform such simple shading tasks as opening or closing doors and window shades or asking an assistant to hold a shading device to affect a given area. Of course, in many natural-light and available-light situations, the photographer must forego even these simple techniques. Here a different approach for control is required.

Local Brightness Control in the Darkroom. When local brightness control is impossible, or when it would be disruptive during actual photography, the effects can often be achieved during printing. Anyone who has made an enlargement using dodging and burning techniques realizes this. There are many good reasons for deferring local brightness control until the darkroom: the action may be too spontaneous and capricious; perhaps the local

area requiring control is inaccessible; or the local control of brightness may be so disruptive during photography that it adversely alters the authentic milieu. This is of special concern to the photojournalist, the landscape photographer, the candid photographer, and others.

However, local brightness control in the darkroom is impossible if the visual information is not on the negative in the first place; areas devoid of detail cannot be controlled. The negative must have sufficient exposure so that there is full visual information in the shadows, and the negative must not be overdeveloped so that the light areas are not recorded as intolerably dense. A negative that has been exposed for the shadows and developed for the highlights is ideal for darkroom manipulation of local brightness quality.

Lighting Tools for Local Brightness Control.
Secondary light sources range from optical spotlights to white paper reflectors in brightness efficiency. However, the control a photographer seeks is not intensity but precision of effect. There are many ways to achieve this, each photographer usually having developed his own special techniques and tricks.

Among the commercially available secondary light sources, there are several brands of mini-spots. These usually contain 150-watt lamps which are movable within the spotlight for wide or narrow angle light beam control. All use a Fresnel lens to focus the light beam and most have adapters to further concentrate the beam.

Barn doors — four hinged doors that attach at the front of the mini-spot — are helpful in restricting the light beam. More precise control can be achieved by using various sized snoots instead. These are metal tubes of varying diameters which

further restrict the light beam into a narrower column of light.

To make the light beam even more precise, some spotlights have an optical snoot as an accessory. The snoot is a metal tube with a lens system so that the columnated light beam is rendered optically precise. Usually, such an optical snoot has a slot located in the tube so that masks can be inserted to more precisely alter the shape of the light beam as it falls on the subject. The photographer can envision a mask of any shape or configuration to enable the light beam to precisely fall on a given area with no spill whatsoever. Despite the precision, it is not a cure-all because such a light source is highly specular. Its specular nature is not compatible when the surface to be illuminated is itself highly specular or when the area to be illuminated has no inherent geographical boundary.

Balcar, a French manufacturer, makes a very good lighting device incorporating these features including a built-in electronic flash lamp. It is one of the few studio lighting devices for electronic flash that is so versatile.

An interesting local brightness illusion can be achieved by shining an optical spot onto a framed painting or photograph. When the light is so directed that the photograph is illuminated, but not the frame around it, the image appears to be a transparency because the whites in it are lighter than the surround. Such a lighting effect is especially effective in displaying framed photographs in a reception room or an exhibit hall.

Another commercially available light source has an iris diaphragm attached to the front of the source which allows brightness control over a very wide range — a useful adjustment for local brightness control.

A clever adapter distributed by Norman Enter-

prises, Inc., of Burbank, California 91505, adjusts light intensity from one stop loss, through a range of several stops, until the light is finally shut off altogether. It consists of two circular movable parts joined at a center pivot. Each part has three pie-shaped openings of equal size and of such dimension that the area is half open and half closed. When one part is rotated against the other, the pie-shaped openings decrease equally in size until they close completely.

Brightness can also be adjusted by using metallic window screen or spun glass. These are discussed later under "Shading Devices."

Almost as important as the light sources themselves is a versatile light stand on which to put the source. A simple roll-around, adjustable-post stand is not as useful as one that has one or more adjustable arms of about three feet long. These arms permit the photographer to cantilever the light into the set, closer to the area he wishes to illuminate. This is an extremely handy feature for local control.

Other local brightness light sources are merely various light-reflecting materials. White cardboard reflects diffused light. Its local brightness influence can be adjusted by choosing the size and shape of the reflecting card. Greater brightness can be achieved with aluminized cardboard, available at most art supply stores and in large rolls from most photographic supply houses that stock seamless background paper. The brightest reflector is a mirror. An ordinary frameless glass mirror works best. Small mirrors are very handy for local brightness control problems. I prefer using thin 25 × 76 mm (1″ × 3″) or 76 × 152 mm (3″ × 6″) glass mirrors. If these are not exactly right, I can cover portions with black tape to achieve the proper reflecting influence.

Small reflecting surfaces generally provide ample local illumination if they can be placed strategically in and around the area being photographed. For example, if several objects are being photographed, reflectors can be hidden behind them to lighten dark shadow pockets. A favorite trick in photographing liquid in a container, such as beer in a glass, is to place a small reflector behind the glass to reflect light into the liquid, thus making it look more luminous and thirst-quenching. Light-reflecting panels often must be suspended over the subject to get top-surface reflections. In such situations, a multi-armed supporting stand, such as the Century Stand with a double arm head assembly made by Mole-Richardson, is extremely handy.

In certain circumstances, these light-reflecting cards and mirrors may not reflect enough light. When this happens, the solution is to bounce extra light off them. Small secondary spots on a boom stand serve this function very nicely.

Why not direct the small source directly onto the subject? Generally, this adds far too much light and its influence is extremely specular. Small reflectors simulate added ambient light but small spotlights, with their direct beams of specular light, usually draw unwanted attention to themselves.

In adding small secondary sources or reflectors for local brightness control, remember that they cannot remove undesirable shadows in the scene — a common misconception. A light and shade effect, once established, is almost impossible to erase and can never be removed without excessive and unwanted lighting influences. Awkward shadows can never be removed; they must be avoided in the first place.

Shading Devices. These are equally important for local brightness control. They reduce illumination brightness in a selected area by shading it or by

reducing the actual intensity of a given light source affecting that area. Shading devices can be either opaque or semi-opaque. Opaque devices remove the illumination from a given light source completely, but the effect on the subject may not result in a completely black shadow. The reason is that existing ambient light and the influence on the area of secondary illumination add their effects.

An opaque shading device tends to produce a sharper-edged shadow than a semi-opaque one. For this reason, open-weave, black-fabric "scrims" are handy shading devices. These are available from motion picture lighting supply houses. A less expensive version can be constructed out of stiff metal screen, available from hardware stores. The screen can be cut into various sizes and shapes too. The screening material does not have to be a fine weave. A screen with about 3.175 mm ($\frac{1}{8}''$) mesh reduces light about $\frac{1}{2}$ stop. If more reduction is desired, place two or more thicknesses of wire mesh together. Again, as with secondary light sources, a suitable stand is very handy to enable the photographer to cantilever such shading devices over the subject if necessary. Self-supporting opaque black screens of about 1.82 - 2.43 m (6 - 8 feet) tall are also useful in the studio. They are handy for shading parts of the scene and also for reducing ambient light to increase lighting contrast.

Another more exotic means for local brightness control is to use selective sized and shaped neutral density filters directly in front of the lens. Usually, these are strategically located and sandwiched between two sheets of thin, flat glass and placed in a supporting device directly in front of the lens. The edges of the neutral density filters are rendered out of focus because they are so close to the lens; generally, the photographer needs to make test shots to see the precise effect, because at smaller

f-stops he cannot see the exact result on the camera ground glass. The advantage of this exotic method for local brightness control is that it can be used outdoors in natural light where local shading may not be possible unless a cloud comes along at the right time.

Speaking of clouds, their use as shading devices outdoors in landscape photography should not be overlooked. On a day when clouds are moving across the sky, skillful timing can produce effective local brightness control.

With black-and-white film, the tonal rendering of colored objects and surfaces can be controlled by selective use of strongly colored filters that absorb complementary colored light. Red filters strongly darken blue skies, green filters lighten green foliage, blue filters increase atmospheric effects and lighten the sky. With either black-and-white or color film, a pola-screen will exert some local brightness control. Glare caused by polarized light is removed and the surface colorization is strengthened, or glare on transparent surfaces is removed, making it possible to see through them. I seldom use a pola-screen because the effect is usually unnatural. The one exception is in photographing flat copy or artwork. Here glare is unnatural and must be avoided. A pola-screen on the lens coupled with acetate pola-screens in front of the lights is a wise idea.

Consideration for Object Surfaces. Local brightness control is affected by the nature of the surface being influenced. We have already alluded to this, but it is worth emphasizing. Specular surfaces generally require local brightness control by means of a diffuse source because a specular source may be reflected as a bright pinpoint of light. Some discretion must be used in applying this rule; for example, specular light reflected off the rippling

surface of water gives visual evidence to that fact while the influence of diffuse light would not reveal the same visual information. But to add local brightness to the specular surface of a shiny plastic object, the only recourse is to use white diffuse cards to supply the illumination that will be reflected off those mirrored surfaces. Conversely, diffuse surfaces often favor the local illumination effects of specular light because this shows off the surface texture. An ice cream cone looks tastier under the local effects of specular light, for example.

How Much Local Brightness Control? Controlling local brightness for visual emphasis is based on a process of selection: What areas are important and what areas are less relevant? If the intent is merely to convey the maximum amount of visual information, the answer is generally self-evident. However, if it is to selectively convey a visual message, the answer is less obvious, because in some cases less is more.

The point I'm making here is that lighting cannot be judged solely by some idealized standard. In many situations, the choice of a local brightness control standard depends entirely on the visual message of the photograph. If the message is clear, the lighting is playing its proper role. If the message is unclear, the lighting technique may be at fault. There is seldom a self-evident answer to the question of how much local brightness control, but when in doubt, exert less rather than more control.

Local Brightness Control and Imagination. This book has shown how to evaluate the effects of light and how to control it. For the most part, we have taken the position of analyzing and utilizing one light source inasmuch as a single source can be a very effective lighting tool. However, control can be extended when the photographer uses several light sources. Carried to a logical extreme, light can be applied almost tone by tone as a painter applies paint stroke by stroke. This is the area of local brightness control and imagination. It is an artificial situation, unnatural, and one that often has a theatrical flair. Yet this is part of the visual message. Control is not camouflaged or integrated into an existing light relationship; it is made self-evident and its evidence is proof that the photographer intended to create a new environment.

This form of local brightness control is typically applied with multiple-source lighting techniques. Many fine examples exist in photography done in the twenties, thirties, and forties using tungsten spots and floods. See also the section titled "Direction Quality with More Than One Light." The control principles mentioned there and those noted in this section under "Local Brightness Control for Visual Emphasis" are also applicable to this topic. The emphasis at this point is on the intent of the lighting plan.

In this situation, local brightness control is the subject, manipulation of light the message, and the six qualities of light the molding tools for a unique light and shade relationship. Consider each of the six qualities of light and utilize individual light sources to convey them. Whatever the subject matter, it will be transformed by local brightness control into your own individualized interpretation.

Using local brightness control to create a new visual environment is much like writing a book. First you pick a subject to illustrate and then conceive a plan for presentation. The plan takes shape step by step. As it evolves, it becomes evident that some initial ideas will not work while new ones present themselves. In fact, the conceptual technique is the same as that applied to any form of

communication which is assembled step by step. Therefore, using local brightness control in photography is somewhat alien to the medium because photography is one of the few forms of communication that can be assembled as one completed entity in a fraction of a second. This is the special challenge to the photographer in using a step-by-step lighting approach: that its timetable for creation be placed in synch with the photographic image that records it.

Synchronization of lighting plan to photography is an element in all lighting control, but one that is dramatically apparent in controlling local brightness effects. One approach is to rehearse the plan and build it up with a stand-in subject — the traditional movie technique. Another is to enlist the active aid of the subject and make the ritual of lighting control a preamble to the moment of photographic record. This approach is difficult for the beginner but is excellent with people who have similar artistic interests. It is the traditional theatrical technique. Yet another approach is that of serendipity. A plan is laid out in the hope that the subject will respond to it or can be coaxed into it. This is a common multiple-source lighting technique used in the portraiture methods of Karsh and Newman, for example.

Local brightness control can be achieved outside the studio too, with startling results. For example, lighting a landscape at night creates a new world. Note the photograph of "The Sphinx and the Pyramids" (page C-10). Also note the daytime landscape illusion created by Michael Becotte (page 168).

CONTROL OF BRIGHTNESS KEY

Brightness key is influenced by the tones and brightnesses of the subject, the contrast of the light and shade relationship, and by camera exposure.

For high-key effect, the preponderance of tones and brightnesses must be lighter than mid-gray, and for low-key effect, they should be darker than mid-gray.

The first step in controlling brightness key is to consider the subject itself. In large measure this determines if a brightness key effect is desirable. Some subjects naturally suggest a certain brightness key: A bride connotes high key while a visual depiction of a human tragedy seems fittingly depicted in a low brightness key.

Several light qualities add their influence in controlling brightness key. For instance, strong direction influence produces a greater proportion of shade and therefore favors low key; conversely, weak direction influence and minimal shade favors high key. Specular and diffuse qualities play a role with the kinds of shadows they create. Diffuse quality light can be used for either high or low key, but because the shadows are nebulous, diffuse light is easily used for high-key effects. The same is not true of specular light. While its hard-edged shadows present no special problem in low-key situations, they do in high-key ones. Overlapping hard-edged shadows cause shadow pockets that are difficult to lighten even under conditions of very high ambient light. However, if shadow pockets can be avoided, specular light used for high-key effects produces a pleasant, sparkling airiness that is visually very appealing. Total contrast plays an important role too because high contrast normally does not favor high key; the dark shadows conflict in tone. However, if the shadows are miniscule, as in the case of a frontal direction influence, then high contrast can sometimes be used for high-key effects. In summary, strong light and shade effects are permissible in low-key situations; they are to be avoided in high-key ones.

The final step is exposure. Here the type of film is an important factor. If the film is a negative film, use full camera exposure. The reasons are these: for high-key effects be sure to avoid dark, underexposed shadows; use a minimum of one stop more exposure than normal to avoid this. For low-key effects, also avoid dark, underexposed shadows — but for a different reason. Because a print will eventually be made from the negative, the print exposure will determine the density of the shadows. If the negative has full exposure in the shadow areas, a dark print will still retain some detail in the shadow reproduction. Black shadows, devoid of detail, are seldom pictorially acceptable.

If the film is reversal film, underexpose about ½ to 1 full stop from normal exposure for low key and overexpose from ½ to 2 stops for high key. Exposure adjustment for brightness key with reversal film is a very subjective matter. Try using at least two or three half-stop variations and decide after processing which exposure best favors the brightness key intended.

Brightness key in lighting is to some extent a departure from reality because our eyes adjust automatically to an enormous brightness range. Yet it is a valid departure if it strengthens the visual message. Low key, or at least a lower key, is quite common in photography. Deep, rich tones have a profundity and a visual strength that are compelling. The emotional content of low-key imagery is not always gloom. When ameliorating influences, such as rich color, strong texture, and contrasting fragments of lightness, are included, low key serves to depict an opulence of form and substance. High key is light, airy, and gay, but there is always a fine line between high-key imagery and a nagging sensation of improper overexposure. We instinctively prefer to see rich visual detail rather than weak detail. Consequently, high key is usually more acceptable if somewhere within the image there is a deep tone or a black. This small visual anchor seems to say the photograph is technically correct and that the high-key feeling is intentional, not accidental.

PART II
ILLUSTRATIONS

The Vocabulary of Light

The following photographs visually demonstrate the six qualities of light. (See the color section for examples of color quality.) The photographs are grouped to show comparison of extremes and the presence or absence of the various qualities. Don't make value judgments about these examples, because the qualities depicted are neither "better" nor "worse"—merely different. They are only intended to organize your thinking about light, since orderly understanding is helpful for better control.

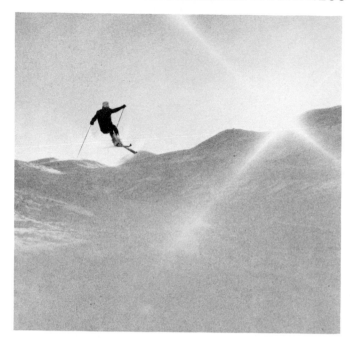

Photographic Interpretation

Brightness quality is seldom duplicated literally in a photograph, since no brightness value in a photograph can be as bright as, say, the sun in a cloudless sky. Photography interprets brightness quality; it seldom duplicates it.

Anyone who skis knows the dazzling combination of sun and snow. These two prints were made from the same negative, one print lighter than the other, yet both containing a rich black and a clean white. But which one best interprets the brightness quality of light? Is it appropriate to visually suggest this extreme brightness by applying overexposure, as in the lighter print, or to make a relatively dark print that shows more visual information than the skier can normally see? There is no "correct" answer here, photographic interpretation of brightness being totally subjective. Preference for one or the other of these treatments, or perhaps an intermediate one, depends on individual feelings and needs for visual communication. If the visual message is clear, the interpretation of brightness is correct, whether or not that interpretation conforms to some preconceived technical standard.

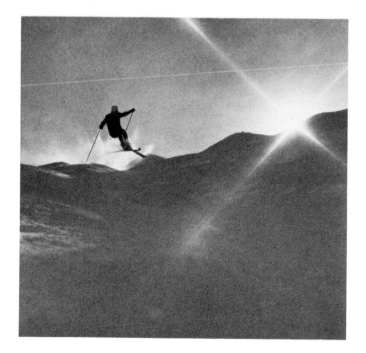

99

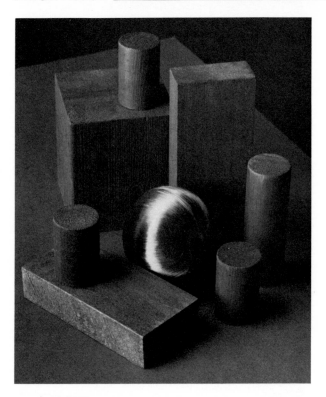 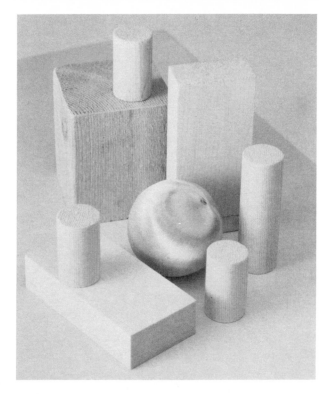

Brightness Key

Brightness key is determined by the preponderance of tones or brightnesses in a photograph. Most photographs have roughly equal areas of dark and light tones—a mixed brightness key. But when light tones dominate, there exists a high brightness key, while a preponderance of dark tones indicates a low brightness key. Brightness key conveys visual and emotional commentary about brightness quality itself. High key is perceived as bright, fresh, gay, clean; low key as dark, profound, somber, mysterious, dirty. These emotional tendencies may be altered by other factors including subject matter but the tendencies are strong nonetheless.

In this low-key photograph, there are dark-stained wood blocks, a dark satin ball on a dark background, and dark shadows; the only light area is the shiny reflection of the light source on the satin ball. Because the light area is small, the low-key

feeling is not destroyed; rather, it is an indication to the viewer that the photograph is not dark merely because of insufficient exposure, but that the effect was deliberate.

This high-key photograph depicts unstained wood blocks and a white satin ball on a light background. Reflectors were brought in close to the subject to lighten the shadows. Generally speaking, it is not necessary to introduce a black area to convince the viewer that the photograph is not improperly overexposed; the presence of clearly defined midtones is a sufficient enough indicator here and in most high-key photographs.

Both photographs were illuminated by the same light source, the only differences being in the tones of the objects themselves and the presence of reflectors to lighten the shadows in the high-key photograph.

Local Brightness

You can control visual emphasis by making certain parts of a scene darker or lighter. This is local brightness control. Local brightness can be modified by restricting or aiming the light source, adding illumination to given areas, introducing subject matter of different tones or brightnesses into the scene, and by shading parts of the scene to make them darker than others.

The top pair of photographs illustrates one form of local brightness control: shading parts of the scene. The only difference in the two photographs was the addition of an opaque screen which created a shadow behind the cluster of blocks. Note how local brightness control changed the physical structure of the scene. The shaded area recedes in visual importance. and the blocks, stand out in sharp relief.

The bottom pair of photos demonstrates another form of local brightness control: adding illumination to a given area in the scene—in this case a dark table used as support for a business machine. In one photograph, it is difficult to determine the configuration of the table, hence visual confusion. In the other, the table is selectively illuminated by a second light source to introduce needed visual information about the table support. The second light source was very carefully directed to illuminate only the dark table but not the business machine on top.

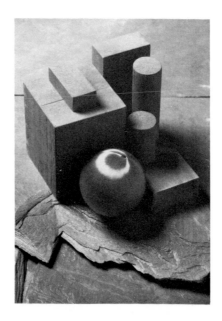

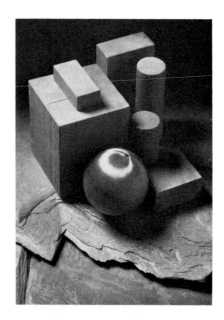

Total Contrast and Local Contrast

Contrast consists of two aspects: total contrast and local contrast of light. Total contrast is controlled by the photographic process and by control of light ratio, while local contrast is only partly influenced by these factors and is more directly controlled by the formative qualities of light: direction, specular, and diffuse qualities.

High total contrast, low local contrast. The photograph at left has strong blacks and whites but few intermediate tones. Diminished ambient light caused dark shadows in the print made on contrasty paper, resulting in high total contrast. The specular quality of the light source produced sharp-edged shadows which only added emotionally to these factors. On the other hand, the light source, close to the camera, had a weak direction influence. This produced less shade, which reduced the likelihood of adjacent tonal differences, resulting in weak local contrast. The photograph has strong visual impact but lacks information about local areas in the scene. The lighting emphasis is on pattern and shape rather than form and space.

Low total contrast, high local contrast. No strong blacks and whites dominate in the photograph at right, but there are definite intermediate tonal differences. The shadows are not black voids but are open and full of detail because of the increased amount of ambient light and because the print was made on low-contrast paper—factors that favor low total contrast. On the other hand, the light source, off to one side, had a strong direction influence, resulting in lots of shadows. The abundance of shadows produced many adjacent tonal differences which resulted in vigorous local contrast. The photograph has low visual impact but does contain ample visual information about all the areas in the scene. The lighting emphasis is on form and space rather than pattern and shape.

Light Ratio

Light ratio is the measurement of the difference in brightness between the light and the shade. If the difference is small, the light ratio is low; if great, the light ratio is high. The measurement would be unimportant if film reproduced a scene the same way our eyes see it. Film sees a smaller range of brightnesses and therefore light ratio measurement is needed in order to predict photographic response. The following photographs depict four different light ratios applied to the same subject, which was carefully arranged to include a variety of tones or brightnesses in both the light and shade. Each photograph was printed to obtain the same gray tone density in the background. Note that some areas in the shade are darker and some lighter than this gray tone density. As light ratio is increased, the darker areas disappear into blackness faster than the lighter ones. The total contrast effects of light ratio are not quite as simple as one might imagine. This is why these examples were deliberately designed so that both light and dark subjects would be in the shade.

Light ratio is 2:1—a one-stop difference between light and shade—is a weak light ratio. Shade is recorded only subtly darker than lighted areas. Full visual information is photographically retained in both.

4:1—two-stops difference—is an average light ratio for most photography. It has visual impact—light and shade are firmly established. It is too strong for high key, however, or when maximum visual information in the shade is essential for good communication.

8:1—three-stops difference—is a very high light ratio. It is typical of sunshine on a clear day. It has great visual impact but is normally too strong when detail in a large or important area of shade is to be recorded.

16:1 is an extreme light ratio. Shadows become black when lighted areas are properly exposed. It is a ratio suited for vivid design, not visual information.

2:1

4:1

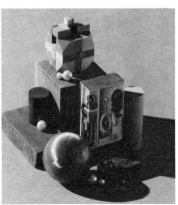

8:1

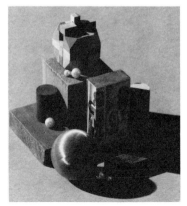

16:1

103

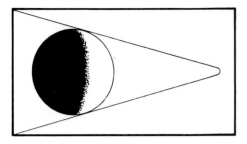

The Visual Difference

The only difference between these two photographs is that the left-hand one was lit by a tiny (specular) light and the other by a relatively large (diffuse) source. Direction quality and total contrast are the same in each photograph, with the light source located to the right and the ambient light level identical.

Study the photographs carefully. The scene was deliberately cluttered to provide many visual clues about specular and diffuse light qualities. Note the silver ball at right center, which mirrors the lighting environment. A tiny catchlight is evidence of a distant, tiny (specular) source, while a big catchlight denotes a nearby, huge (diffuse) source. Note too how the tiny source produces shadows with sharply defined edges while the large source does not. Even on rounded surfaces, such as the cylinder, the difference in edge sharpness of shadows is apparent. The geometry of why specular light behaves in this manner is shown in the left-hand diagram.

104

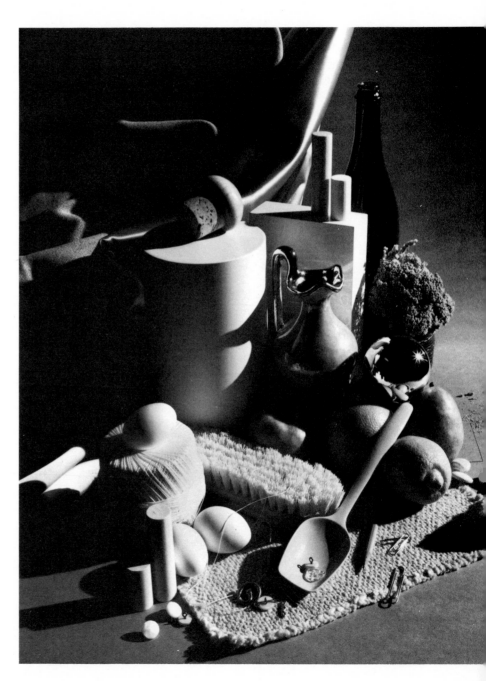

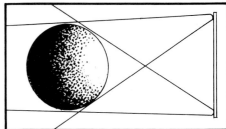

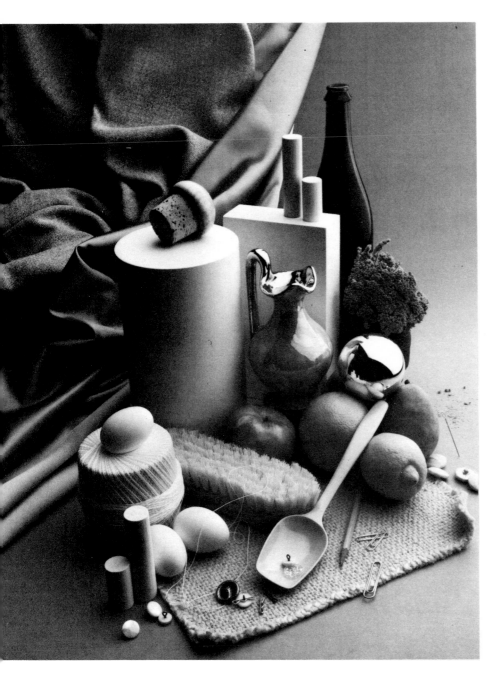

An overall glance at the pictures clearly demonstrates that specular light creates shadows which become important visual elements in the scene—as important as the objects themselves. On the other hand, diffuse light creates shadows with indefinable edges; diffuse shadows do not compete with the objects in the scene but serve to emphasize the form and space inherent in the objects. Specular light creates an illusion of higher total contrast (actual light measurement proves otherwise). Diffuse light creates more local contrast because it wraps around the surface undulations of various forms, revealing more adjacent tonal differences. The reason for this enveloping quality is shown by the geometry of the right-hand diagram.

Finally, note some of the small things—the cast shadow of the needle, the texture of the brush, the highlights on the surfaces of the shiny glass bottle and the ceramic pitcher, the folds and textures of cloth, and the delineation of the thread—each of which is "drawn" differently in specular or diffuse light.

105

Minimum and Maximum Direction Effects

The direction quality of light controls the formation of shadows, and shadows provide visual clues about dimension. When the light source is near the camera, direction influence is at a minimum; when the source is off to one side, direction influence increases. This information, together with the other visual clues of perspective, relative size, and overlapping relationships, greatly influences photographic depiction of reality.

With Specular Light

The Aztec plate contains very strong textures, but these are minimized when the specular source is close to the camera, as in the left-hand photograph. In fact the plate, hanging from a white wall, appears to float in space because no cast shadows are apparent. The light source was some distance behind the camera and only one or two degrees above it.

When a specular light source is placed almost 90° to the lens-to-subject axis, the light skims across the subject and direction influence is at a maximum. The plate casts a large shadow on the white wall and even the subtle stipple paint marks on the wall are revealed. Textures of the plate are strongly revealed, clearly showing which parts recede and which protrude, even when the change is a fraction of a millimetre.

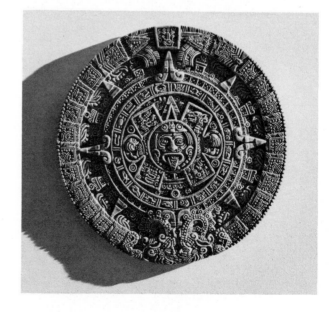

With Diffuse Light

The direction influence of diffuse light is also at a minimum when the light is near the camera, as has been demonstrated, or when the source is so large that it completely envelopes the subject, as it does in the photograph at left, taken outdoors on an overcast day in winter. The silver ball mirrors the environment of overcast sky and snow-covered ground. The only "shade" present results from inherent tones of the objects and variable reflectance of light off surfaces that are at divergent angles. (Variable reflectance is due to the angle of incidence equals angle of reflectance law of illumination.) But this shade is weak—the lighting does little to add visual information about form and space—and the viewer must depend on visual clues of optical perspective, relative size, and overlapping elements for information about form and space.

When the same subject was brought indoors and illuminated from only one side by a finite-size (in this case 4' × 4') diffuse source, a set of shadows was introduced which added more visual information about form and space. A third dimension is more obvious because the direction quality of light adds its influence to the other visual clues already present.

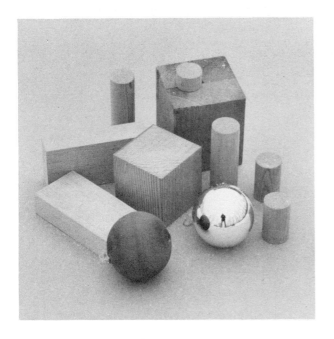

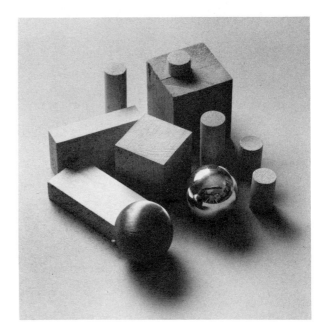

Angle of Incidence Equals Angle of Reflectance

The direction influence of a light source is revealed not only by cast shadows but by reflection of light as well, because light rays reflect off a surface at the same angle at which they strike it. Such reflectance is more apparent when a surface is smooth and shiny.

These two photographs were lit with a 4' × 4' diffuse source, but with two different direction influences. When the light source was off to the right, its rays were reflected to the left; but when the source was above and behind the subject, its rays were reflected off the subject and directly into the camera lens. The light source had to be large so that its rays would be reflected evenly off all the shiny surfaces of the objects in the scene. A small, specular source would have reflected as only small points of light on the shiny surfaces.

The Light And Shade
Relationship

One role of light is to illuminate; another more sophisticated function is to convey additional visual information about form, space, texture, and pattern by the alternating presence and absence of light. This condition is called the light and shade relationship. This light and shade relationship is modified by the direction quality of light, contrast between light and shade (light ratio), the relative size of the light source (specular or diffuse), atmospheric haze, variable reflection of light off divergent angles of objects in the scene (angle of incidence equals angle of reflectance), and the existence of multiple artificial light sources enabling creation of unique or unnatural lighting relationships.

Light and Shade Before Photography

By the fifteenth century, painters had begun introducing light and shade into their images via a technique called *chiaroscuro*. These Renaissance painters recognized the formative qualities of light: they saw that direction quality influenced depiction of dimension; that the relative size of the light source controlled the character of light and shade; and they understood the effects of total and local contrast. The following four paintings include *chiaroscuro* as an important visual element. Two use the soft-edge shadows of diffuse light and the other two the hard-edge shadows of specular light.

In the two diffuse examples below, the light source—windows open to the sky—is included. In each case the painter positioned himself in relation to the direction influence. This produced a vigorous light and shade relationship containing added visual information about form, space, substance, and dimension. Local contrast was strong, but total contrast was kept low enough to retain visual information in the shadows; there was sufficient ambient light to keep the light ratio from being too high. A photographer confronted with similar lighting and subject matter could expect a similar depiction of light and shade in a photograph.

JOHANNES VERMEER: *Young Woman with a Water Jug* (1665). Metropolitan Museum of Art, New York. Gift of Henry G. Marquand, 1889.

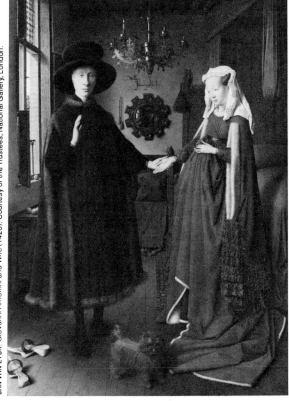

JAN VAN EYCK. *Giovanni Arnolfini and Wife* (1426). Courtesy of the Trustees, National Gallery, London.

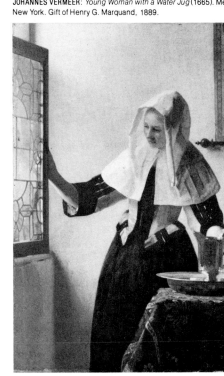

111

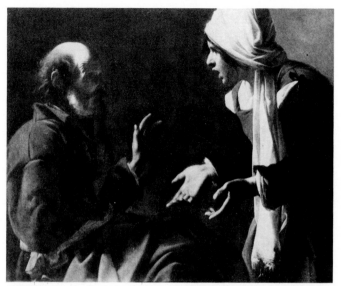

Few painters depicted a specular light and shade relationship, but Caravaggio used it almost exclusively. Specular light quality suited his purpose: to illustrate religious figures and events with a dramatic and literal realism—depicted as if he had suddenly stumbled upon the scene. In these two examples by him, the light source was obviously a small, artificial specular one—probably an oil lantern hung from the ceiling. Direction influence was strong, but the ambient light level very low, hence the total contrast was very high. Local contrast was also low. Substance and form are implied rather than clearly stated. The sharp-edge shadows place visual emphasis on pattern and shape, and are so sharp and strong that they are more emphatic than the edges of the figures. A photographer, confronted with similar lighting and subject matter, could expect a similar depiction of light and shade in a photograph.

CARAVAGGIO: *Peter Denying the Lord* (1600). Vatican Museum, Rome. Alinari/Scala.

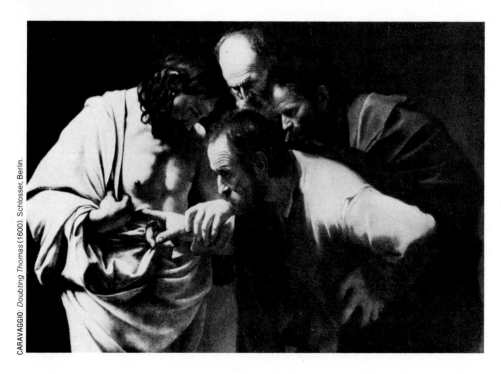

CARAVAGGIO: *Doubting Thomas* (1600). Schlosser, Berlin.

An Interesting Light and Shade
Comparison

Most painters and draftsmen who depict reality prefer the form-enhancing quality of diffuse light. Leonardo da Vinci's silverpoint and pastel drawing and Nadar's photograph show remarkable similarities. The reason: Leonardo studiously depicted exactly what he saw, and both he and Nadar saw drapery in diffuse-quality light from a window open to the sky.

NADAR: *Sarah Bernhardt* (1859). Courtesy of the International Museum of Photography at George Eastman House, Rochester, N.Y.

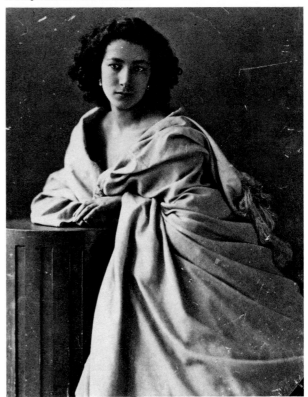

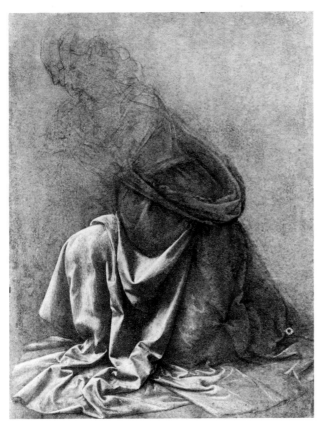

LEONARDO DA VINCI: *Study of the Drapery of a Woman* (1477). Galleria Nazionale d'Arte Antica, Rome. Alinari/Scala.

113

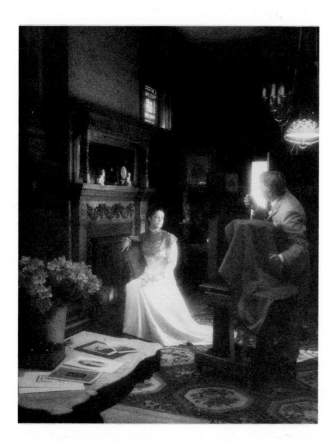 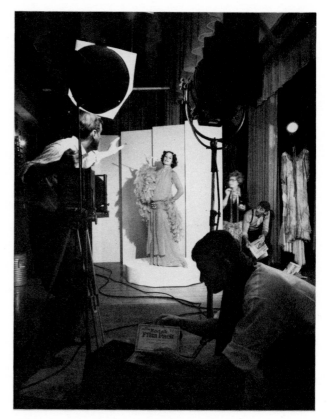

Trends in Artificial Lighting

A study of photographic techniques for *Studio Light*'s 75th Anniversary Issue revealed that historically there has been a shifting emphasis between specular and diffuse qualities in artificial lighting. Among the reasons for lighting trends are technical breakthroughs in equipment and materials, waning interest in old pictorial traditions, and increasing photographer and viewer sophistication.

The earliest artificial studio light source was the arc light. It was employed to produce a single-source diffuse lighting similar to that created by window light. When the more facile tungsten lamps and fixtures became available, artificial lighting changed dramatically. Emphasis shifted to specular quality and multiple lighting techniques, in part because tungsten lamps were too weak for bounce lighting, but more significantly because these sources could easily be used in multiples in a variety of lighting fixtures—a fascinatingly new lighting situation.

After several decades of using specular multiple lighting techniques, studio photographers renewed their interest in diffuse lighting, and omnipresent umbrella reflector sources were typical of studio lighting in the 1960s. They are still used today, but most studios prefer a large transmitted diffuse light source, some as large as 8' × 8'.

Artificial lighting techniques are changing once again. It is common to see hard-edge specular lighting techniques in fashion photography, and there is also considerable experimentation with combining the action-stopping ability of electronic flash with long exposure blurs—the deliberate mixing of artificial and natural light.

To depict the turn-of-the-century portrait studio (left), the bounced diffuse light produced by a single arc lamp suspended in the V of two white reflectors was entirely appropriate. Some early arc lamp manufacturers also provided an umbrella stand from which to bounce the arc light. Both techniques produce a diffuse light similar to the natural window light which earlier photographers used as their sole indoor light source.

For the 1920s fashion photograph (center), spots and floods were used in a manner typical of the era. A large flood near the camera served as fill light, while the main light source was a large spot with the back door opened and the reflector removed so that the bulb filament served as a point light source casting the sharp shadow on the background. Other spots were used to light important areas.

For the 1960s fashion photograph (right), a single, diffuse umbrella source is the main light. Rapid-fire electronic flash bounced off a large umbrella facilitates photography when there are rapid changes in posing and camera positions.

All three photographs courtesy of *Studio Light,* 75th Anniversary Issue.

Direction

The direction quality of light is the mechanism for molding the light and shade relationship. Late afternoon light skimming across this scene in Teotihuacan, Mexico, revealed rich architectural detail. This lighting effect could not have

occurred at noon or in early morning light; it was only late in the day that the sun's direction quality molded the light and shade relationship in this manner at this location. A photographer cannot command effects to happen in natural light; instead, he must be alert to the possibilities and exercise patience.

117

One Source or Many

The light and shade relationship can be simple or complex. With one source, a singular relationship occurs; with many sources, myriad relationships are formed. A single, specular source, such as sunshine, can be vividly posterish when direction quality is vigorous. The photograph of skiers at Snowbird, Utah, was shot from a helicopter using a Brooks Veriwide camera. The light and shade effect was so strong that it became the principal element.

The ancient temple in Baalbek, Lebanon, was illuminated by many light sources, each producing its own light and shade effect. Lighting chaos is avoided by careful organization—each source has a role to play. Light from many sources reveals more architectural detail than light from a single source can. Wires and fixtures were carefully hidden in the stonework for the nightly *Son et Lumière* performances. Total contrast in the photograph was reduced by flashing two No. 50 flashbulbs on either side of the arch to provide general fill-in. The flash lamps were kept sufficiently far away so that, by guide number calculation, their light was two stops less powerful than the time exposure required for the tungsten lighting. Negative film exposure was based on the flash guide number.

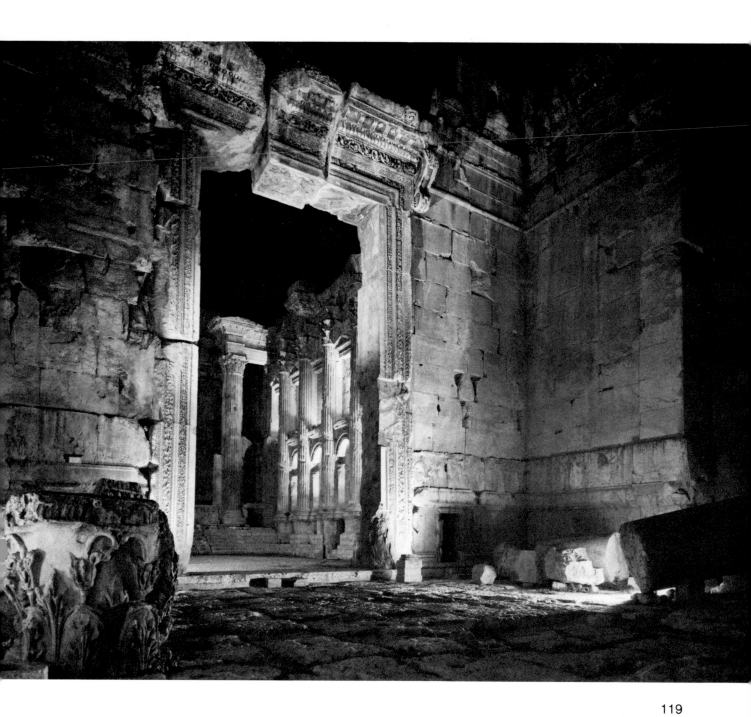

Daylight—Specular and Diffuse

Daylight naturally changes from specular to diffuse as the sun's influence wanes and that of skylight increases. Midday sunshine is very specular; it also has a very high total contrast unless there are nearby light-reflecting surfaces to create additional ambient light. In the movie motif photograph, three 4′ × 8′ white foam-core panels were placed on the ground in front of the couple to reduce an 8:1 light ratio to about 4:1. In addition, a deep blue filter (No. 47) was used to simulate the nonpanchromatic

(orthochromatic) film commonly used in the 1930s.

The photograph at the Pyramids was made just before sunset, when specular sunshine was feeble as compared to diffuse skylight. Such a situation generally produces a weak light and shade relationship, excellent for color but often too "flat"

for black-and-white. In this case, however, object identity is very strong—strong tonal relationships in the Egyptian girl's dark eyes, hair, and costume. At midday, a strong specular light and shade relationship probably would have added unnecessary and conflicting visual competition.

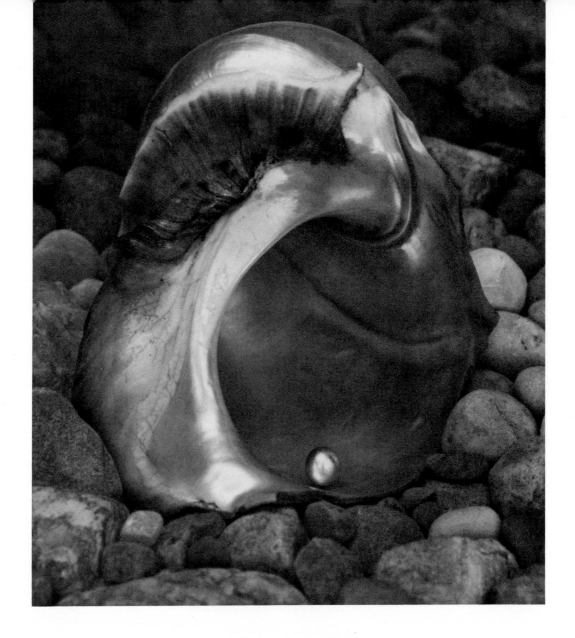

Object Identity

Many objects containing their own inherently strong
tonal relationships are sufficiently revealed by
lighting which acts only as an illuminator. A strong
light and shade relationship may be unnecessary or
even undesirable in such cases because of visual

conflicts. Following are some examples of strong
object identity.

 The shell and bead were lit by a single
overhead 4′ × 4′ light panel plus a front reflector.
The shell's pearly luminosity is an inherent tonal

JIM DENNIS: *Here's Looking at You.*

characteristic, and there was no need to introduce a stronger light and shade relationship.

The two mimes leave the viewer wondering which eyes are real and which are comic configurations. A strong light and shade relationship imposed on these subjects would ruin their illusion.

The shot of the girl with the rya rug was made

in the totally diffuse light of the woods very late in the day. A pseudo light and shade relationship was formed by a moiré pattern of two negatives placed in alignment at the subject's face and then pivoted slightly out of register. The moiré pattern occurred as a result of regular patterns—in this case, ground cover leaves—placed in misalignment.

123

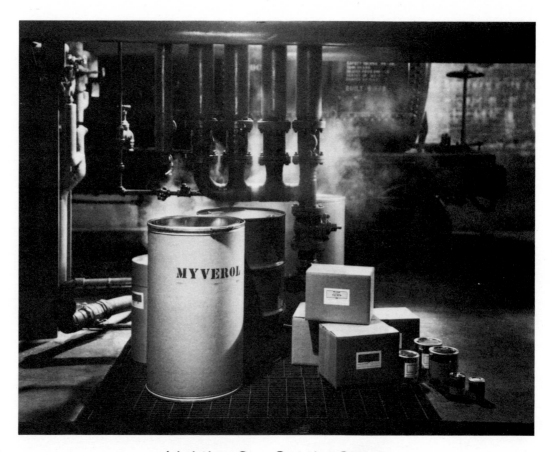

Lighting Can Set the Stage

Light and shade relationships produced through careful use of lighting can create new environments. In one of these examples, there is a lighting environment that is visible only in a photographic record of it. In the other, there is a mixture of utilitarian artificial lighting that, when seen under appropriate circumstances, attains a special beauty of its own.

The convention display photograph, above, illustrates the various ways of packaging a chemical compound—from tank car to tiny tin box. Six No. 22B flashbulbs were fired—two to backlight the steam, one to light the far wall, one in a spotlight fixture to light the containers, and two bounced off a nearby wall to create a modest amount of ambient light.

The distillation towers were photographed only after special preparation. First the timing of lighting balance between skylight and artificial light was calculated for that particular site, then arrangement was made to wet down the street to reflect these effects.

Often the best photography of artificial lighting at dusk occurs when skylight visually balances with artificial light. However, a double exposure is required when the artificial light is weak—one for the pre-dark sky, the other after dark for the weak artificial lights. Make sure that the pre-dark exposure is sufficient only for the sky, otherwise later artificial lighting effects will be photographically "washed out."

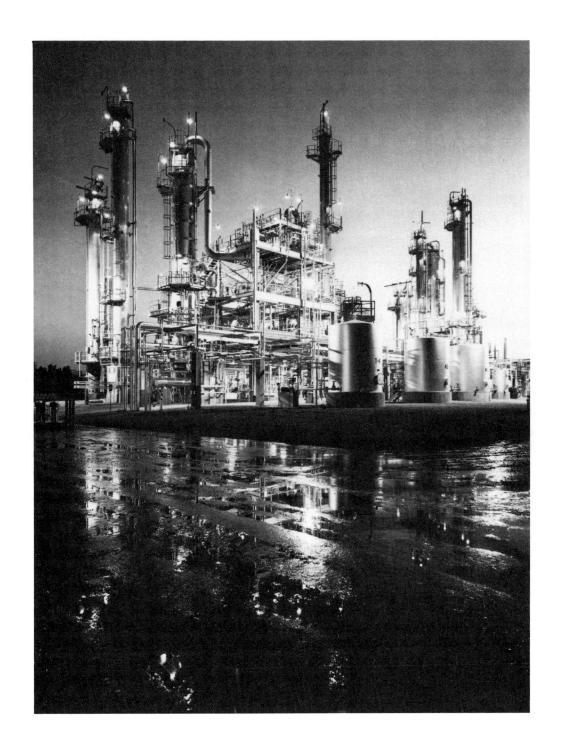

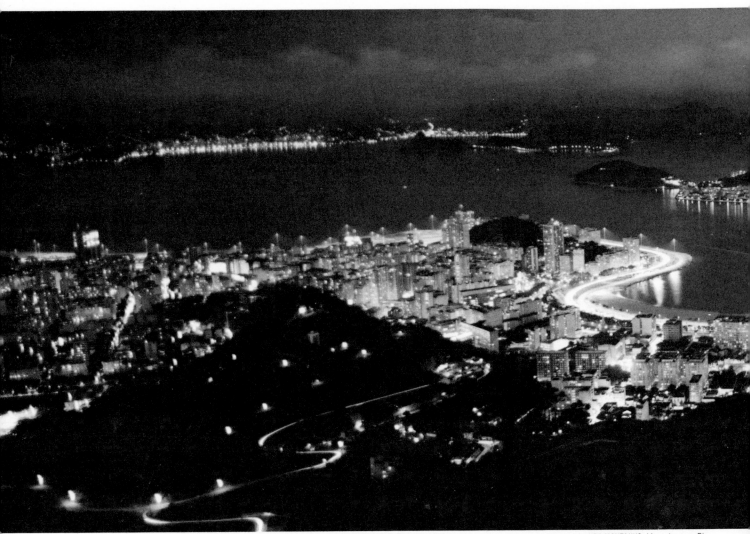

NEIL MONTANUS: *Moonrise over Rio.*

City lights and the moon create a dramatic panorama. An exposure of one second at *f*/5.6 on ASA 50 film was made of the moonrise during the twilight period after sunset. An hour later, with the moon out of view and the sky black, a

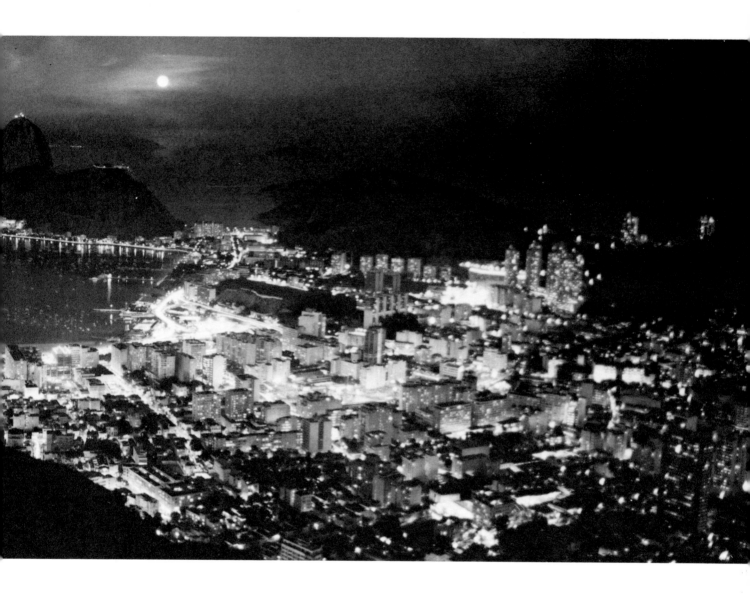

second, two-minute exposure was made for the city lights and traffic. The timing
of moonrise and dusk, as in this scene, occurs only once or twice a month.
Awareness of natural phenomena is a very important lighting control.

LEE HOWICK: *Living Room Colorama.*

Manufactured Believability

In photography, lighting often must be designed to simulate what is familiar and comfortable rather than to create a unique environment. In this photograph, light and shade effects match those of ordinary household available light, resulting in lighting that looks familiar and comfortable. The photograph was made, not with a motor drive 35, but with an 8″ × 20″ view camera! Such a huge format requires tiny apertures of f/32 and smaller to obtain a pictorially usable depth of field.

Powerful studio electronic flash—approximately 10,000 wattseconds—was chosen as the main light source. Such a tremendous blast of light goes on and off with a whoomph-like sound in about 1/200 sec.—brief enough to stop action yet bright enough to allow use of the smallest apertures. Used as a direct, specular source, the light from this unit would have been too harsh to simulate the gentler atmosphere of household illumination, so the electronic flash was bounced off large panels of white paper and overhead umbrellas six feet in

diameter. To add a homey touch, the light fixtures were fitted with small flashbulbs to match in brightness the electronic flash. Thus the lighting consisted of bounced flash for ambient light and small flashbulbs in the light fixtures to visually simulate the source of that ambient light. Technically impressive yet visually simple and effective.

Today's photographers are seldom confronted with enormous power challenges in lighting. What in the past had to be shot on 8″ × 20″ film to produce the 18′ × 60′ Colorama in Grand Central Station is now normally done on much sharper, finer-grain, and far smaller-format film. The same is true for advertising illustration, where smaller-format films produce images equal to the larger-format ones of several years ago. However, the need to simulate ordinary existing lighting relationships for photographic purposes still exists, and the techniques used here still apply, at least in principle.

Complex Subjects Usually Look Better with Simpler Lighting Plans

Complex scenes can be made visually confusing if the light and shade relationship is busy or unnecessarily complex. Simplicity usually works best.

 The shadowbox still life is a complex subject. The idea here was to include tiny details requiring great sharpness, a full range of tones, and as great a variety of color as possible to demonstrate film potential. Lighting was very simple. A 4′ × 4′

diffusion screen placed in front of two mini-quartz lights was the transmitted diffuse light source. It is mirrored in the brandy snifter. Light ratio was kept low by placing a 4′ × 8′ reflector close and to the right of the subject. Note how the relatively large diffuse source creates an ample light and shade relationship for form identification without detracting attention from the many objects in the scene.

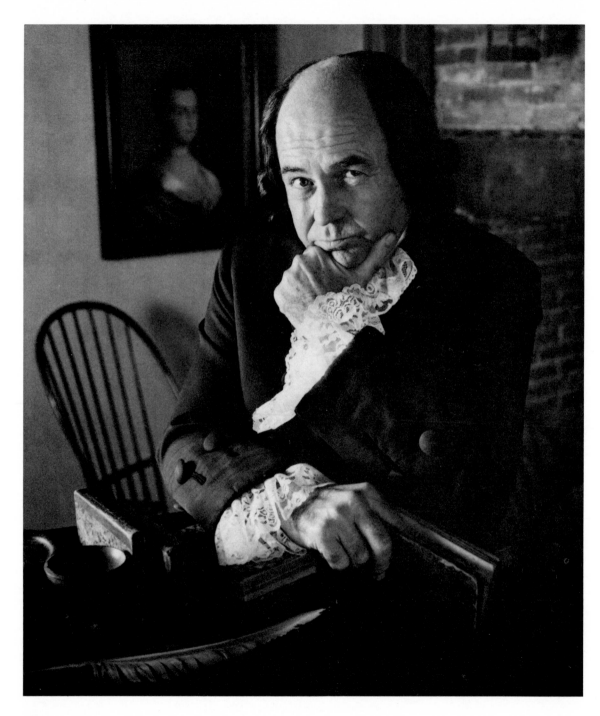

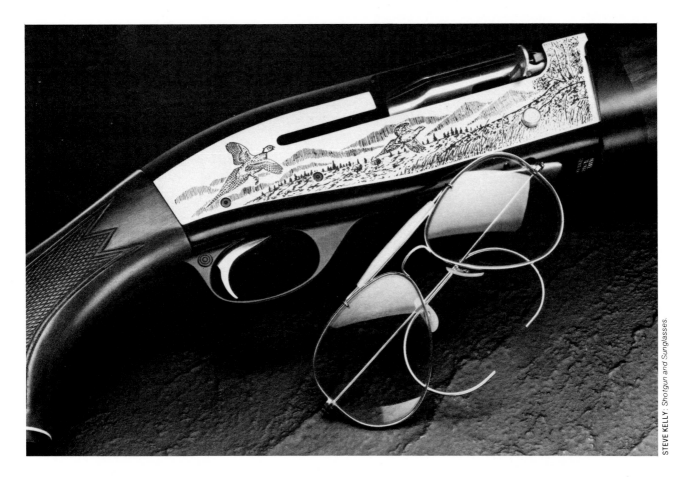

Specular Highlights

Specular highlights are reflections of the light source on the surface of an object that is being illuminated. The shinier the surface, the more it will mirror the light source. Specular highlights add an extra tonal dimension that is visually appealing.

The photograph of a model depicting John Adams was shot at Adams' birthplace in Quincy, Massachusetts. The main light source was electronic flash bounced off a silver 3′ ×6′ Reflectasol placed to the left and rear. At this angle, most of the light skipped off the face into the lens with little loss due to scattering effects. Slight perspiration made the skin more shiny, further enhancing the formation of the specular highlights on the face. Specular highlights formation can be excessive if the rearward influence light source is too bright and/or too specular.

The sunglasses and metalwork are highly reflective specular surfaces. When lit with a large light panel (diffuse light), the specular reflections have a languid, liquid appearance that effectively reveals surface character at the same time that it adds tonal dimension. Again, as in the portrait, the light had a rearward direction influence, but this time it was placed above the objects. (Remember the angle of incidence equals angle of reflectance law of illumination.)

Casual and Manipulated Available Light

Most snapshots and candids are best lit by available light with some care given to camera viewpoint in relation to the existing illumination. The absence of studied lighting effects provides a desirable veracity. For a more formal and studied feeling, you may want to exert a deliberate control over the existing illumination. This is frequently done by professional photographers when making environmental portraits, as it makes the portrait more flattering for display purposes and gives the photograph a more finished appearance.

At left are several snapshots with only casual control over the lighting; the picture at far right has a controlled light and shade relationship. Directly behind the camera a small, portable electronic flash covered with one thickness of handkerchief was bounced into a 40″ umbrella for a very gentle fill illumination that preserved the existing available light. The answer to whether casual or manipulated available light is best depends on visual needs and photographic intent. However, the professional will usually choose to exert the extra effort required to achieve the greater lighting control.

These four photographs of women were all lit by carefully analyzed available light. A white reflector was used in the first and third photos to reduce the light ratio. Available light and shade relationships can be very effective when care is

NEIL MONTANUS: *Woman in wicker throne chair.*

taken to pose the subject and position the camera relative to the existing lighting conditions. The use of existing light and shade relationships allows the environment to play a visually supporting role.

Product Illustration—The Most
Careful Control

When a photograph must substitute for the real thing, or when lighting must impart a certain visual flair, control of lighting becomes paramount. The two illustrations of projector lenses and accessories are too dark for catalog use, but they are intended to convey feelings of precision and attractiveness. Both photographs were lit with a single overhead diffuse source: the lenses with a 3′ ×3′ pan light, the projector with a 4′ ×4′ light panel. In the latter, the accessories were carefully shaded for a sense of

lighting drama and to visually indicate that the photograph is a generalized representation.

On the other hand, the photo of the man holding the camera is intended to show every tiny detail in the product. It is an excellent example of clean product identification coupled with a believable human appreciation of the value of the product. To light this difficult combination of visual elements, a huge 8′ ×8′ electronic flash light panel was placed close to the subject. The huge light source enveloped the subject with light that had good directional quality and good local contrast yet did not produce large areas of dark shadows. This kind of light and shade relationship is only possible when the light source is a huge light panel.

137

Fantasy and Special Effects

Lighting can create a visual world of the photographer's own imagination. The antique toy Noah's Ark was photographed on a deserted beach in October. A wide-angle lens was used to include the scudding clouds. Later, a lightning bolt from another photograph was copied and the copy film sandwiched with the first photograph. The lightning creates a lighting environment that, while realistic, could never have been planned for a given situation.

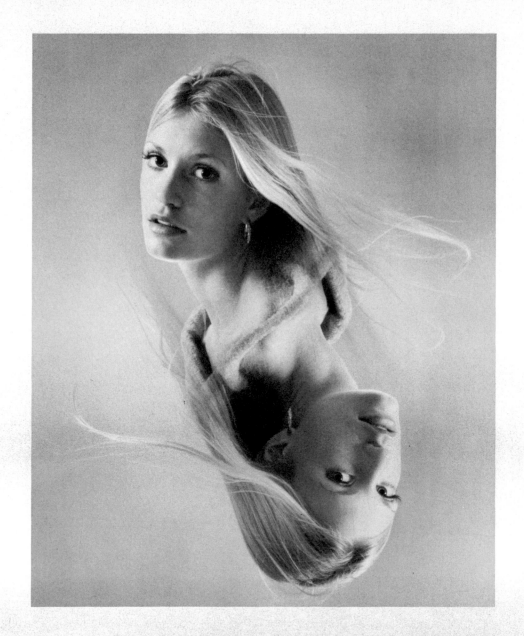

The playing card motif was done with two exposures on one piece of film. Half the scene was blocked with an opaque mask for each exposure and the camera was turned upside-down between the first and second exposures. The background was fully illuminated to provide a surreal high-key environment.

The pattern of the four faces is the result of sandwiching together four

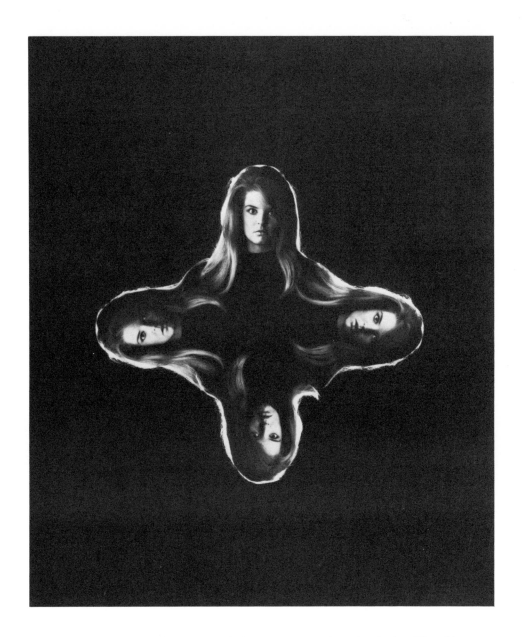

similar negatives, each of which was lit the same way, to form the design. The girl was draped with black cloth and placed in front of a black background. A diffuse but directional light was placed to the left, and a small specular light placed directly behind her head to obtain the halo rim of light on the hair. It is this latter light which provides the design continuity.

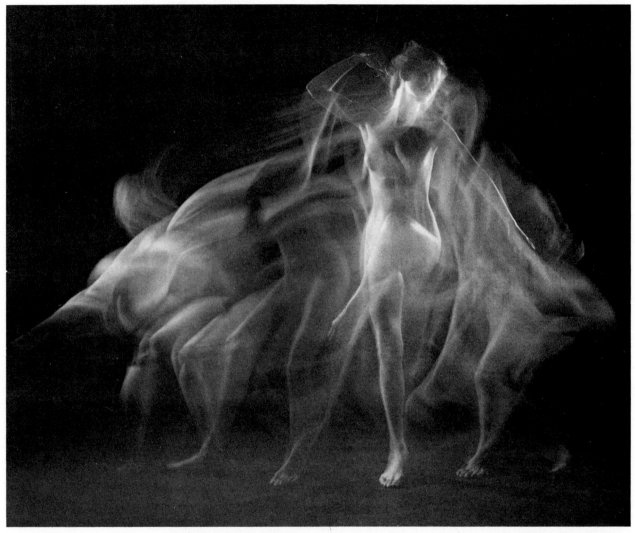

NEIL MONTANUS: *Nude Dancer.*

A lighting effect that combines tungsten light and electronic flash introduces the passage of time into a single photograph. The camera shutter remained open for the model's movement under the tungsten light while the electronic flash was fired at the moment an interesting pose occurred. Many photographs were made before achieving a smooth, fluid movement in combination with the flash-frozen pose.

Two carefully screened tungsten spotlights and electronic flash units were placed to the rear, on either side of the model, for the illumination. A precise lens shade was required to avoid lens flare.

Color

While most of the qualities of light can be illustrated with black-and-white photography, color quality cannot. In some respects, color is the most fascinating of the qualities of light, with an influence so pervasive that it can be as intriguing a phenomenon as light itself.

The following photographs were chosen because color quality is an important element, both technically and emotionally. Nevertheless, the other qualities of light are also present. In analyzing lighting one must not be so seduced by the presence of color that the other qualities of light are ignored.

Color Neutrality and Color Effects

The color quality of light has two major influences: one is to impart no coloration—to be a neutral influence that allows all colors and neutral tones to be photographed without modification; the other is to deliberately impart a color effect that modifies the photograph.

Color neutrality requires an awareness of the color quality of the light source and an understanding of how specific photographic materials will reproduce color under those conditions. Usually the normal practice of using a given type color film in the illumination for which it is balanced is sufficient to obtain an acceptably neutral color balance. There are times when this casual control is not enough, and this is especially true of subjects which contain a preponderance of neutral tones and subtle colors. In these cases, careful testing and control of all phases of the photographic process may be required to achieve an exacting neutral color balance.

This photograph of millefleur beads and eggs contains delicate neutral areas. Without careful attention to color neutrality, these areas would be degraded by unwanted colorations.

Color effects require an awareness of the emotional nature of color itself. Color is intriguing, sensuous, and seductive. The use of a color effect may add to the visual message or it may seriously detract; there are no exact guidelines because color effects depend on the specifics of subject matter and the intended visual message. One rule of thumb is: Do not use color effects unless you are convinced that they add to the visual message.

This winter-bare tree was photographed through a deep blue filter for a color effect that makes a more active visual statement.

C-1

Identity of the Primary Photographic Colors

Red, green, blue, cyan, magenta, and yellow are the six primary photographic colors. Skill in recognizing them facilitates evaluation and adjustment of color balance.

Color-Compensating (CC) filters in precisely measured strengths of the six primary colors are the basic tools for making color balance adjustments. This illustration attempts, as closely as printing inks will allow, to depict the six primary colors in two different strengths: a strong saturation equivalent to a CC 50 value, and a weak saturation equivalent to a CC 10 value.

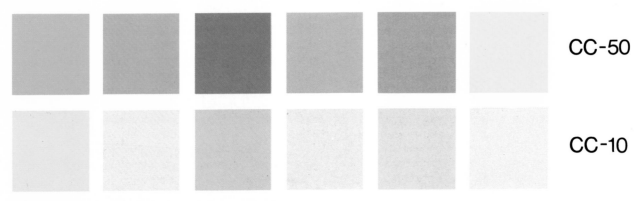

CC-50

CC-10

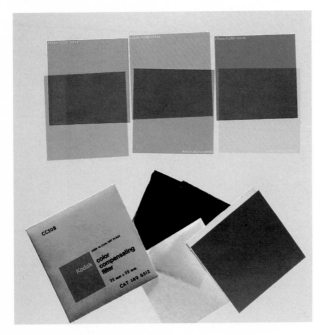

Complementary Colors

Besides being able to identify the primary colors, it is important to know which pairs are complementary. Color imbalance is adjusted back to neutrality by using a complementary color CC filter of the necessary strength.

In the photograph at left, three pairs of complementary CC 50 filters were placed on an illuminator so that they partially overlapped. The red and cyan filters overlapped, as did green and magenta, and blue and yellow. There is color neutrality (gray) in the overlapping area, which occurred because complementary color filters of equal strength cancel one another out.

Cyan is complementary to red; magenta to green; blue to yellow. Thus, for example, if a color transparency of a scene is too blue, another transparency of the scene (using the *same* emulsion number film) can be made neutral by adding a CC yellow filter of the proper strength in front of the camera lens.

The color quality of light becomes an active visual element when color effects occur in transition periods between night and day. (Left) While it is still night in Darjeeling, dawn comes to the world's third highest mountain, Kanchenjunga, photographed from Tiger Hill in the Himalayas on Kodachrome 64 film.

(Right) An orange dawn at the Taj Mahal suggests the midday heat to follow. Taken on Kodacolor II and printed to this color balance. Because the film was negative, the photographer could print for other color balances too.

Timing—of people, action, and natural light. Direct sunlight slashing across full, open shade helps set the emotional tone of a warm Sunday afternoon in the summer of 1937. Lemonade seems necessary. Existing ambient light was not strong enough to allow proper photographic depiction of emotional reality, so several white foam-core panels were set up on the lawn to reflect additional illumination into the shade. This lowered an 8:1 light ratio to about 4:1. Technically, flash fill near the camera could have accomplished the same result, but emotionally its obvious presence would have destroyed the milieu.

Lighting control is as important as props and costumes when visually suggesting another era. An attempt to picture Thomas Jefferson at work in Philadelphia in July, 1776, required simulation of emerging daylight—his favorite time to write.

Use of a view camera and extreme depth of field precluded weak natural light. So one electronic flash was bounced off a 3′ ×6′ gold Reflectasol to the rear left to simulate window light, a second off white foam-core to the near left, and a third off the ceiling to the far right to produce added ambient light for fill. Light ratio was about 4:1. The flashes were bounced because direct specular light would not simulate early morning window light.

Natural light's variety is ideal for casual color photographs of people. However, indirect diffuse light produced by skylight, cloudy days, rainy days, and late afternoon dusk, is usually preferable to the harsh specular quality of direct sunlight. The reason is that the vivid light and shade relationship of direct sunlight is inhibiting; it usually causes people to squint, freedom of movement is restricted because the strong shadows intrude as vivid design elements, and the light ratio is so high that it can overpower subtle facial features.

The tennis player stood in the diffuse light of open shade while the arrangement of specular sunlight shadow designs on the court served to frame her presence.

In a dark woodland clearing, there was a natural brightness difference between girl and environment. Diffuse, rainy light supported and preserved the difference.

Father and daughter were backlit by a midday equatorial sun in Nairobi, Kenya. The narrow angle of view of a telephoto lens speared a portion of dark background. Because background and subjects were dark and the sunlit portions very small, there was no need for added fill and this preserved the delicate yellow reflections on the child's chubby

cheeks. Added fill is not required in every situation. Use lighting finesse, not formulas.

A trio of girls, an ancient apple tree, and the glow of a late, hazy summer sun. When you discover settings like this, note them down for future reference. If an opportunity presents itself you will be prepared to take advantage of it. Once the stage is set, one settles down to see what happens.

The Viennese model also posed on an overcast day but her gay coat looked too drab in relation to autumn leaves. A small electronic flash covered with two thicknesses of handkerchief added delicate fill light. Note the catchlights in the eyes. A telephoto lens with ample distance between subject and camera plus a flash held next to the lens minimized unwanted specular shadows.

Waiting for clouded sunlight at this Swiss picnic proved more satisfactory than using direct sunlight. It was a pleasant wait.

The photo of a Maine lobsterman is a careful construction of light and location. While not a professional model, he was posed as a model to make a more formal visual statement. The direction quality of natural light can be precisely controlled by merely locating subject and photographer in relation to the source.

STEVE KELLY: *Little Girls and Flower.*

Artificial light offers control not possible with natural light; here are two good examples. One uses a huge diffuse light, the other, several specular lights. Artificial light enables the photographer to invent new lighting relationships. The challenge is to have consistency between method and message.

The little girls were placed directly in front of an 8′ × 8′ transmitted diffuse light source. Black silhouettes were avoided by exposing for the shadows, which were illuminated solely by ambient light reflected from nearby white walls. A preponderance of light tones produced a high brightness key. Lens flare generated by the extreme overexposure of the light source background softened and blurred outlines, creating a lovely fragility that emotionally supports the innocence of childhood.

NEIL MONTANUS. *Dancer.*

The dancer was lit by three specular—reflectored electronic flash—light sources: one directly overhead and two, covered with red-orange theatrical gels, placed to the rear on either side. Here a lens shade was used to carefully avoid flare. A preponderance of dark tones produced a low brightness key. The crisp, vigorous light and shade created by specular quality light enhances the design of masculine grace.

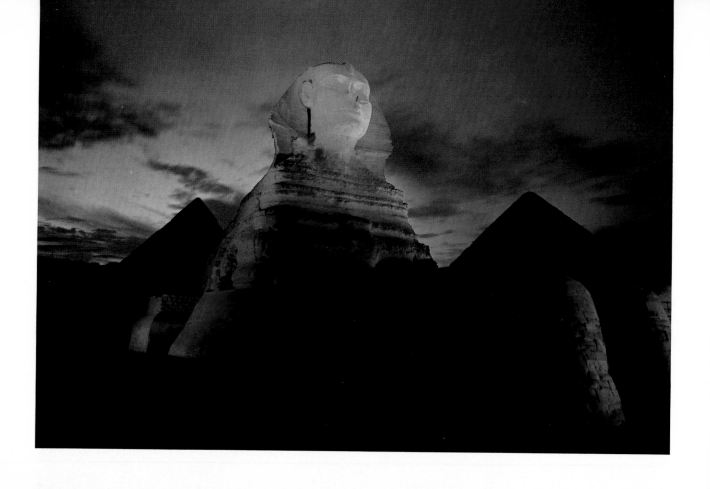

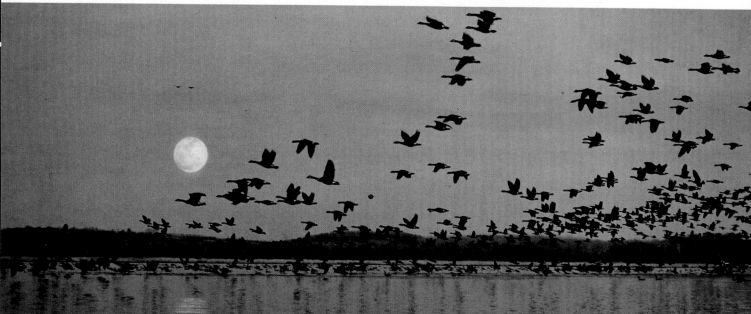

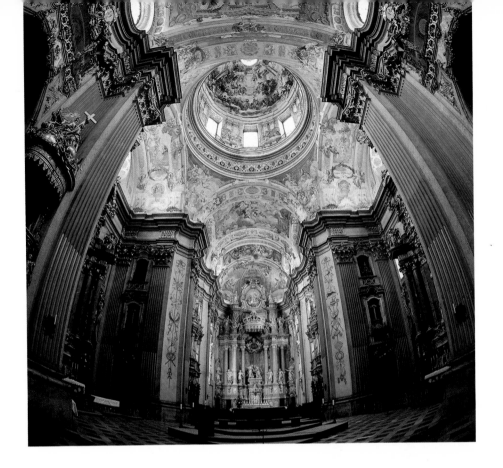

Son et Lumière is a French technique for using narration, music, and theatrical lighting effects to symbolically generate life into famous architectural monuments. An exposure of several seconds at the smallest lens aperture recorded sky detail and cloud movement just before dark. Without moving the camera or changing film, several more exposures were made later of artificial lighting effects during the performance. These exposures were made when the Sphinx alone was illuminated. Since this lighting situation occurred only at momentary intervals, several interrupted exposures had to be made to obtain sufficient detail on the Sphinx. The color negative film was deliberately overexposed to guarantee suitable image detail for subsequent printing.

The geese at Montezuma National Wildlife Refuge, New York, were recorded in hazy afternoon light at 1/500 sec. on color negative film. Later in the darkroom, a black-and-white negative of moon and reflection was sandwiched with the color negative and printed dark to produce the final result. Here natural light was carefully simulated because this photograph, done on 8″ × 10″ format, could not technically achieve what the eye and miniature camera could more easily record.

This photograph of the Abbey of Melk, Austria, is a happy correlation of lovely but weak artificial lighting with equally weak natural light. A heavily overcast sky of low brightness produced the proper balance between natural and artificial light. The brightness quality balance between indoor and outdoor light was essential here to record intricate architectural detail.

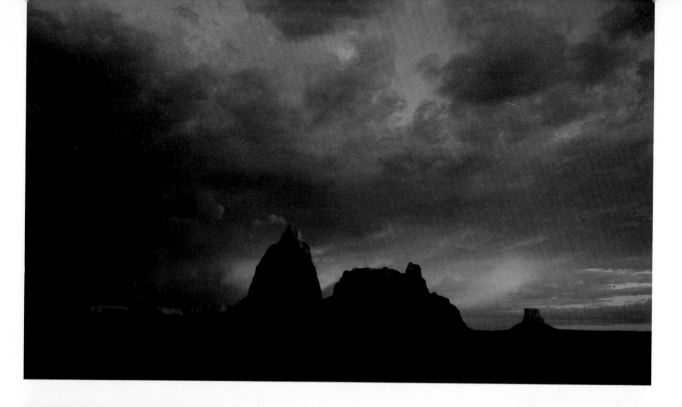

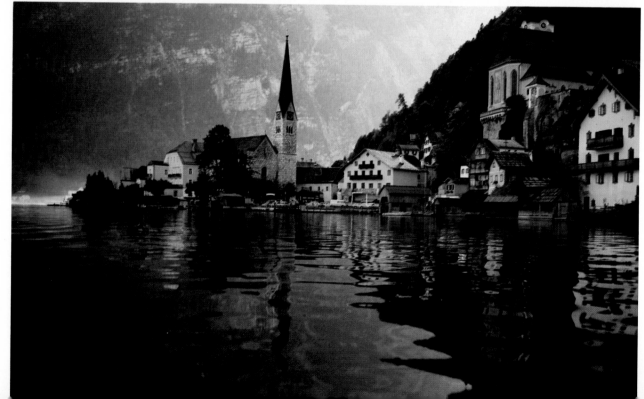

(Left, top) Sunsets are always fascinating. It is unwise to put your camera away too soon, as the sun may suddenly pop out from behind a cloud and produce new effects.

(Left, bottom) In this shot, the sun shines down the valley between the village and the distant mountain, defining an atmospheric haze which sharply delineates near and far elements. The village was lit by diffuse skylight from the left. The camera was a few inches above the gently undulating surface of the water on Hallstatter See, in Austria.

(Right) A spooky, silent walk from boat landing to a great natural wonder—Utah's Rainbow Bridge—at predawn set the stage for a memorable experience. As the moon descended in countermotion to the rising sun, specular shadows and the natural sandstone art-form wove an abstract design around the minute lunar disc. Less than one-thousandth part of the clear blue sky, the moon seems to be a fulcrum for the universe.

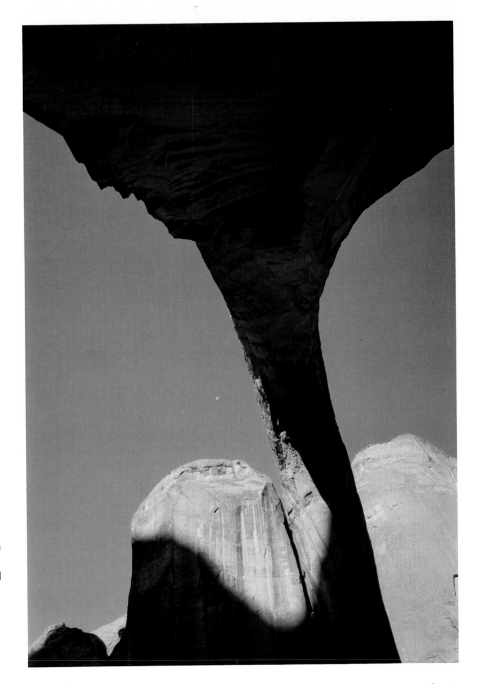

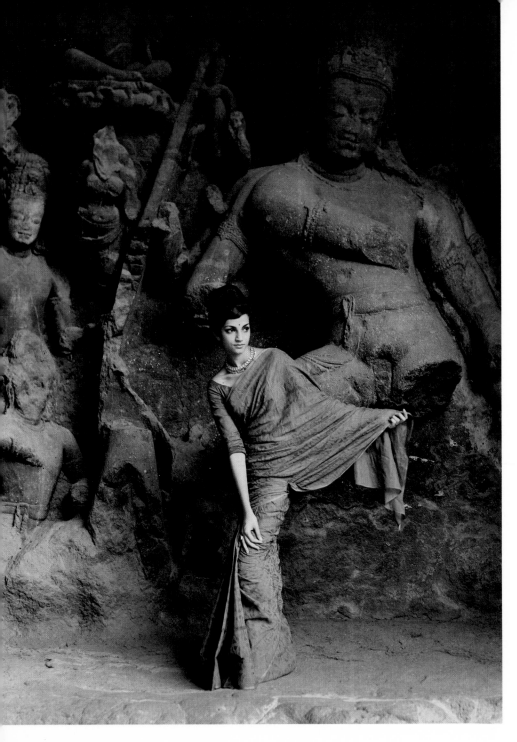

(Left) Color does not have to be vivid to be significant. The moss-greens of rock and sari at Elephanta Caves, Bombay, generate a cool elegance which a black-and-white image cannot convey. The lighting was diffuse skylight entering the cave from the right.

(Right) Irving Penn makes color ▶ an integral part of a strong design. The singular color provides an interesting test. Would the photograph work as well if seen only in black-and-white? What feelings would you have if the color of the umbrella was different? Color is more than just a mechanism for visual identity; it has its own message to contribute.

C-14

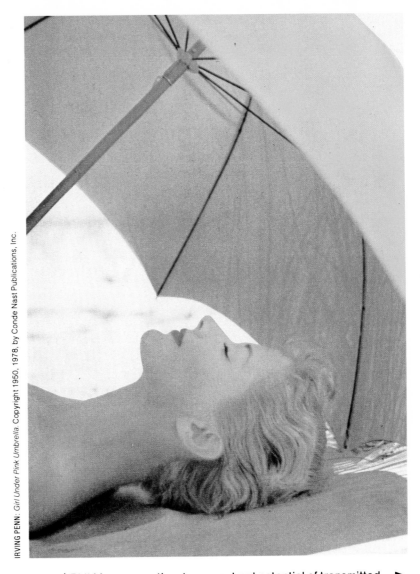

(Following page) Phil Marco uses the strong contrast potential of transmitted ▶ diffuse light (as opposed to bounced diffuse light), low levels of ambient light, and a strong rearward direction influence to obtain both high total contrast and high local contrast in his images. In this way he is able to depict form and texture visually stronger than seems photographically possible. Here you see precision of design and substance, feel the sharpness of the knife, observe the clarity of liquid, and sense the sour taste of sliced citrus. Local contrast in his photographs exceeds limits of reality, bringing the viewer's consciousness into super-reality.

C-16

Light and Emotion

Photography's explicit documentation of the effects of light generates a compelling fascination. From its beginnings, photography has demonstrated its power to record the emotional qualities of light—a unique heritage. The following photographs—only a few among myriad possibilities—help demonstrate this fact.

Minutes-long exposure in direct sunshine with shadows lightened by reflecting mirrors required herculean determination on the part of photographer and subject. Despite this, and the textured screening effects of the Calotype paper negative process, the force of directional specular light still conveys feelings of chiselled character and venerable strength in this portrait of the aged sculptor John Henning.

Julia Margaret Cameron is one of the great portrait photographers, due in part to her utilization of the emotional character of light. It is apparent from her work that she preferred to work only in the quality of light that suited her purpose, regardless of length of exposure, ignoring technical dictum and listening to intuitive urges. Here she succeeded in capturing this wonderful revelation of form and substance, probably illuminated by partly diffused late afternoon daylight entering her chicken coop "glass house" studio.

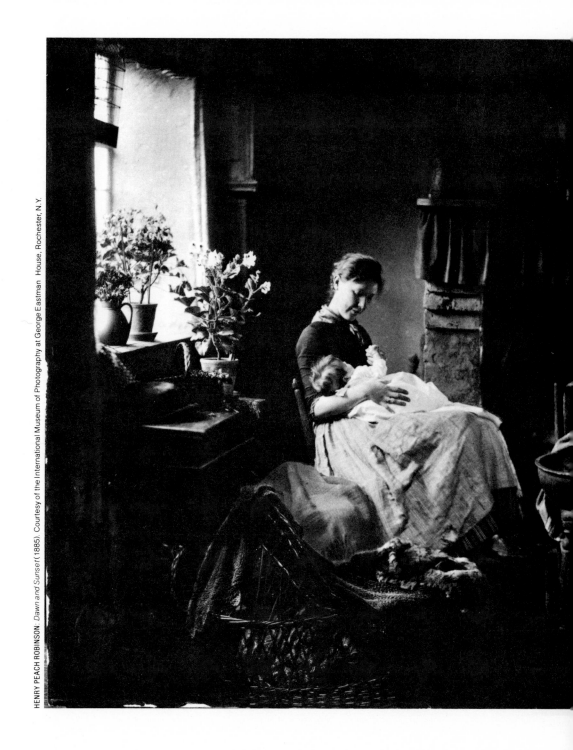

HENRY PEACH ROBINSON: *Dawn and Sunset* (1885). Courtesy of the International Museum of Photography at George Eastman House, Rochester, N.Y.

148

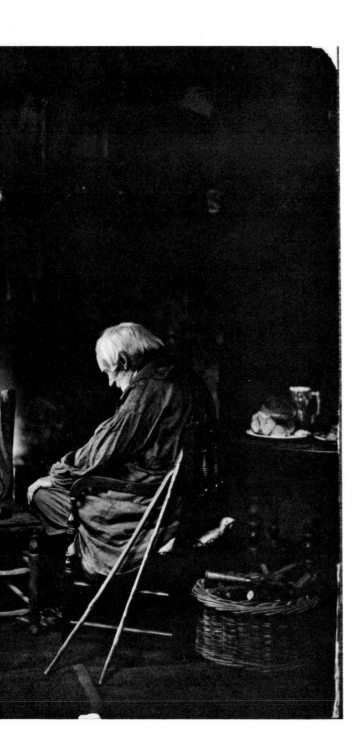

Diffuse window light and a glowing hearth suffuses this three-generation portrait. The young mother contemplates the future in her cherub, while the old man contemplates the past in the coals. The emotional quality of light is the fourth member in this cast of characters. Robinson excelled in producing composite prints. Here, five separate collodion negatives were used to make the one print. Without such an approach this image could not have been made, because the contrast characteristic of the film used was extremely high and it was sensitive only to blue and ultraviolet. Combination printing enabled Robinson to convey what the eye could perceive but a single negative could not. With modern films, it is possible to photograph a subject like this using one sheet of film if exposure is based on the deepest shadows, development greatly reduced, and the print manipulated as required during printing. Nevertheless, it is instructive to today's photographers that Robinson achieved his consistency of vision in spite of available materials, not because of them.

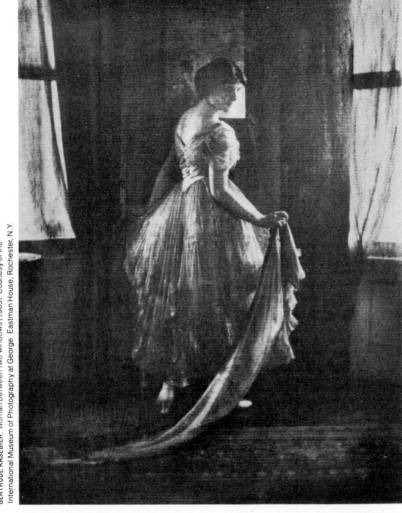

(Above) two large, diffuse window light sources with rearward direction quality reveal rich textures and luminosity in this gum bichromate print. The young lady glows with light-assisted self-assurance. Perhaps Käsebier first discovered the unique lighting situation and then arranged a subject to take advantage of it. Regardless, subject and light have an emotional consistency.

(Right) Steichen became a master of the extremely difficult technique of multiple specular lighting while working as a professional advertising and fashion photographer. This self-portrait is a jewel of lighting precision and impeccable timing, effectively displaying mastery of what he called the two most challenging technical problems in photography: conquering light and capturing a moment of reality.

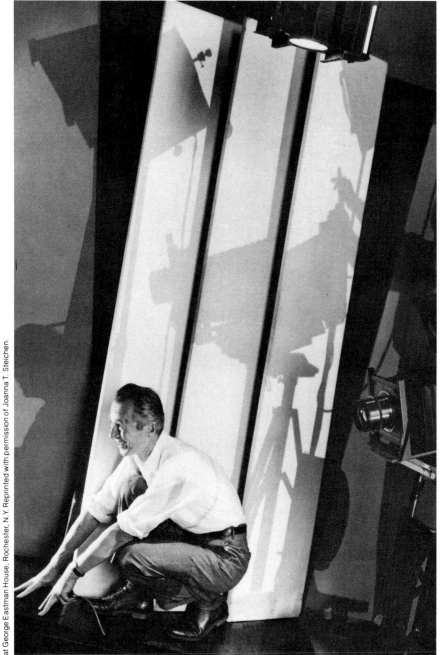

EDWARD STEICHEN: *Self-Portrait with Photographic Paraphernalia* (1929). Courtesy of the International Museum of Photography at George Eastman House, Rochester, N.Y. Reprinted with permission of Joanna T. Steichen.

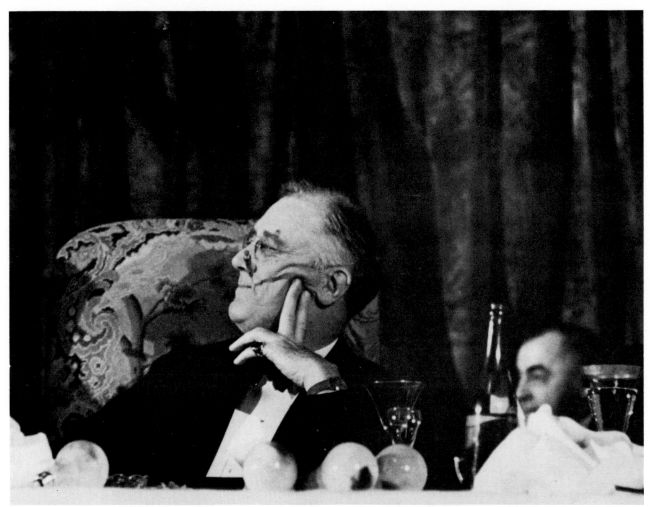

THOMAS MC AVOY: *FDR at the Jackson Day Dinner, 1938.* ©Time-Life, Inc.

Spent flashbulbs, used for photographs long since forgotten, remain in one of McAvoy's memorable candids of Franklin Delano Roosevelt. Available light, thought by many at the time to be technically inferior lighting, adds convincing authenticity which places the viewer across the table as a participant. When authenticity becomes the most important emotional consideration for lighting, requirements for veracity may run exactly contrary to technical criteria. An alert user of light will recognize this.

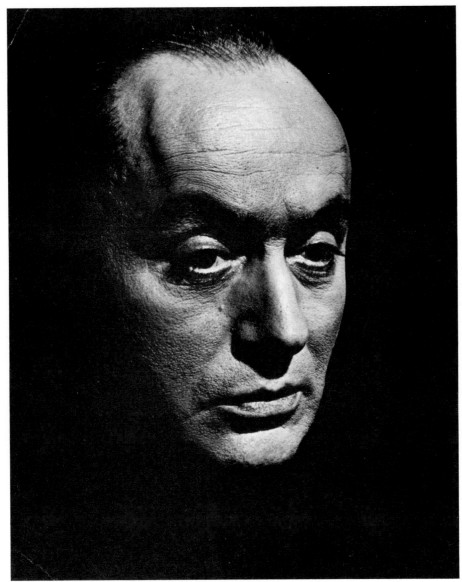

PHILIPPE HALSMAN: *Charles Boyer* (1948). Copyright © by Philippe Halsman.

A specular flash, aimed with the precision of a spotlight, conveys the shadings of a theatrical masque. The viewer senses the hushed intensity of a center-stage soliloquy, with light and actor each playing a role. Halsman used lighting instinct and experience in applying direction control to the light source, because this was made before modeling lamps were conveniently used with flash.

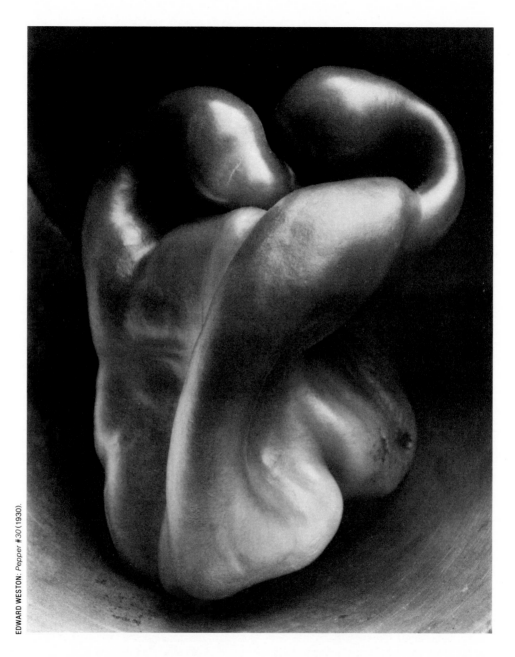

The pepper was lit by dimming diffuse daylight plus reflections of that light from the encompassing large tin funnel in which the pepper had been placed.

Diffuse light burnished the pepper to a sensual lustre and supported feelings of monumental masculine power.

154

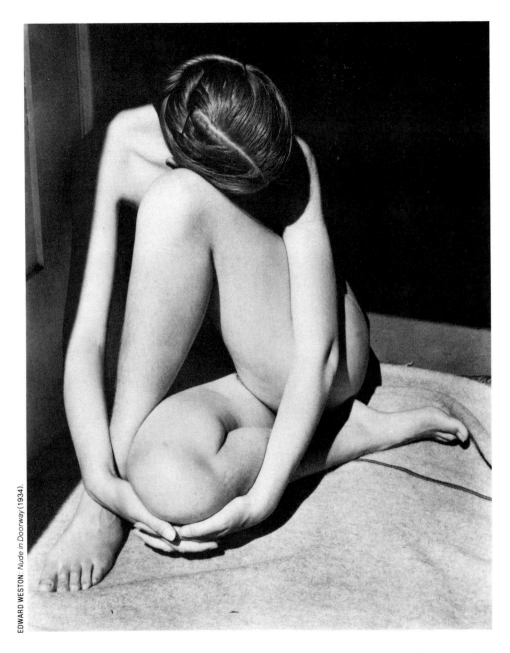

EDWARD WESTON: *Nude in Doorway* (1934).

The nude was lit by direct, specular sunshine. The crisp light and shade relationship conveyed precision and clarity of a tightly organized design.

Neither image would be as emotionally successful in the illumination of the other.

155

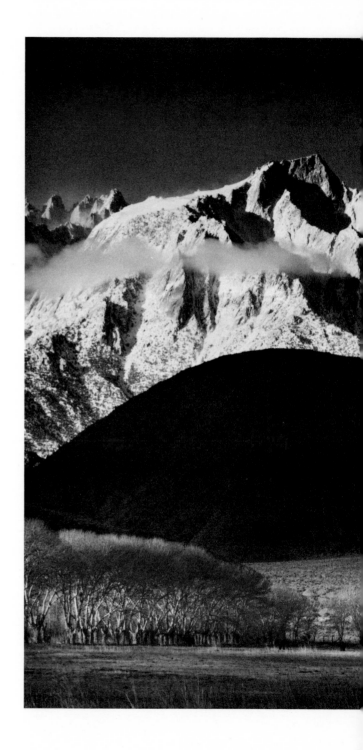

Natural lighting on a grand scale. This is not a figment of imagination but magnificent reality. A treasure of natural light revealed and retained, to be savored again and again.

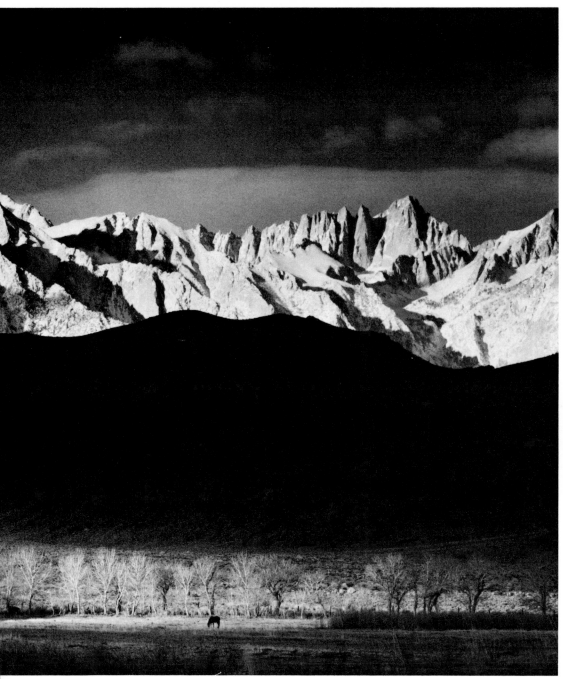

ANSEL ADAMS: *Winter Sunrise. Sierra Nevada. from Lone Pine. California* (1944).

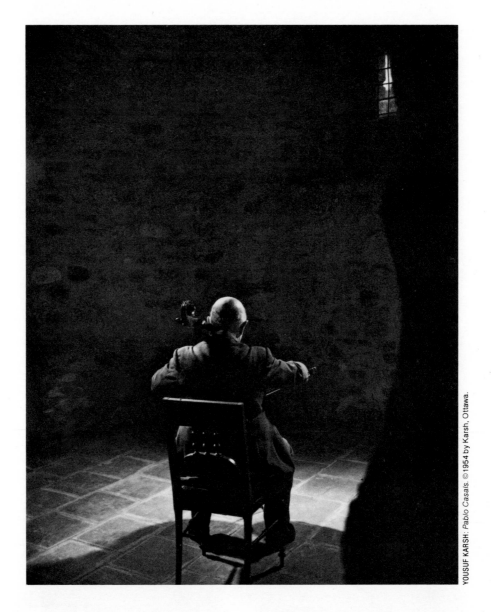

In his book *Portraits of Greatness,* Karsh describes his portrait session with Pablo Casals, the self-exiled Spaniard protesting the Franco regime. Karsh "decided on an unusual experiment" for depicting the voluntary prisoner who, with his music, had escaped his own detainment. He decided to photograph Casals from the back. In this photograph, Casals glows with an inner vitality; his music visually fills the room. With lighting alone, Karsh has provided a statement about the man and his music, although Casal's face is hidden and his musical instrument barely discernible.

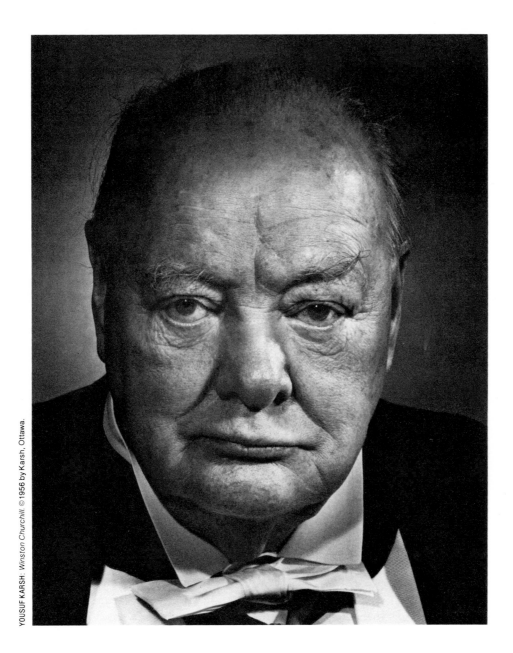

A frail old man with an indomitable spirit. Moderately specular, directional lighting adds emotional substance to weakening flesh. The viewer is witness to a photographic record of empathy between two vital human beings. The lighting is controlled with consistent affection and respect.

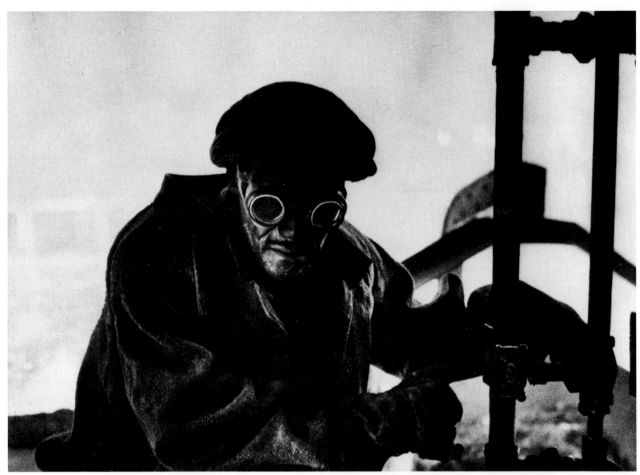

W. EUGENE SMITH: *Devil Goggles.* ©1955.

A tough, hot, and sensitively competent steelworker. The blaze and roar of hot steel is visually conveyed by the background haze. Note the strength of shadow detail, which can be achieved only if the exposure is based on full shadow detail. This means overexposure of about one stop if read with an incident meter. Highlights were kept under control by subsequent reduction of film development. The print was then made to the density which satisfied the photographer's visual intent. Full exposure enables a photographer to print for shadow renditions that have strength instead of obscurity.

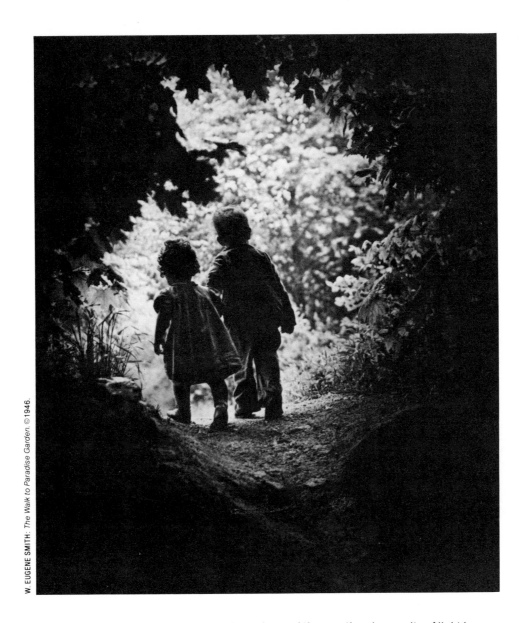

Few photographers have so consistently used the emotional capacity of light in their work as W. Eugene Smith. After a two-year recovery from wounds suffered in World War II, he set himself a goal, namely, that his first image upon recovery would be a special success. This image was the result—one of the most memorable photographs of childhood ever made, and one in which the emotional quality of light plays a significant role.

161

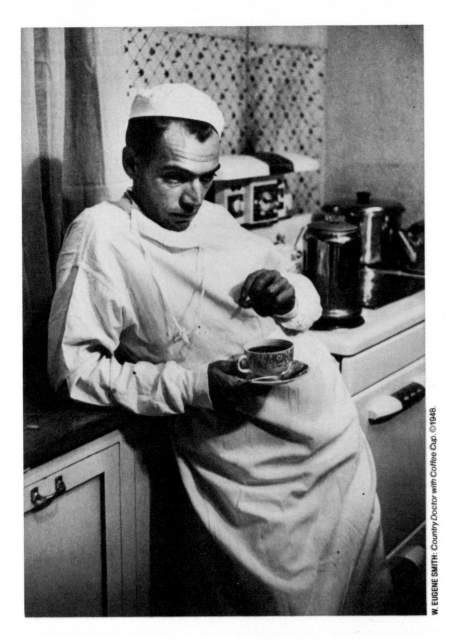

W. EUGENE SMITH: *Country Doctor with Coffee Cup.* © 1948.

You can feel the physical drain not only in the slump, the stare, and the dying cigarette stub, but also in the stark presence of a ceiling light fixture late at night. The curtain covers the blackness of light, not the brightness of day. Here the emotional emphasis of light is not on beauty or drama but on authenticity.

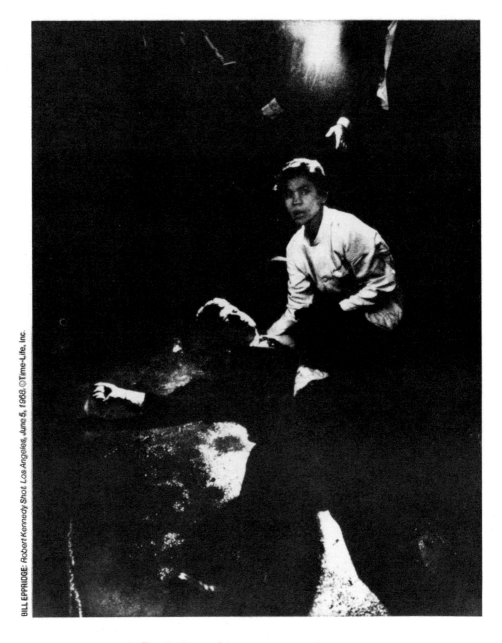

Tragedy—and a photojournalist instinctively responds. But the image is more than news. By controlling the emotional potential of light later in the darkroom, the photographer creates a lamentation no one can ever forget.

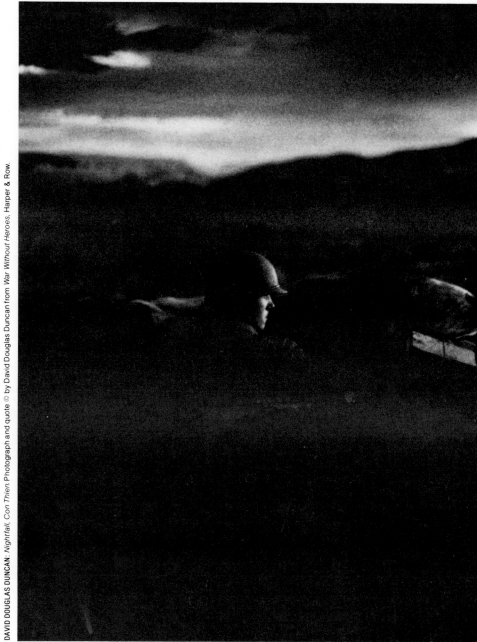

DAVID DOUGLAS DUNCAN: *Nightfall, Con Thien.* Photograph and quote © by David Douglas Duncan from *War Without Heroes,* Harper & Row.

". . . nearly dark. The birth of another world and life—
alone." The slowly enveloping terror of impending
nightfall, a topic not easily discussed by war
veterans, is vividly conveyed here by the emotional
quality of light—and by someone sensitive enough
to depict it.

The photo at left is cool and elegant, soft and feminine, bright and fresh. Diffuse, high key, low total contrast, and well-modulated local contrast lighting are emotionally consistent with the visual message. The eyes mirror the lighting. An umbrella source was located directly above the camera and a very strong reflector placed beneath, giving the eyes a special luminosity. The background, illuminated separately, and the very low light ratio indicate the presence of ample ambient light.

In the photo at right, the warmth of home and family in a wan winter evening's fading glow is strongly suggested by the emotional contrast of artificial and natural light.

The landscape explodes into sparks of foliage and mysterious lighting fantasy. A person seems to merge into the environment as light's energy melts physical substance. Light no longer illuminates; instead, it emotionally transfers dimensions of reality into another existence. The lighting is more than a technical trick and was probably produced by multiple flashes of a portable electronic flash during a time exposure. This creates emotions in a way that is uniquely photographic and adds to lighting the dimension of time.

168

Control of Light

The most effective way to control light and lighting is to control its six qualities. One solution for control is to use the changing nature of light itself inasmuch as all six qualities are normally in flux: the sun moves across the sky; artificial lighting relationships become different at every flick of a switch; and subject or photographer are continually shifting positions. In other words, indirect control can be achieved by waiting and observing, or by relocating oneself or the subject in relation to the scene. Indirect control is passive; the photographer should also learn how to make lighting effects happen by applying direct control.

Direct control of the qualities of light requires knowledge of what causes them, as well as a firm understanding of appropriateness, because self-evident clues are not available. Direct control of lighting is more difficult than indirect control, but the former can be more fun because you, the photographer, are in charge, not the whims of change.

The following illustrations and photographs show additional aspects of controlling the six qualities of light, but by no means do they depict all of them. Control of light depends on specifics of subject matter and the imponderables of visual intent. Therefore, these observations are only helpful guidelines.

A Suggested Working Procedure for Control of Lighting

- Decide whether specular or diffuse quality should predominate.
- Decide whether to strive for color neutrality or color effect.
- Consider direction influence.
- Decide if more than one light source is necessary.
- Decide if total contrast (light ratio) should be high or low.
- Evaluate the local contrast to see if it is sufficient for your communication needs.
- Consider brightness in terms of light measurement and local brightness control.
- Decide if a given brightness key is needed.

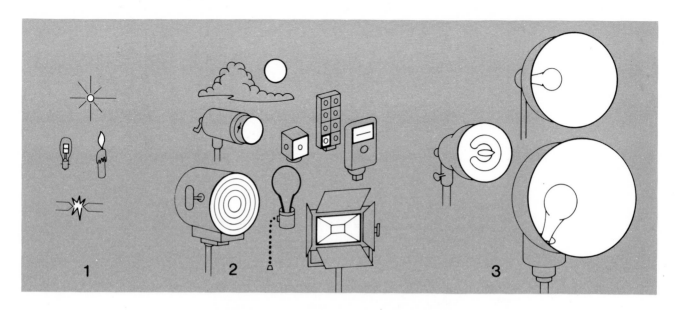

1

2

3

Specular–Diffuse Progression

The specularity or diffuseness of illumination is based on the relative size of the light source. A small source produces specular illumination and a large one diffuse illumination. An earlier geometric diagram showed us why this is so. Therefore, to control specular–diffuse quality, you should be aware of light sources that typically possess more of one quality than the other and should also note that most primary light sources (ones that actually generate light) are specular. A specular, primary source must be modified in order to create a diffuse source.

1. Point source. The most specular source is a point light source. Among the sources which come close to achieving this theoretical limit, especially if placed some distance from the subject, are arc lamps, small filament lamps, and a steady candle flame.

2. Small sources and optically focused sources. These subtend a small angle of arc, just a few degrees or less. The sun subtends ½° of arc; other tiny sources such as small electronic flash units, bare light bulbs, mini-quartz lamp fixtures, flipflash, flash cubes, and small spotlights are in the

same category. Even large optically focused spotlights—for example, theatrical spotlights—fall into this category when used at great distances. Because small sources have measurable dimensions, the shadow cast by them will have both an umbra and a penumbra—the edge of the cast shadow is no longer a sharp line unless the cast shadow is quite close to the object that is casting it.

3. Reflector sources. Reflectors add noticeable dimension to the primary light source. They vary in size from about 6 to 20 inches in diameter. Reflector size plays the biggest role, but also important are the specular presence of the light bulb and the finish and shape of the reflector. A matte-finish parabolic reflector has the least hot spot in its illumination, while a shiny, spherical reflector has the most. The hot spot in the illumination adds a specular presence. Thus a shiny, spherical reflector placed at a distance of many feet will be much more specular than a matte-finish parabolic reflector close to the subject. A fitted diffuser over the reflector merely removes the hot spot in the illumination; since it does not physically increase the size of the source, it does little to alter

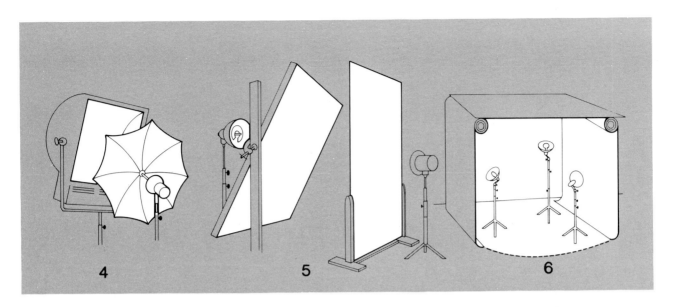

4 5 6

the specular–diffuse character of the illumination unless the reflector source is placed quite close to the subject.

4. Umbrella sources and pan reflectors. These are two feet in diameter or larger and thus add noticeable diffuseness to the illumination. Umbrellas are convenient, inexpensive, and portable, but the mechanism can get in the way; also, umbrellas may be reflected off such specular surfaces as mirrors, a characteristic which makes them unsuitable for most product photography. Pan reflectors are heavy and expensive, but they do provide a clean pane of light that is suitable for lighting mirror surfaces. Umbrellas also possess a hot spot if they are silvered. These are not brighter than matte umbrellas; they merely collect more of the primary source light into the center of the umbrella's illumination, creating a brighter hot spot. This hot spot can be an effective lighting tool, though not for increasing overall brightness quality—unless you use a narrow angle-of-view lens on the camera.

5. Light panels. These are 4′ × 4′ or larger. Bounce light panels generate more ambient light and thus produce less total contrast than transmitted light panels, other things being equal.

Skylight coming in a north window is a natural light panel. Light panels, although large, still possess direction quality. For this reason, they are excellent for revealing form and space in the scene being illuminated. Portable light panels are easy to make. White cloth or a piece of translucent plastic sheeting stretched between two collapsible light stands will nicely modify a primary, specular light source into a large light panel.

6. Nondirectional light sources. Light that emanates more or less equally from all directions is the most diffuse light source. At this step in the S–D progression, light ceases to have a definable direction quality except that it does seem to come from above. If the subject is placed on a light table, even this subtle distinction will disappear. Light bounced off the surfaces of a small, white room, an overcast sky, the overhead fluorescent illumination in a typical office building, and ambient light are nondirectional light sources. Ambient light occurs naturally in all lighting environments in which there are reflecting surfaces. When you want to reduce total contrast for photographic purposes, it is generally best to do so by actually increasing the ambient light level.

173

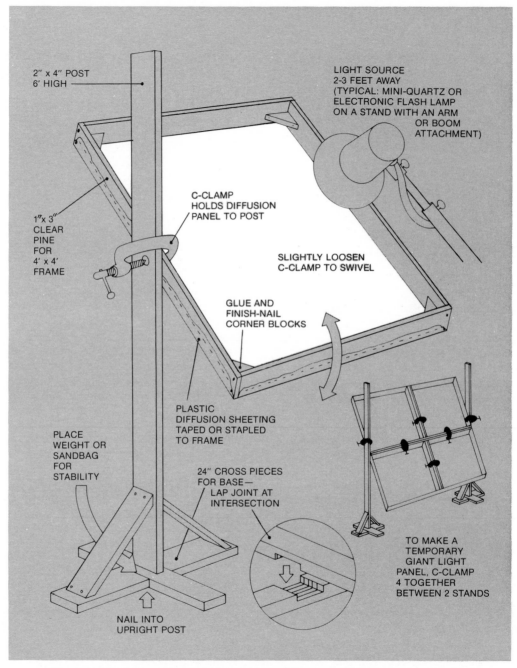

2" x 4" POST
6' HIGH

LIGHT SOURCE
2-3 FEET AWAY
(TYPICAL: MINI-QUARTZ OR
ELECTRONIC FLASH LAMP
ON A STAND WITH AN ARM
OR BOOM
ATTACHMENT)

1"x 3"
CLEAR
PINE
FOR
4' x 4'
FRAME

C-CLAMP
HOLDS DIFFUSION
PANEL TO POST

SLIGHTLY LOOSEN
C-CLAMP TO SWIVEL

GLUE AND
FINISH-NAIL
CORNER BLOCKS

PLACE
WEIGHT OR
SANDBAG
FOR
STABILITY

PLASTIC
DIFFUSION SHEETING
TAPED OR STAPLED
TO FRAME

24" CROSS PIECES
FOR BASE—
LAP JOINT AT
INTERSECTION

TO MAKE A
TEMPORARY
GIANT LIGHT
PANEL, C-CLAMP
4 TOGETHER
BETWEEN 2 STANDS

NAIL INTO
UPRIGHT POST

CONSTRUCTION OF ADJUSTABLE, INEXPENSIVE 4'x 4' TRANSMITTED DIFFUSE LIGHT PANEL

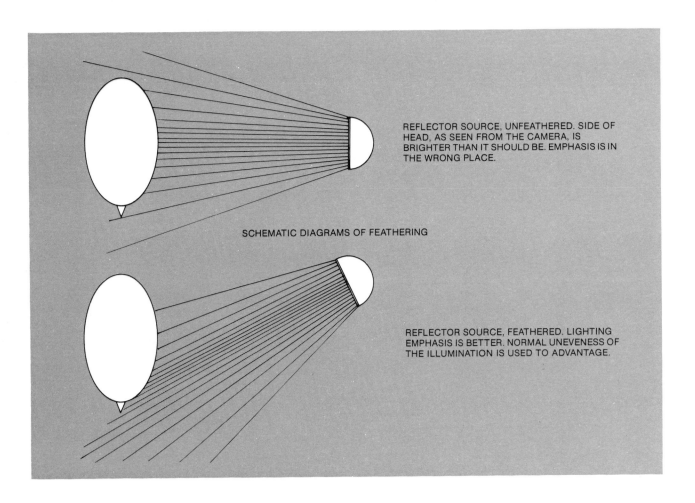

REFLECTOR SOURCE, UNFEATHERED. SIDE OF HEAD, AS SEEN FROM THE CAMERA, IS BRIGHTER THAN IT SHOULD BE. EMPHASIS IS IN THE WRONG PLACE.

SCHEMATIC DIAGRAMS OF FEATHERING

REFLECTOR SOURCE, FEATHERED. LIGHTING EMPHASIS IS BETTER. NORMAL UNEVENESS OF THE ILLUMINATION IS USED TO ADVANTAGE.

Feathering the Light Source

Most light sources possessing some direction quality have a falloff in illumination toward the edges of that illumination. These sources can therefore be "feathered" to avoid excess brightness in those parts of the scene which are nearest the light source. Feathering is accomplished by aiming the light source at an imaginary point somewhere between the camera and the subject, but not directly at the subject.

Feathering is a lighting subtlety not readily discerned by the eye, but one that is easily appreciated when the scene in a photograph is isolated within the borders of the finished print. Once the reference of the frame is established, unwanted irregularities of lighting become much more apparent.

Those light sources which can be feathered are nearly all reflector light sources, umbrellas (especially silvered ones), and most diffuse sources that are not a smooth pane of lightness. Point sources and spotlights are not featherable.

Direction Influences of One Light

These photographs clearly show several direction influences of a moderately diffuse light source on a common subject, the human face. The angles are in relation to the lens-to-subject axis line. A 40-inch umbrella was used about four to seven feet away. The black wall behind the subject was lit with a second light to provide tonal separation. Because the walls, ceiling, and floor were painted black, the ambient light level was extremely low.

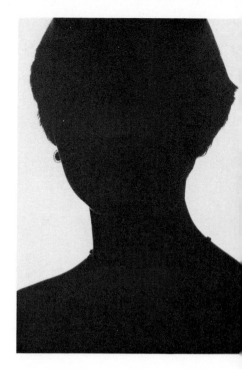

Extreme Angles of Influence

Full front influence (0°). The umbrella source was positioned behind the camera on the lens-to-subject axis. Note the absence of cast shadows which produced a light and shade relationship with a minimum of form and texture. However, the inherent tonal relationships of the subject itself—eyes, hair, skin, lips—are fully revealed because there was no light and shade relationship imposed on them to cause tonal modification.

Silhouette influence (180°). The umbrella was positioned directly behind the subject, hence only its glow surrounding the silhouette of the face is apparent. Form, texture, and brightness are at a minimum, but there is a strong revelation of shape.

Three 90° influences: above, below, and from one side. These three extremes produce light and shade relationships with a maximum of form and texture. But because the human face has an irregularity of form, each of these 90° extremes produces a light and shade relationship with a different character.

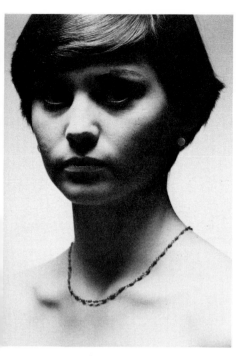 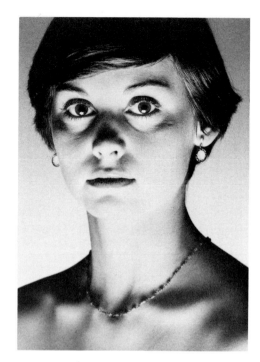 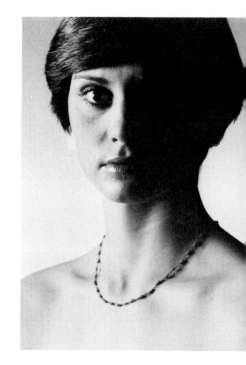

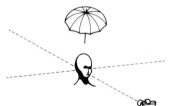 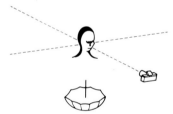

When the light source is directly overhead, the form of the skull beneath the skin is revealed and the eyes are hidden in shadow — visually informative but not very flattering. Emotionally the face seems lifeless.

When the light source is directly below, the effect is unnatural. Natural light seldom has such a direction quality, therefore the light and shade relationship can seem distorted. It doesn't take too much imagination to perceive the nose as a depression instead of a protrusion.

When the light source is from one side, the light and shade relationship cuts the face in half. With the face symmetrical, the effect is not agreeable; turning the profile toward the light source gives a more agreeable effect.

Remember that in the lighting equation, you should consider both the light source and the subject. Thus most angular influences can be modified very easily simply by having the subject turn his or her head.

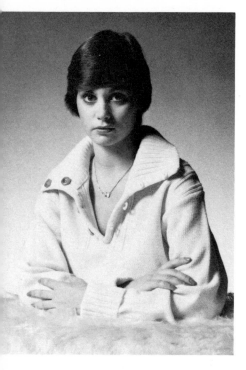
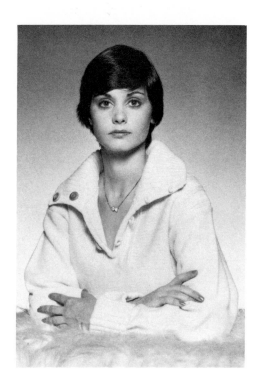
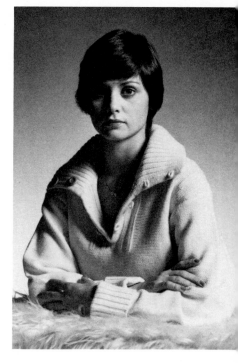

Intermediate Angles of Influence

Of the six intermediate angles of influence, three have a frontal influence while the other three have a rearward influence. They are also midway between the other extremes; in other words, 45° above the lens-to-subject axis and 45° to the left or right, or 45° above the lens-to-subject axis and directly in front of or behind the subject.

The three frontal positions produce good revelations of form and texture, but because the human face has an irregularity of form, the positions to the left and right produce more texture on the face than that directly over the lens-to-subject axis. This latter position is used frequently in fashion photography while the other two are more often used in traditional studio portraiture.

The three rearward positions produce edge-lighting effects and are seldom used alone unless there is ample ambient light to illuminate the

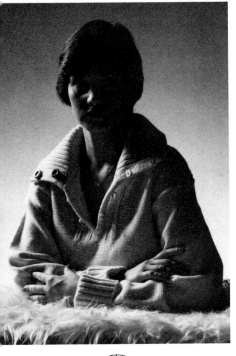

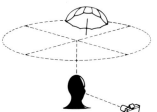

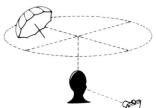

shadows. These positions skip the light off the head with little scattering directly into the lens. Because the light reflection off the subject is so efficient, the rearward directions of influence can be generated with relatively weak light sources. Also, with rearward directional lighting, remember to use a lens shade to avoid unwanted lens flare.

It should be readily apparent that each of several lights can be assigned a given directional influence to achieve a summation of lighting effects. This is precisely what multiple lighting techniques are intended to do. Since the possibilities are both obvious and infinite, examples of the many combinations are not depicted. But now that you know the fundamentals, you can produce your own formulations. The main problem to avoid is overlapping light and shade relationships. Once created, they cannot be removed by adding more lights; they must be avoided in the first place. Multiple lighting effects are complex and intricate; they are best learned by experience, because the subtleties cannot be adequately diagrammed.

Special Lighting Problems in Making Large Posters

Lighting for a full-size image of a single subject presents special problems. This is especially true for large display posters, and the Kodak Summer Girl is a good example. Here a photograph of a vivacious young woman was made into a life-size poster for point-of-purchase advertising displays. As such, the image is frozen in space and time, subject to careful scrutiny, and casual inconsistencies of lighting draw attention in a way that does not happen in real life. To avoid them, make the lighting as simple as possible but with good local contrast for visual impact.

One way to achieve this is to use a very large light panel placed to one side of the subject. The illumination brightness changes less than ¼ f-stop from head to toe, which is very important, and the light and shade relationship wraps around the figure for good local contrast.

This print was made on ordinary black-and-white paper from the color negative to exaggerate tonal relationships and make them clearer. Note that the model is also standing in a white environment, which produces a very high level of ambient light. Black shadows must be avoided at all costs in large posters. The strip on the floor gives the model a precise guide for posing; this avoids wasting needless time and energy refocusing the 8″ × 10″ view camera. The young woman was charming and intelligent, and she, not technical problems, deserved the photographer's maximum attention.

Tools for Color Evaluation

Color film is nominally balanced to a neutral by using the proper type of color film with a given type of lighting—5400 K for daylight and electronic flash, and 3200 K for tungsten. For most color photography, matching film type to lighting is a satisfactory control. And even when the color balance of the lighting changes, such changes are frequently not bothersome, often producing attractive color effects.

There are times, however, when exacting color balance is important, for example, in product illustration and high-key situations. For an exacting color balance, you must exercise special care in processing and handling and make tests noting, by careful evaluation, any necessary color corrections. Corrections are made by placing Color Compensating (CC) filters in front of the camera lens when using color reversal films. With color negative films, the decision about color balance can be deferred to the printing stage. CC filters are the best method for achieving an exacting color balance because they produce a photographic correction rather than just a visual one.

Careful evaluation of tests and results requires the proper tools, some of which appear here. You need a standard viewing device, such as the Macbeth Prooflight 5000, and a set of CC filters for evaluation and correction, although some photographers prefer to use less expensive viewing filters for evaluation only. A *Kodak Color Dataguide* provides useful data plus filter computers for use in color printing. The Spectra Tricolor Meter is a relatively new and important color measuring device. It reads three color components of light, not two as in a color temperature meter, thus providing photographically useful information about the color quality of lighting. It is expensive and requires some training and testing to be used properly, but for many photographers, especially professionals, it soon pays for itself.

DON BUCK: *Machinery component* (two versions).

Decisions About Total Contrast
(and Light Ratio)

The intended use of the photograph helps one decide about total contrast and light ratio.

If the photograph is meant to be a substitute for the real thing, as when photographing machinery for a repair manual, total contrast must be carefully controlled to fit the limits of the reproduction process. The viewer must be given all the visual information possible. Lower total contrast is better because high total contrast, shown in the photograph at left, causes black shadows that obscure too much internal detail in the machine.

However, if the photograph is meant to communicate feelings or emotions, different criteria can apply. For reasons of visual emphasis or artistic expression, a high total contrast may be preferred because it attracts attention or conveys an intended mood. Note that the left photograph has greater visual impact than the right photograph.

Don't forget that total contrast is variable at all stages of the photographic process. Light ratio must be considered as well as the choice of paper grade and other factors affecting the contrast of photographic materials and processes.

182

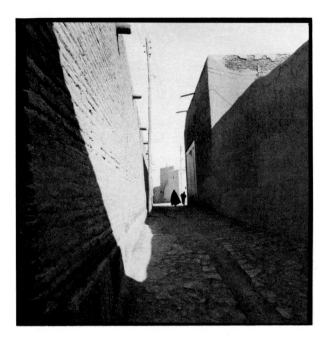 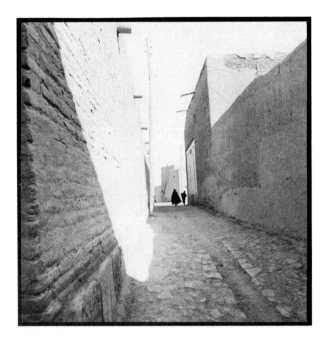

Effect of Brightness Measurement on Brightness Quality

Brightness measurement (exposure) should not always be based on some standardized ideal. Individualized control is also a useful means for conveying visual feelings about the brightness quality of light. You can exercise such control at the time of exposure with reversal film or during the printmaking stage with negative film.

These two prints were made on negative film and adjusted for brightness quality at the printing stage: one is technically correct while the other is more emotionally appropriate; one possesses a full tonal scale while the other is limited in that respect; one shows literally all the details of the scene while the other conveys feelings of heat, dryness, and blinding solar ambience.

(With negative film, fully expose for sufficient shadow information; the desired amount of shadow detail can be decided upon at the printing stage. Today's thin-emulsion films, both black-and-white and color, are almost impossible to block up, and increased granularity caused by increased exposure is not nearly the problem that most photographic literature makes it out to be.)

With reversal film materials, it is wise to bracket exposures when in doubt about how to render a scene. Even an experienced photographer is not always able to predict exactly all the nuances of the brightness quality of light that will be rendered in the finished transparency.

Local Brightness Control Tools

When considering brightness quality, you must consider not only overall brightness (exposure) but also the brightness of local areas in the scene. Some local brightness control can be achieved in the darkroom, but it is better when this control is exercised at the time of exposure with lighting. Here are some tools to do the job.

Adding Local Brightness

To increase local brightness, use a light fixture that projects a light beam with a limited area of influence. This is accomplished with lights in deep reflectors, spotlights, and small lights fitted with barn doors, optical or tubular snoots, and so forth. (Some of these devices are illustrated in the photo at right.) Such fixtures attached to a boom let you suspend it out over a set for more precise direction control. The brightness of the light itself can be adjusted by fitting it with an iris diaphragm, metal scrim, or filter. With internal masks, optical spots (or even ordinary slide projectors) will cast an optically sharp-edge beam of light of any shape produced by the mask. Today such specialized lighting devices are manufactured for both tungsten and electronic flash light sources.

To add local brightness more subtly, use such small reflectors as white paper, silver paper, or even glass mirrors. (The more specular the surface of the reflector, the brighter and more precisely defined will be its reflected illumination.)

Reducing Local Brightness

To remove or reduce local brightness, use various shading devices. Opaque screens cast darker shadows while translucent ones (scrims) cast weaker shadows that are also less well defined. Some of these devices are commercially available, but you can make your own from ordinary window screen, cardboard, and cloth. Remember that the more specular the light source being screened, the more precisely defined the cast shadow of the screen. With a diffuse source, an opaque screen will cast only a modestly dark, nebulous shadow onto the set.

Bibliography

Adams, Ansel. *Artificial-Light Photography.* Dobbs Ferry, N.Y.: Morgan and Morgan, Inc., 1956.

——. *Natural-Light Photography.* Dobbs Ferry, N.Y.: Morgan and Morgan, Inc., 1952.

de la Croix, H., and R.G. Tansey. *Gardner's Art Through the Ages,* 6th ed. New York: Harcourt Brace Jovanovich, Inc., 1975.

Eastman Kodak Company. *Kodak Color Dataguide.* Rochester, N.Y.: Eastman Kodak Company, 1977.

——. *Kodak Professional Black and White Films.* Rochester, N.Y.: Eastman Kodak Company, 1976.

——. *Kodak Professional Dataguide.* Rochester, N.Y.: Eastman Kodak Company, 1977.

Elisofon, Eliot. *Color Photography.* New York: The Viking Press, 1961.

Evans, Ralph M. *An Introduction to Color.* New York: John Wiley and Sons, 1948.
——. *Eye, Film and Camera in Color Photography.* New York: John Wiley and Sons, 1959.

Halsman, Philippe. "Psychological Portraiture." *Popular Photography* (December 1958), pp. 119–141, 160–164.

Lambert, Herbert. *Studio Portrait Lighting.* London: Sir Isaac Pitman and Sons, Ltd., 1930.

Liberman, Alexander. *The Art and Technique of Color Photography.* New York: Simon and Schuster, 1951.

Luckiesh, M. *Light and Shade and their Applications.* New York: D. Van Nostrand, 1916.

Bibliography (continued)

Newhall, Beaumont. *The History of Photography.* New York: The Museum of Modern Art, 1964.

Newhall, Beaumont, and Nancy Newhall. *Masters of Photography.* New York: George Braziller, Inc., 1958.

Reedy, William A. *Impact—Photography for Advertising.* Rochester, N.Y.: Eastman Kodak Company, 1973.

Robb, David M., and J.J. Garrison. *Art in the Western World.* New York: Harper and Bros., 1942, 1953.

Steichen, Edward. *A Life in Photography.* New York: Doubleday and Co., Inc., 1963.

Index

Author's note: Numbers in boldface type indicate the more important entries for each topic. All page numbers over 98 refer to illustrations; numbers C-1 through C-16 refer to the color section.